Tangle-Inspired Botanicals

EXPLORING THE NATURAL WORLD THROUGH MINDFUL, EXPRESSIVE DRAWING

Sharla R. Hicks, CZT

Quarto.com

© 2017 Quarto Publishing Group USA Inc.
Text © 2017 Sharla R. Hicks
Photography © 2017 Sharla R. Hicks, except page 128, which is copyright David La Neve

First published in the United States of America in 2017 by
Quarry Books, an imprint of The Quarto Group,
100 Cummings Center, Suite 265-D,
Beverly, MA 01915, USA.
T (978) 282-9590 F (978) 283-2742

All rights reserved. No part of this book may be reproduced in any form without written permission of the copyright owners. All images in this book have been reproduced with the knowledge and prior consent of the artists concerned, and no responsibility is accepted by producer, publisher, or printer for any infringement of copyright or otherwise, arising from the contents of this publication. Every effort has been made to ensure that credits accurately comply with information supplied. We apologize for any inaccuracies that may have occurred and will resolve inaccurate or missing information in a subsequent reprinting of the book.

Quarry Books titles are also available at discount for retail, wholesale, promotional, and bulk purchase. For details, contact the Special Sales Manager by email at specialsales@quarto.com or by mail at The Quarto Group, Attn: Special Sales Manager, 100 Cummings Center, Suite 265-D, Beverly, MA 01915, USA.

ISBN: 978-1-63159-288-1

Digital edition published in 2017

Library of Congress Cataloging-in-Publication Data
Hicks, Sharla R., author.
Tangle-inspired botanicals : exploring the natural world through mindful, expressive drawing / Sharla Hicks.
ISBN 9781631592881 (paperback)
1. Nature in art. 2. Drawing--Technique.
NC825.N34 H53 2017
700/.46--dc23
LCCN 2016056819

Cover Design: Shubhani Sarkar
Cover Image: Sharla R. Hicks
Page Design and Layout: Sporto
Photography: Sharla R. Hicks and David La Neve
Illustration: Sharla R. Hicks

Printed in USA

The name "Zentangle" is a registered trademark of Zentangle, Inc.

The red square logo, the terms "Anything is possible one stroke at a time," "Zentomology" and "Certified Zentangle Teacher CZT" are registered trademarks of Zentangle, Inc.

It is essential that before writing, blogging, or creating Zentangle-Inspired Art for publication or sale that you refer to the legal page of the Zentangle website. Zentangle.com

▶ Rim of the World, Arrowhead Fire

Make Your Mark!

Beauty surrounds.
Monumental grandeur demands.
Creation reverberates.
Pattern integrates.
The soul resonates.

Make Your Mark!
Art, many come wounded.
Expression blocked. Fear.
Structure embraced.
Repetition seized.
Line, dot, curve, the stroke.

Make Your Mark!
Stop.
Listen.
Feel.
Embrace.
Engage.

Make Your Mark!
Embrace Chaos.
Embrace Tremor.
Embrace Fear.
Embrace Muse.
Embrace Rhythm.

Make Your Mark!
Engage Fear.
Engage Logic.
Engage Intuition.
Engage Stroke, Form, Rhythm.
Engage Petal, Leaf, Tree.

Make Your Mark!

—Sharla R. Hicks, 2016

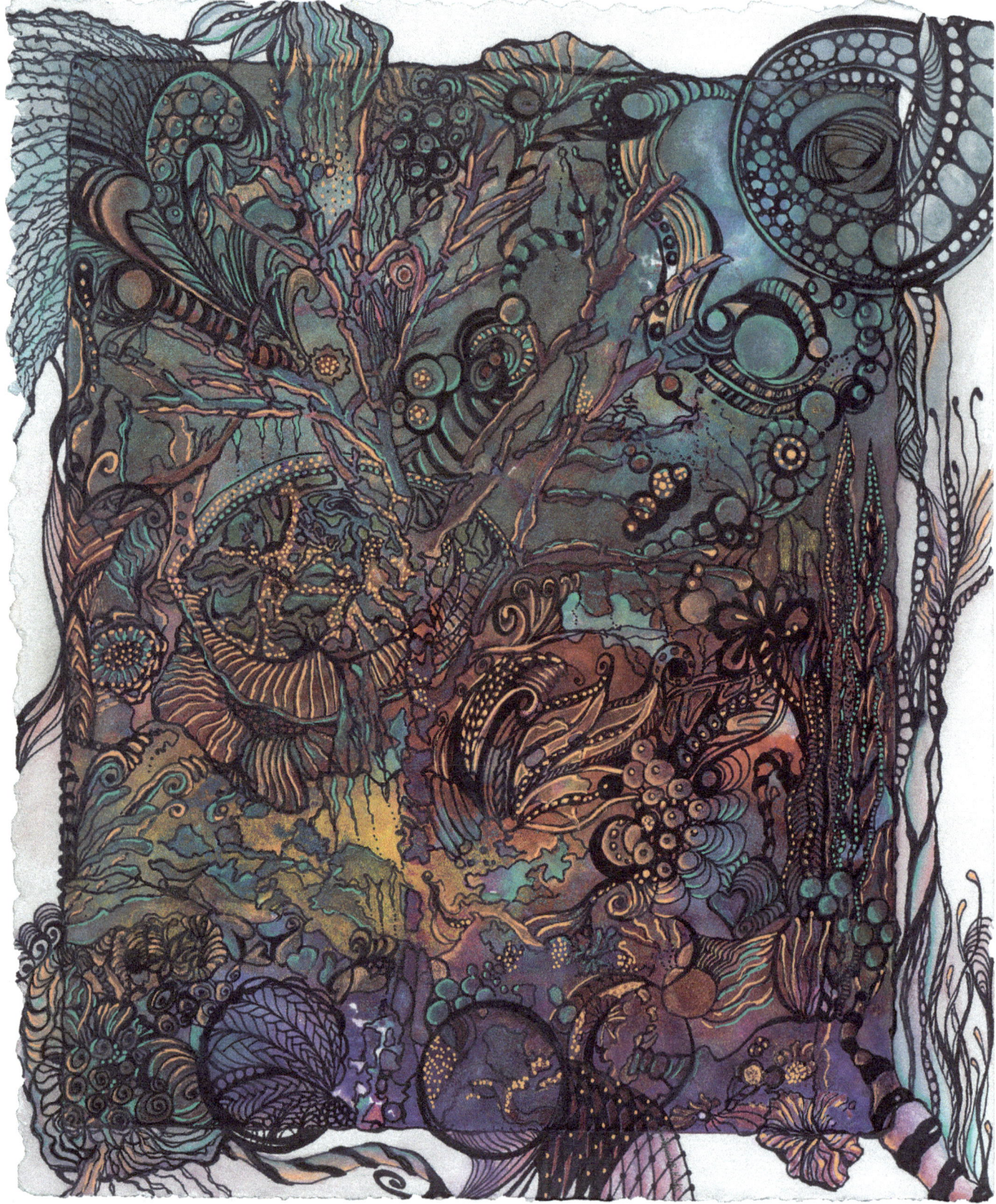

Contents

Introduction 8

Set the Stage: Ergonomics of Drawing 10

Helpful Vocabulary 12

Pens and Paper 14

CHAPTER 1

Find Your Rhythm with the Dancing Duo: Logic and Intuition Explore Botanical Lines, Strokes, and Patterns 17

Introduction The Tango of Expressive Botanicals 18

Lesson 1 Repetitive Pattern: The Dance between Logic and Intuition 20

Lesson 2 Find Rhythm in the Strokes: The Counting Exercise 22

Lesson 3 The Line Dance: Bow to Intuition 24

Lesson 4 The Shape Dance: Bow to Logic 26

Lesson 5 The Team Dance: Define and Refine 28

Lesson 6 Invite Curves to the Line Dance 30

Lesson 7 Is the Dance Over? Time to Stop? 32

Lesson 8 The Tripoli Dance 34

Lesson 9 Glide Through S and C Curves: Point, Hook, and Spiral 38

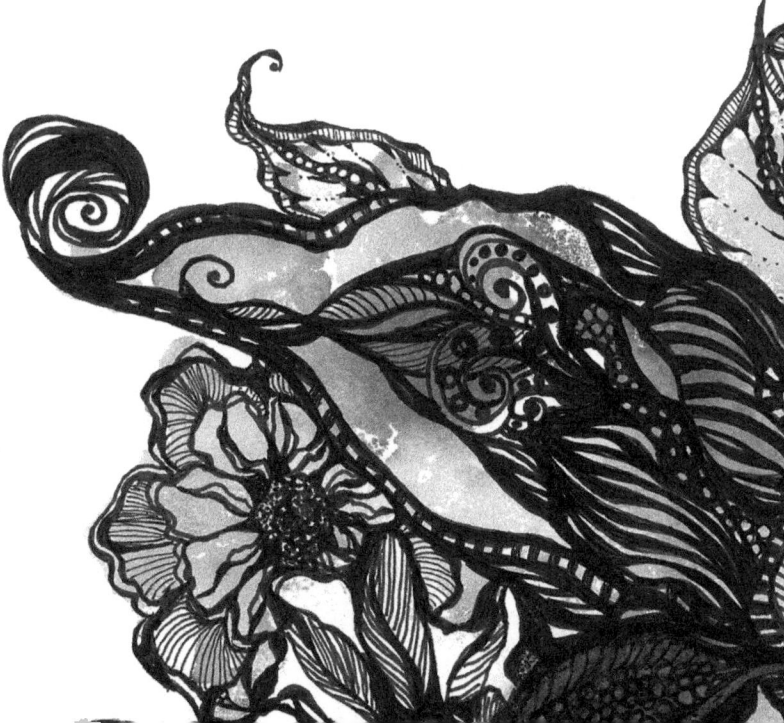

◀ *Fantasy Entangled*, 2012, 8" x 10" (20 x 25 cm)
Creating *Fantasy Entangled* gifted me profound joy. I vividly recall that day, where I was sitting, how the pen choices changed with the light from morning to evening, and the overwhelming feeling of gratitude. For the first time, I had found my artistic voice as the tangle-inspired botanical intuitively evolved, morphed, and emerged.

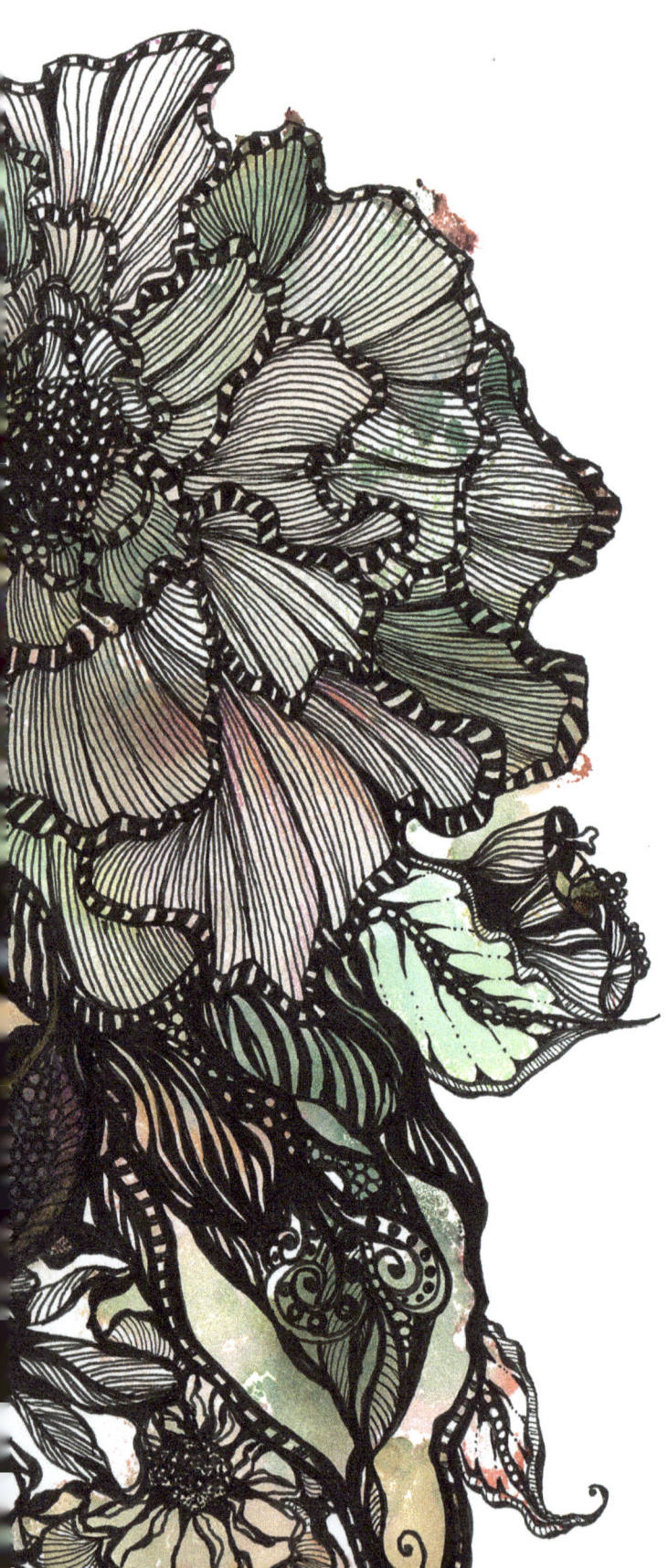

CHAPTER 2

Working in a Series: Blending Tangles with Expressive Line 41

Introduction What Is a Series? 42

Lesson 10 Expression in Nature: The Essence of the Undulating Line 44

Lesson 11 Expressive Partners: Pen Marks and Weighted Lines 46

Lesson 12 The Line Equalizer: Shade, Shadow, and Dimension 48

Lesson 13 The Jazz Dance: The Undulating Zigzag 52

Lesson 14 Verdigogh's Partner: The Expressive Line 54

Lesson 15 The Mooka Botanical Dance: Form a Hook and Cross Under 56

Lesson 16 Magical Pens and New Backgrounds Partner with Expressive Line 62

Lesson 17 Expressive Guidelines Partner with Verdigogh and Mooka 64

CHAPTER 3

The Alchemy of Texture and Line Embellishment 67

Introduction The More is More Factor: Natural Textures and Patterns in Nature Offer Inspiration 68

Lesson 18 The Heavy Lifters: Blackout, the Background, the Frame 70

Lesson 19 The Implied Frame Engages the Audience 74

Lesson 20 Circles, Orbs, Pearls 76

Lesson 21 The Double, Triple, Quadruple Outline 78

Lesson 22 The Stripe 82

Lesson 23 Checks, Checkerboards, Grids **84**

Lesson 24 Teeny Tiny Betweens and Intentional Intuition **86**

Lesson 25 Shapes and Strokes Dance with the Daisy-esque Posy **90**

Lesson 26 The Petals Dance with Variation and Exaggeration **92**

CHAPTER 4
Adding Expression Through Shade, Shadow, and Highlights **96**

Introduction Shade and Shadow in Nature **98**

Lesson 27 Shading Tools and Tips **100**

Lesson 28 The Pencil Partners with Expressive Line, the Outline, and Blue Pastel **102**

Lesson 29 The Circle and the Leaf Meet Pillow Shading and Cast Shadow **104**

Lesson 30 Shading Dances with Undulating Line and Overlapping Shapes **108**

Lesson 31 Grounded Landscape Shading Partners with Verdigogh and Mooka **110**

Lesson 32 Black Backgrounds Partner with Shading and Highlights **112**

Lesson 33 Neutral Backgrounds Partner with Pen Line, Shading, and Highlights **114**

Lesson 34 Bring Color, Shading, and Highlights to the Botanical Dance **116**

Lesson 35 Reeds & Weeds Meets Color and the Grounded Landscape **118**

Lesson 36 Pulling It All Together **124**

Final Words of Advice **126**

Artist Contributors **127**

About the Author **128**

Acknowledgments **128**

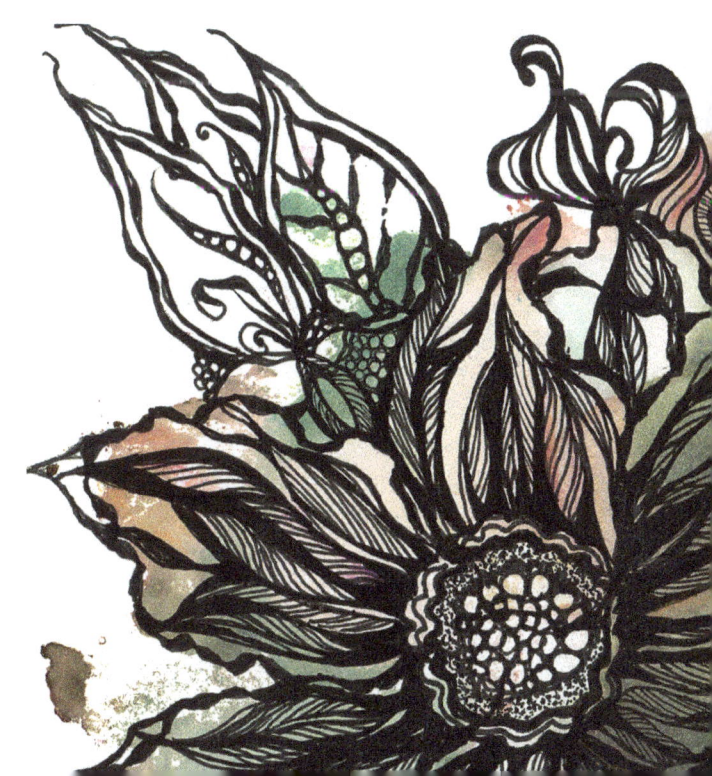

Introduction

Life often includes profound moments: falling in love, the birth of a child, the death of a loved one. As an artist, equally profound moments have shaped my creative journey and led to writing this book. The first time I saw Zentangle® was one of those moments.

In 2010, I was shown a tangled journal and recognized the black-and-white patterning from my earlier op-art and morphed patterned works (see opposite). I excitedly turned each page and knew a revisit was coming. Using large paper, black pens, visual vocabulary, and repetitive patterning, I gave myself permission to draw from "my imagination" and not worry about rendering the perfect drawing.

My world blossomed.

I am grateful for all I have learned from my art education, creative retreats and workshops, Certified Zentangle Teacher training, and a lifetime of doing art. Each has helped my work evolve and morph into a unique style of repetitive patterned botanicals. The purpose of this book is to share the gifts I have discovered through daily practice and the jubilance of finding my artistic voice through tangle-inspired botanicals using expressive lines and curves to develop shapes and forms.

It is a privilege to share lessons that blend together my formal art studies using logic, intuition, visual vocabulary, design, composition, and color with my love of nature, photography, pen, pencil, oil painting, watercolor, and pastel, as well as the craftsmanship of printmaking, assemblage, collage, tailoring, embroidery, quilt making, and textile art. Today each genre has coalesced into a fusion of mixed-media experimentation and unique tangle-inspired botanicals.

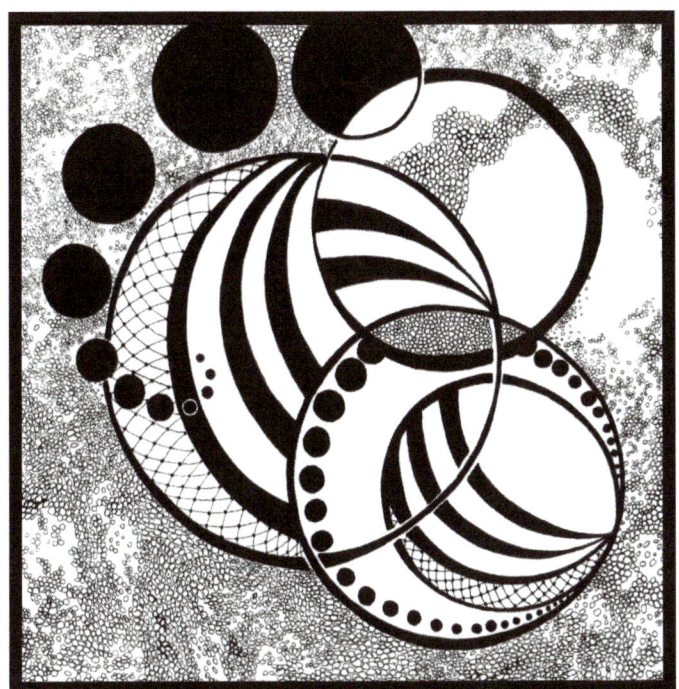

Circles, 2010, 8" x 8" (20 x 20 cm)

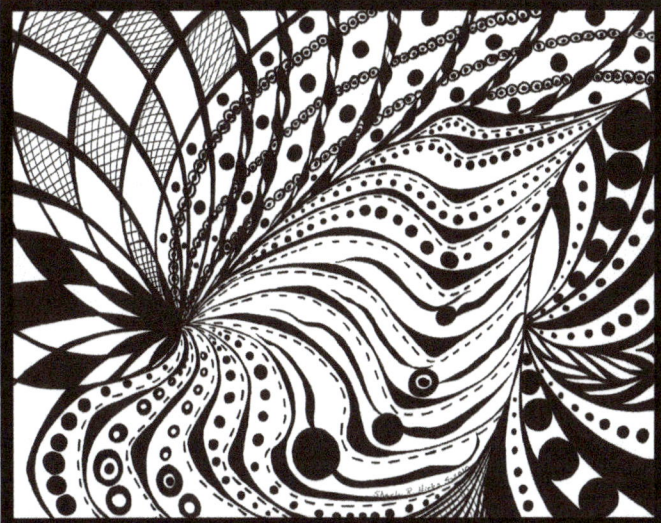

Butterfly, 2010, 12" x 9" (30 x 23 cm)

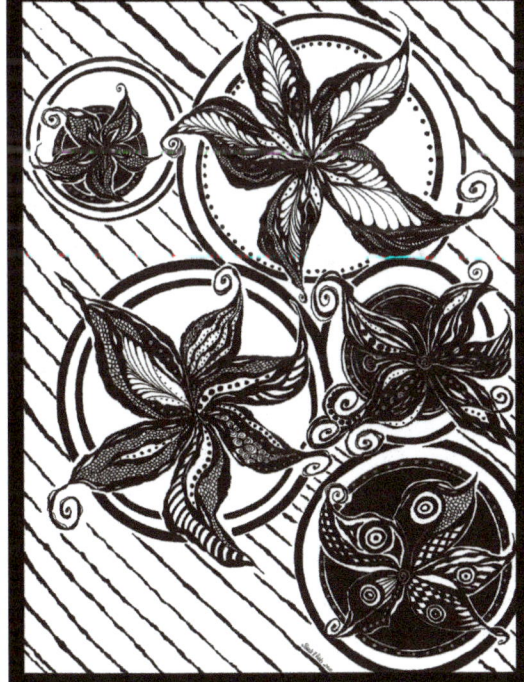

Dancing Petals and Circles, 2010, 9" x 12" (23 x 30 cm)

The Grid, 2010, 8" x 8" (20 x 20 cm)

Set the Stage: Ergonomics of Drawing

A happy body makes a better tangling partner and ergonomics should not be ignored. This may seem obvious, but we often neglect the obvious. Here are suggestions my students have found helpful.

THE BODY

- Adjust the angle of the drawing surface and chair height so the bent arm is in a relaxed L position that does not raise or slump the shoulders.
- Use a comfortable chair with padding for longer sessions of drawing. A wedge can protect the tailbone.
- Take a break now and then to stand, stretch, and walk. Your body will thank you. *Tip:* Set a timer to remind you, as it is easy to get lost in a drawing.
- If you work in an overstuffed chair or on the couch, make sure you have a drawing surface at the correct height.

It surprises most to know that I do 90 percent of my work in a recliner with good lighting and a lap drawing surface. When precision line work is needed, I wear lighted CraftOptics glasses (jeweler magnifiers).

THE EYES

Good lighting is a requirement when drawing, especially for weak or older eyes.

- A table stand magnifier and light combination is an excellent tool for everyone.
- Sometimes putting on magnifier readers is enough, but it often doesn't work for those with prescription eyeglasses.
- Trifocals can be troublesome when looking for clarity's sweet spot between the hand and the work, making the table, drawing surface, chair angle, and height very important.
- Today many go for a new fashion statement by wearing a magnifier visor or CraftOptics lenses.
 Craft Optics is a high-end jeweler's magnifier with two telescopes that spot magnify and light the section you are working with. If desired, you can add your glasses' prescription. There is a learning curve to getting used to them, but well worth working through.
- A magnifier visor can be worn with glasses and has a broad line of vision. It comes with a range of magnification lenses.

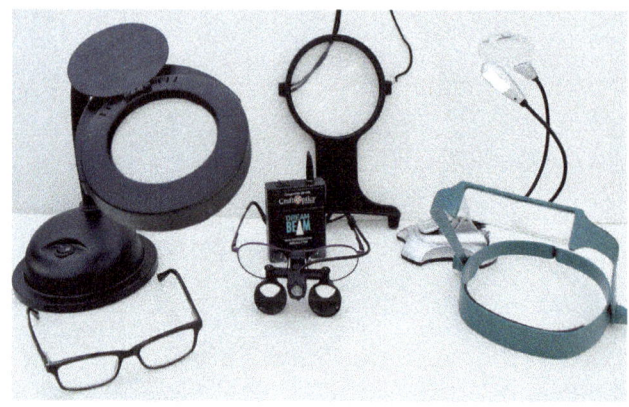

▲ An assortment of helpful magnifying tools

A SHAKE IN THE STROKES

Some may have a shake or tremor in the hand from nerves, bad body position, or a biological issue.

- Please don't perch your wrist on the edge of the table: It creates weak, shaky strokes.
- Stabilize your forearm by resting it in a relaxed L angle on the drawing surface. If you feel raised shoulders or a slump, the L angle is not even with the drawing surface.
- Use the Counting Exercise on page 22 to quiet the shake.

Still Shaky?
Please do not let that you stop you from doing the art. Both of the artists shown on the right live with a constant severe tremor in their hands.

- Drawing the strokes more quickly can result in a smoother line.
- Test different pens and papers. See "Pens and Paper," page 14, for more information.
- Smooth paper allows the pen to move more quickly. Textured paper has a drag that may contribute to the shaky line.
- Fiber-tipped pens have more drag. Nylon tips and ballpoint tips flow more quickly.
- Still shaky? Do not be discouraged—simply embrace the shake as your unique mark!

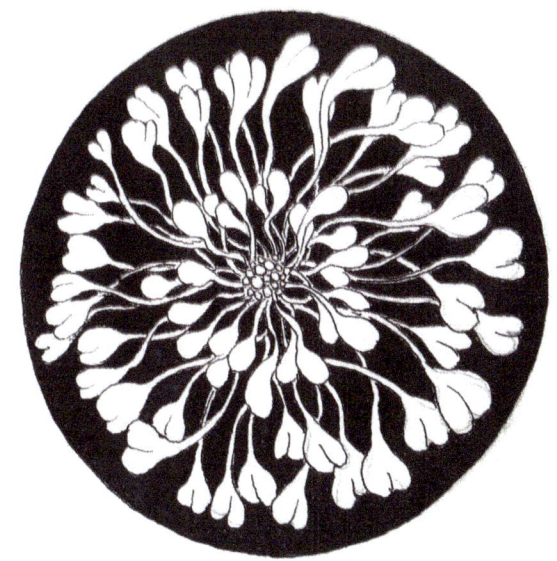

▲ Anne Cathcart finds if she lays down a pencil line first, she has better control.

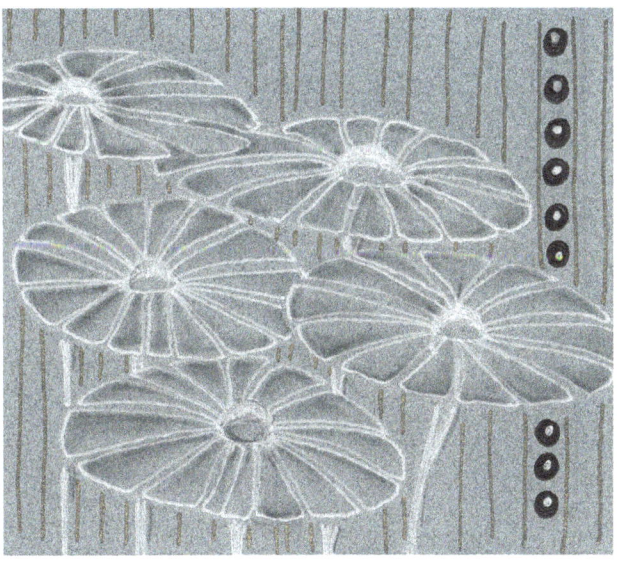

▲ Ed Gutierrez discovered with testing that ballpoint-tipped gel pens helped him create smoother strokes.

Helpful Vocabulary

Patterns that can feel botanical include: Verdigogh variation, Flux, Purk, Festune, Bronx Cheer, Betweed, Cubine. Enhanced with shading, weighted line, black out, stippling, perfs.

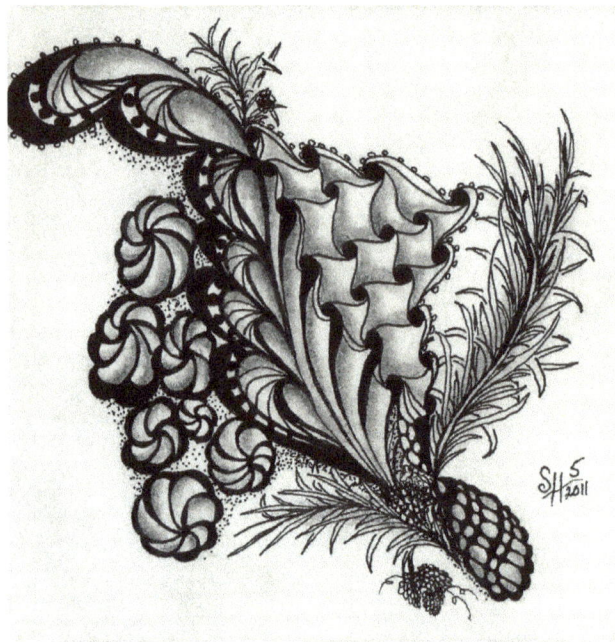

▲ Traditional Zentangle tile, 2011

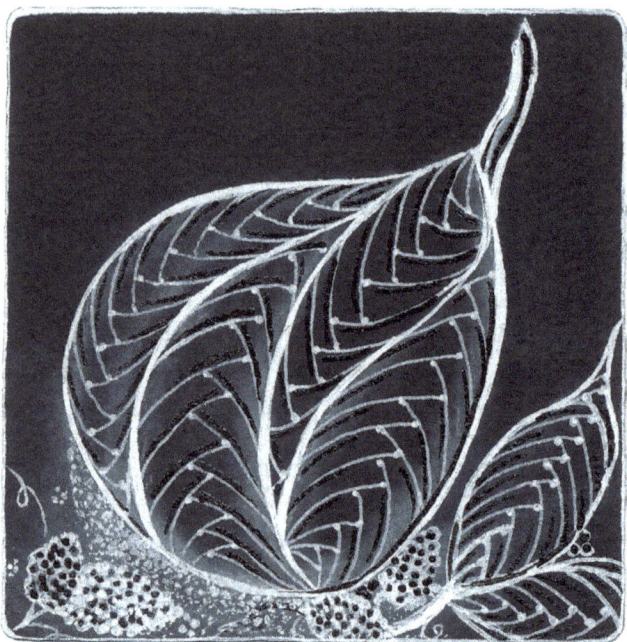

▲ Tangle-inspired botanical, white pen, black glaze, white pastel shading, black 3½" (8.9 cm) tile. Stylized with a tangle-esque feel.

- *Deconstruct:* To break down pattern to see how it is created.
- *Enhancements and embellishments*: Used to add texture, weighted line, shading, and extra personality to a pattern or its background. See chapter 3, "The Alchemy of Texture and Line Embellishment," page 67.
- *Step-outs:* A step-by-step visual explanation of the strokes and repeated marks needed to build a pattern.
- *Stylized:* Botanical form that is filled with tangle-esque pattern(s).
- *Tangle:* Verb: The process of making marks to form a pattern.

 Noun. 1. The step-outs that form a pattern. 2. A finished tile.

- *Variation:* A pattern that shares similar shapes and strokes found in another tangle, making it feel different from the original.
- *Tangle-inspired botanical:* Stylized botanical that has a tangle-esque feel with optional color for shading, petals and leaves, enhancements, pens, and backgrounds.

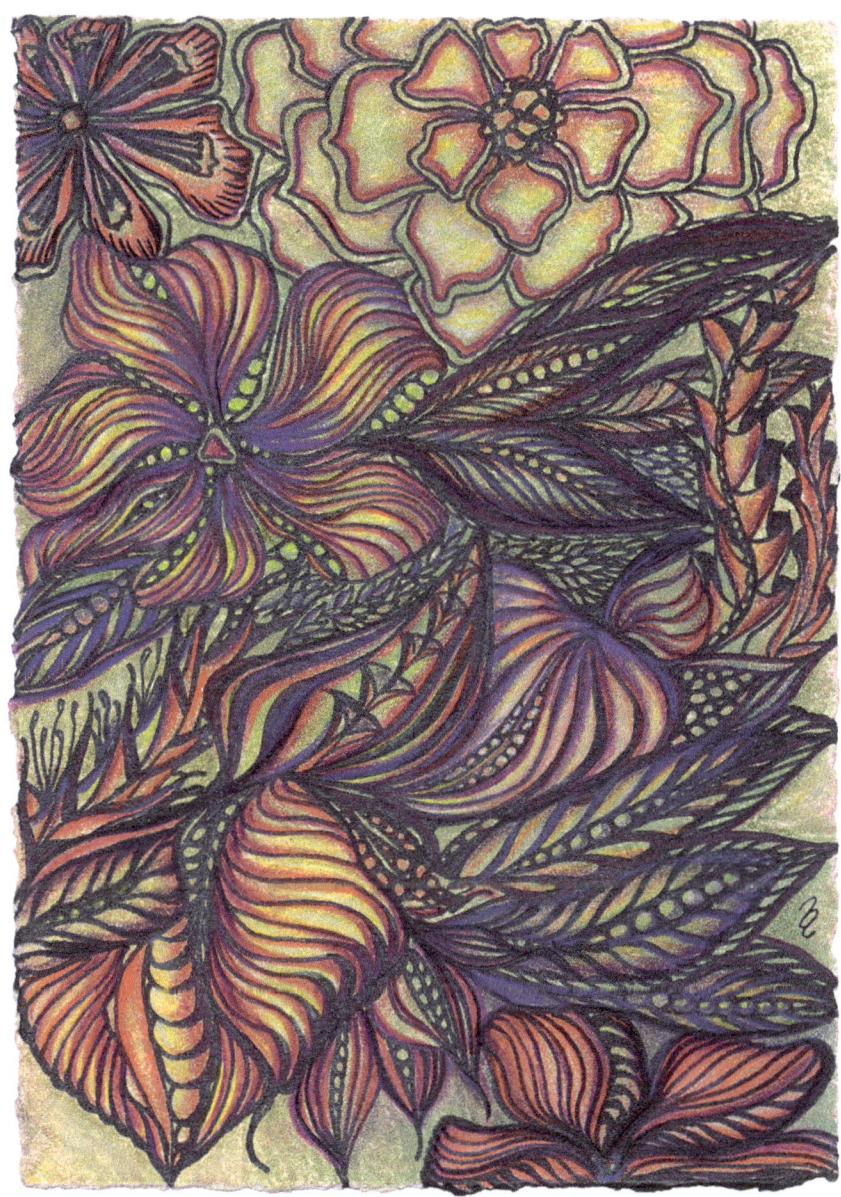

▲ **Study in red and green, 2014, 5" x 7" (12.5 x 17.8 cm)**

Pens and Paper

PENS

A fine-line nib or ballpoint pen sized from .005 to .08 is commonly used for line drawing and tangling. Testing a pen's interaction with your paper is important because each brand comes with its own level of juiciness, permanence, transparency, and opaque coverage. Some are archival, meaning they will stand the test of time, and some are prone to fading. Others are water or alcohol activated.

Archival choices are very significant if you expect long-term vibrancy over a number of years or plan on selling your artwork. If you have questions about permanency, do a sunny window line test: Cover half of the drawing with black paper and tape it to a window. Check after one to two weeks and again in a month.

Not all art is done on paper, so select your pens based on the task. There are pens that write on plastic, glass, rocks, and other surfaces. The information needed to evaluate each pen's properties can be found on packaging, brochures, and manufacture websites.

Tip: Learn more about shading and pencils choices on page 100.

PAPER

It is important to test the interaction among your paper, pen, pencil, and shading tools. The following summary offers generalities to help make archival paper choices that preserve and extend the life of artworks. The simple act of using quality materials validates the importance of your tangle journey.

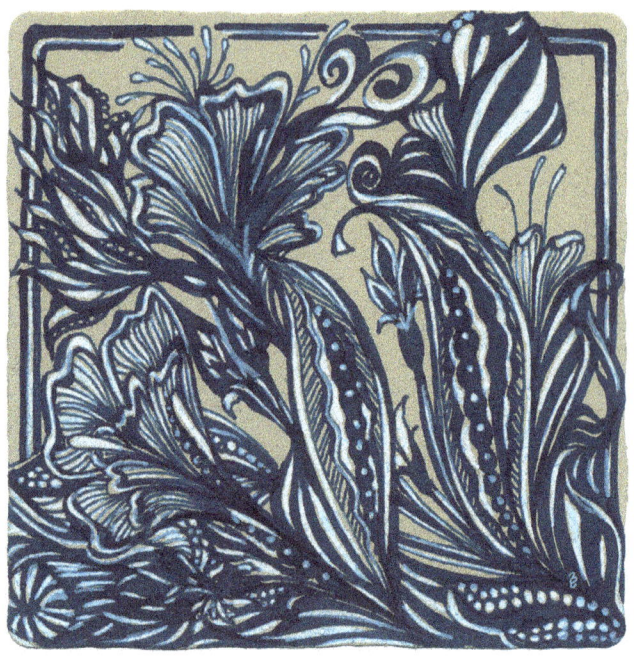

▲ **Expressive botanical, 2015**
Example of an unexpected pen interaction. The water-soluble ink, when adding white pen highlights to blue pen, creates an interesting, albeit unexpected, look. Each pen and paper has a unique interaction. It's a good idea to do a quick test when using a new combination.

Printmaking and Watercolor Papers and Zentangle Tiles

Printmaking and watercolor papers (140 lb/ 300+ gsm) and Zentangle tiles, a 3½" (8.9 cm) tile developed for tangling, are made from high-quality absorbent cotton fiber and take wet media well. The surface allows deep ink and watercolor penetration and produces a tactile drag that can be felt with each mark and stroke. Not all brands are equal, so

testing different papers is advisable. The juiciness of the pen choice is a variable to consider, as each has a different penetration and spread through the porous fibers. These papers have a smooth, luxurious surface for shading with a light hand with charcoal, graphite, pastel, and colored pencils. Heavy-handed smudging will cause the paper surface to mar and pill.

Illustration, Bristol, Mixed-Media Paper, Journals
Illustration, Bristol, and mixed-media papers are heavier-weight papers that offer smooth and slightly textured surfaces (100 lb/300 gsm to 150 lb/250 gsm) suitable for framing. The surface is labeled smooth or vellum. In my experience, both surfaces offer a smooth drag for pens, pencils, and markers. Ink lines and shading go on smoothly with little penetration past the top fibers. If you are looking at subtle differences, smooth takes pen, ink, fine line pencil, and markers well. It is an excellent choice for the line-only artist. Vellum is slightly more textured but not rough and holds the media well, making it an excellent choice for multiple shading techniques. These papers will handle light wet media applications for shading and backgrounds, but will pill and lift with wet brush scrubbing.

Bleed Through
The amount of sizing mixed into the paper formulation affects the rate of bleed through to the back of the paper. The bleed through becomes more significant when using juicy pens and wet media applications. When creating backgrounds with wet media, bleed through on the reverse side is often as beautiful as the front. If working in a journal or on lightweight paper, bleed through can be problematic. Look for papers labeled "bleed proof" or use heavier-weight paper.

Colored Paper
Colored paper comes in a wide range of qualities, weights, and textures, with personal preference play-

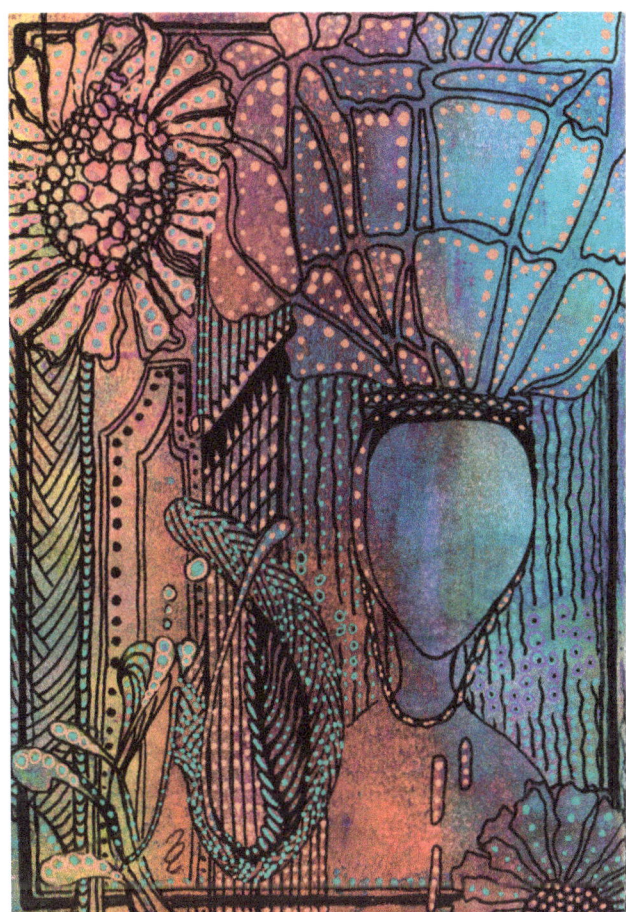

▲ *The Lady*, 2015, 5" x 7" (12.5 x 17.8 cm)
Understanding ink's transparency and opacity allows you to create glow and subtle or strong marks.

ing a large role. Some have a smooth surface similar to Bristol vellum; others are more textured. An excellent choice is pastel drawing paper. It has a lightly textured surface; comes in a wide range of neutral colors for mid-range to dark-toned backgrounds; and interacts well when shading and drawing with ink, pencil, colored pencil, and pastels.

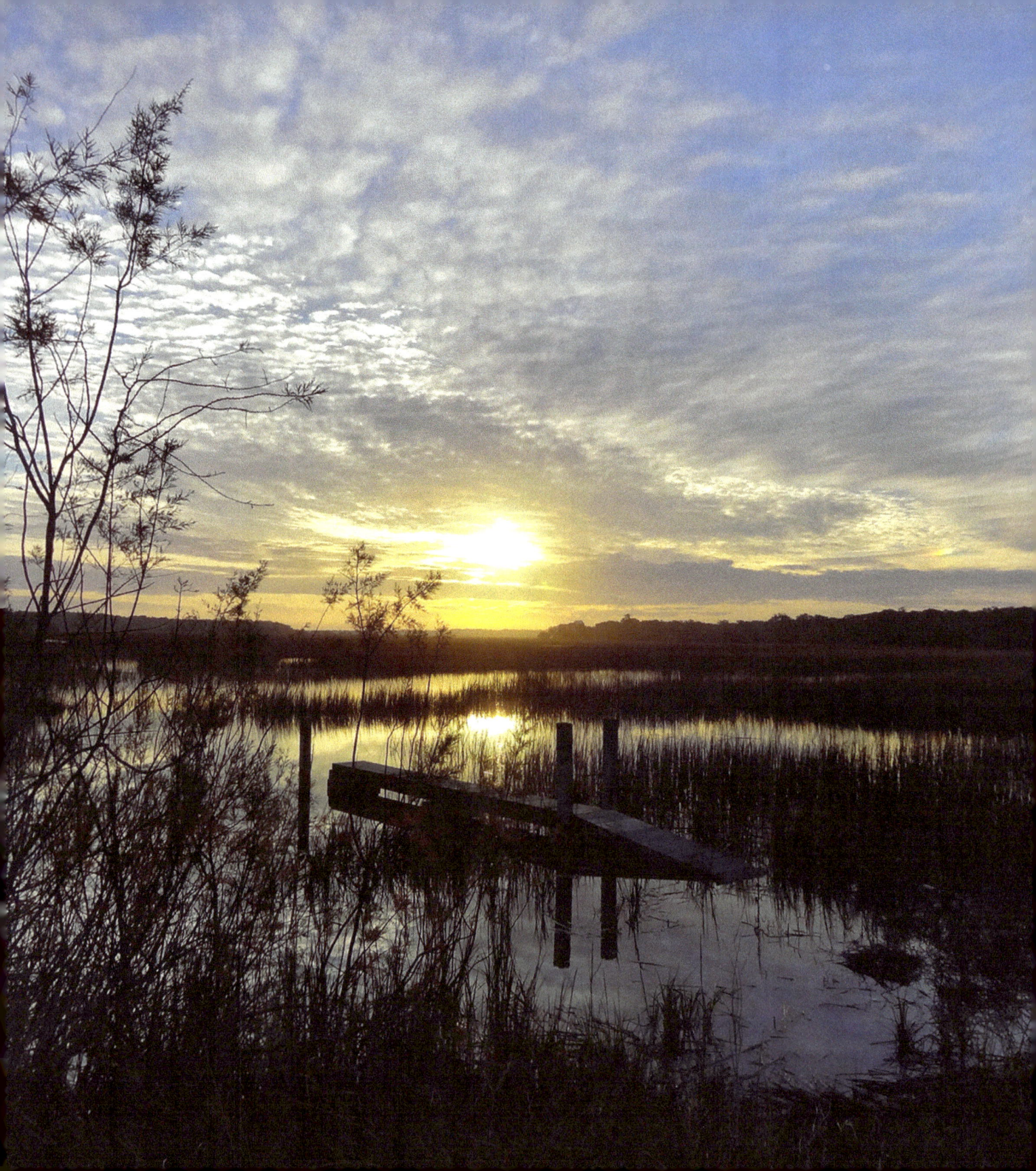

CHAPTER 1

Find Your Rhythm with the Dancing Duo:

Logic and Intuition Explore Botanical Lines, Strokes, and Patterns

Make Your Mark!

"Beauty surrounds.
Monumental grandeur demands.
Creation reverberates.
Pattern integrates.
The soul resonates."

—Sharla R. Hicks, 2016

◀ *Reeds and Weeds*, Edisto Island, South Carolina

Introduction:
The Tango of Expressive Botanicals

Unfortunately for many, the act of making art brought so much joy in childhood but disappeared as self-awareness increased, bringing on a transition where we compared our artwork to those of others. If we did not measure up, felt incompetent in drawing, or a callous remark discouraged us—somehow that became the measure of whether or not to continue doing art. Then our social and school lives got complicated, and the end result was that art began to take on a minor role.

Many felt something was missing, and for the lucky, the door to art reopened with Zentangle, a simple method for drawing patterns. The childhood joy returned with many additional gifts, like mindful focus and the creative desire to do more with simple strokes and repetitive pattern. The unspoken question remains, How do you keep patterning and drawing interesting so you don't fall away from art again?

Learning is fundamental to keeping engaged in an artful journey. My intention is to guide you through the art of tangling, patterning, and expressive botanicals by opening up the intuitive artist within to find your style of expressive mark making. It will be a narrow focus that uncovers the magical alchemy of weighted line and enhancements and the expressive potential of two tangles, Mooka and Verdigogh, and a few others along the way. You will discover the intuitive fundamentals of what you already know, fusing it with a logical approach that incorporates mindful focus, visual language, and memories with the art essentials of expressive line, design, and composition. These simple tools will become your guides to a lifetime of creative joy in art. Welcome to the journey!

> To learn more about Zentangle or to look for a Certified Zentangle Teacher in your area, go to www.Zentangle.com.

▶ *The Rose*, expressive botanical illustration using mixed media, alcohol ink, black pen, 2013, 8" x 10" (20.3 x 25.4 cm)

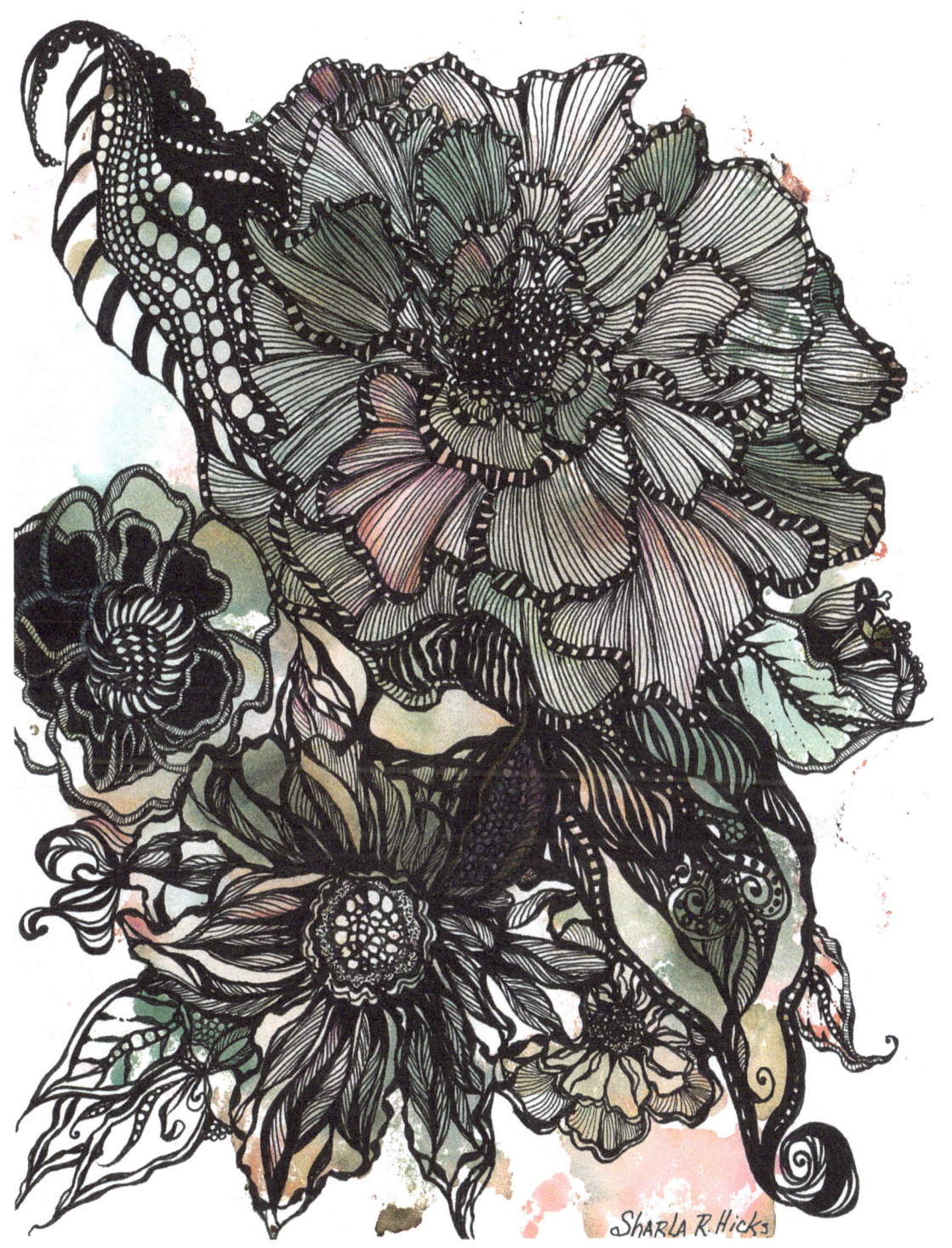

Chapter 1: Find Your Rhythm with the Dancing Duo

LESSON 1

Repetitive Pattern:
The Dance between Logic and Intuition

Artists who use repetitive patterns are drawn to the simplicity of the process. For those not comfortable with their drawing skills, this safe technique allows the intuitive brain to settle into a mindful focus that aids the creative process.

Each sequence prompts mindful focus by inviting you to experience the dance between **logic** and **intuition**. Logic observes and feels the rhythm with insightful observations and communicates via visual vocabulary that enhances intuition's creative imagination. As in a dance, there is trust for the other's skills. Like all teams, if one is ignored, the other is unsettled, thus their kinship is forever synergistically connected, waiting to be tapped.

How often have you seen a design you wanted to draw but did not have the visual tools to execute it? The ability to see and deconstruct pattern was not instantaneous for me. It came after daily journal practice for over a year. Each page became more and more exciting as I explored my own artistic voice and style. Though inspired by my background in tangling, they began to evolve and morph, emerging as expressive botanicals and variations. I had an "aha" moment on the final pages, when a rose design on gift wrap inspired me to "dance with logic" in a new way and deconstruct the pattern to create my version of *The Rose*.

The Rose (right) is an example of how the repetitive patterns of botanicals lend themselves to a free-form compositional style of expressive drawing.

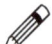 **EXERCISE:** Following Stepouts

▲ *The Rose*, Stepouts, 2012

In your journal, replicate these visual instructions to learn firsthand how repetitive strokes can create a pattern.

▲ *The Rose*, 2012 journal, 6" x 12" (15.2 x 30.5 cm)

Botanical-Inspired Art and Mixed Media

Repetitive patterning provides the visual structure that allows logic and intuition to become a unified team of cohorts exploring creative joy. By adding personal flair and style with shading nuances, color change-ups with pens, pencils, and paper, and the excitement of mixed-media backgrounds of watercolor, printmaking, collage, and assemblage—you, too, can create expressive botanicals.

◀ Tangle-inspired botanical, Susan Zimmerman. Mixed media, alcohol ink monoprint, black pen, 9" x 12" (22.9 x 30.5 cm), 2015

LESSON 2

Find Rhythm in the Strokes:
The Counting Exercise

▲ Botanical example that finds rhythm in the strokes, 2016

Mindful focus inspires the creative dance of logic and intuition by gifting rhythm in the strokes, giving us access to visual memories, vocabulary, and creativity. It is important to stay in the moment. Calm your mind and open your senses to create deliberate, careful strokes and to feel the quietness that is inherent in the process.

Use the Counting Exercise below to set the tone for each tangle session and whenever fear, negative self-talk, or agitation overwhelms the process. Counting out loud offers multisensory input, while repetition of the strokes invites logic and intuition to calmly and quietly begin the creative dance.

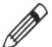 **EXERCISE: The Counting Exercise**

1. With journal and pen in hand, find a comfortable position.

2. Select a line, curve, or shape.

3. Open your senses as the body and mind prepare for practice.

4. Begin a series of six deliberate strokes while slowly counting out loud: *one, two, three, four, five, six*. Stop and evaluate.

5. As the mind and body calm, mindful focus sets in. Observe how distractions recede to the background and the noise around you fades away. The room becomes quieter even though the noise level did not change.

6. A rhythm develops, and line quality steadies as the shaky stutter in the stroke begins to disappear. Each stroke becomes smoother as spacing and length consistency improve.

SUPPLIES
- Quality blank art journal (with no show through or heavier-weight pages, 90 to 110 lb.)
- Quality black, gray, or dark brown pens in varying sizes: .01, .02, .03, or .05

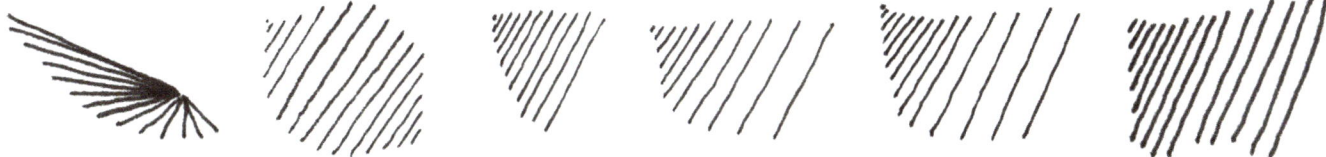

▲ Note how the strokes grow smoother and more even during the Counting Exercise.

7. Logic and intuition accept the invitation to quietly start the creative dance.

8. Repeat the Counting Exercise until the strokes are smooth. Perfection is not required—if a wobble in the strokes remains, do not be discouraged, simply embrace the shake as your unique mark!

Why Does the Counting Exercise Work?
It is astoundingly simple: The mind quickly calms, moves into mindful focus, and then becomes bored with repetition and looks for creative new ways to make the strokes.

Make Your Mark!

Stop. Listen. Feel.
Embrace. Engage.

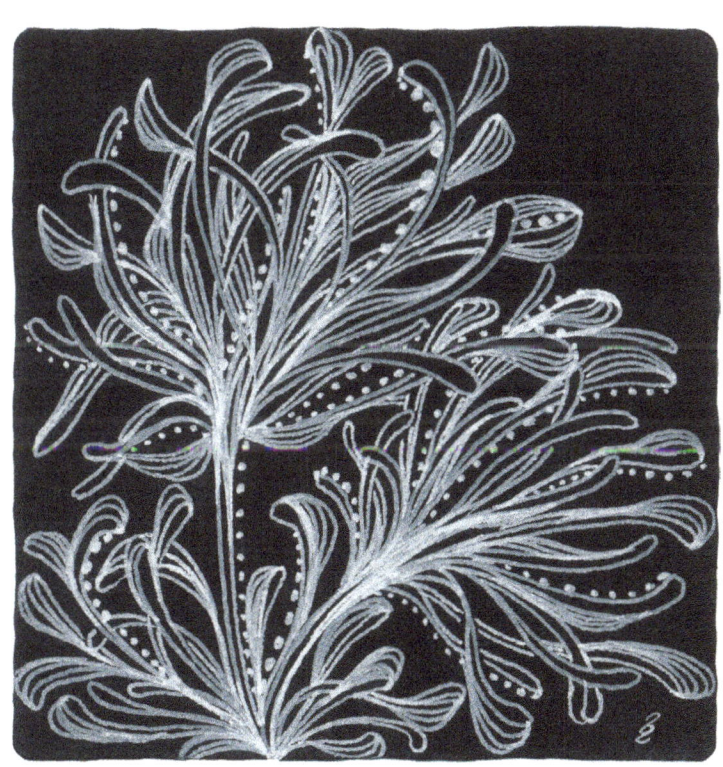

▲ Mooka-inspired botanical, finding rhythm in the strokes, 2016

Tips for Journal Study and Practice
- Black, gray, or dark brown pens allow you to focus on the strokes and intuitive process. Using colored pens is a complicated variable that will be covered in later lessons.
- Pen lines can appear as shadows on the back of a page. One work-around is to draw on one side of the page only. This also preserves a page that you may want to frame.
- A juicy pen can bleed through to the next page, so put some scrap paper between pages to help protect your work.

Chapter 1: Find Your Rhythm with the Dancing Duo

LESSON 3

The Line Dance: Bow to Intuition

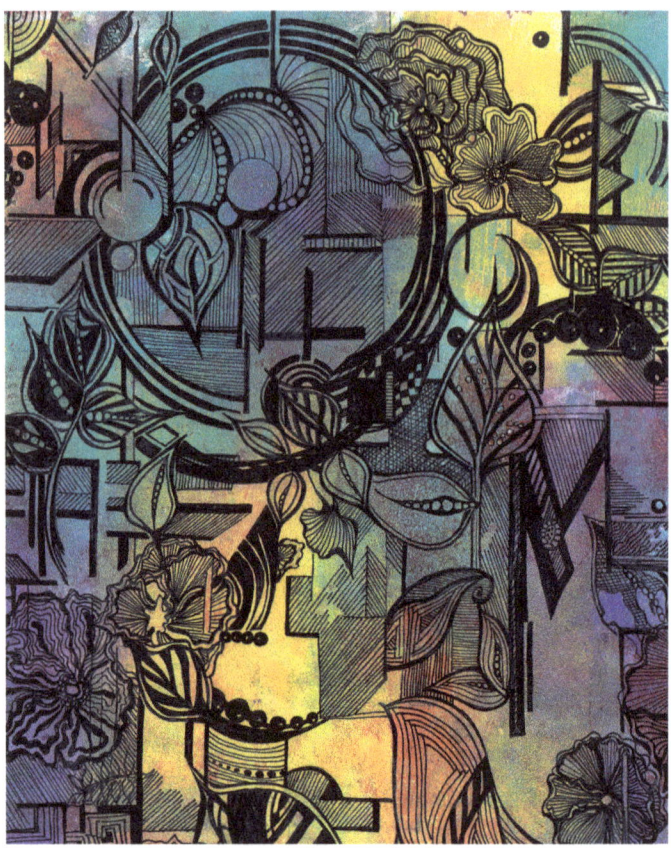

▲ *Rhythms in Deco*, 2012, 8" x 10" (20.3 x 25.4 cm). Straight lines act as an accent to the composition of curvilinear botanical forms and create an interesting background.

The focus of this lesson is to see how the rhythmic nature of straight lines builds muscle memory as you intuitively explore simple forms, memories of botanical imagery, and repeating patterns.

 EXERCISE: Explore Botanical Variations Using Repetitive Straight Lines

For this exercise, create a minimum of ten to twenty different pattern ideas using repetitive straight lines. Tap your visual memories: Think leaves, petals, thorns, stamens, spines, pine needles, and background texture for landscapes.

1. Use a neutral-color pen in black, gray, or dark brown.

2. Choose between two styles of practice: freestyle to fill a page (see Lesson 4, page 26) or use a grid of 1½" (3.8 cm) squares that fills your journal page (see example opposite).

3. Begin with the Counting Exercise on page 22. Create a series of six straight lines. Be deliberate with each mark as you slowly count: *one, two, three, four, five, six*. Focus on each stroke and the pen drag. Once you find your rhythm, move on to the next step.

4. Draw ten to twenty-four straight line designs using your style of choice.

5. Remember, perfection is not required. The lines will evolve, morph, and blossom under your pen as petals, leaves, stems, trees, reeds, weeds, and backgrounds emerge. The first few designs will be warm-up and may not be botanical, but as you continue drawing, welcome mindful focus and intuition as many lines are waiting to join the botanical dance.

6. When you find it difficult to tune out distraction, repeat the Counting Exercise.

SUPPLIES
- Quality black, gray, or dark brown pens in varying sizes: .01, .02, .03, or .05
- Quality blank art journal (with no show through or heavier-weight pages, 90 to 110 lb.)

▲ Tap into nature's inspirational lines. Embrace the visual memories waiting to emerge.

> **Don't overthink it, as the poet Allen Ginsberg states: "First thought, best thought."**
>
> This is not a test. Do not rush. Perfection is not required. The time spent will develop muscle memory to be called upon later. Each practice will become easier.

▲ Susan Valentino's insight: After filling a few boxes with lines, the need to develop more complex patterns emerged. Many of these patterns would make excellent background textures for a landscape, a floral center, or as fill and textures for petals, leaves, trees, and more.

Chapter 1: Find Your Rhythm with the Dancing Duo 25

LESSON 4

The Shape Dance: Bow to Logic

▲ *The Tutors at the Getty,* Los Angeles, California, 2012

SUPPLIES
- Quality blank art journal (with no show through or heavier-weight pages, 90 to 110 lb.)
- Quality black, gray, or dark brown pens in varying sizes: .01, .02, .03, or .05

When doing the line dance, you may have noticed familiar shapes and forms pushing to the forefront, each calling, "Notice me." This is natural. You have spent a lifetime being tutored in line and pattern, with visual memories waiting to express the beauty of land, ocean, and cityscapes. Once permission is granted, the floodgates open.

As intuition guided your hand in Lesson 3, you may have noticed that you were thinking or even talking to yourself, offering ideas on how to repeat and vary your line study. Self-talk is a well-honed skill we use daily to solve problems, so it is a logical progression in the tangle process of creative thinking. The examples (opposite) show how I use "what if" to explore a botanical shape using repetition and variation.

 EXERCISE: Explore a Single Shape

Explore ten to twenty variations using a single shape as the starting point for growing a unique botanical-inspired pattern.

1. Select a simple shape like a leaf, petal, or posy.

2. Begin with the Counting Exercise, repeating your selected shape in your journal. *One, two, three, four, five, six,* pause—evaluate—repeat. Take your time and don't stress: Many ideas are waiting to join the dance.

3. As new ideas float into the mind's eye, begin asking "what if" questions.

4. The repeating shape will change—evolve—morph into new organic ideas.

5. Tap into your visual memories and if additional ideas are needed, study the examples offered for inspiration.

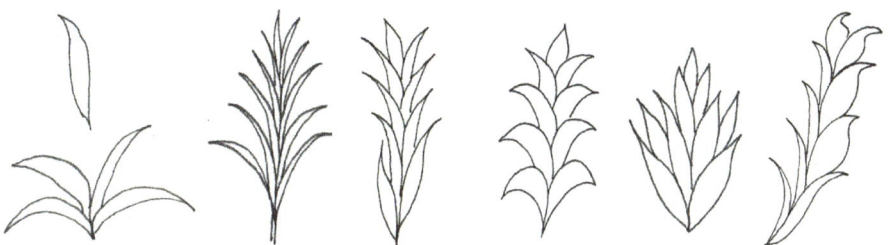

▲ What if I vary the leaf using thin, medium, or thick shapes? What if I nest an extra leaf between shapes or change the leaf shape?

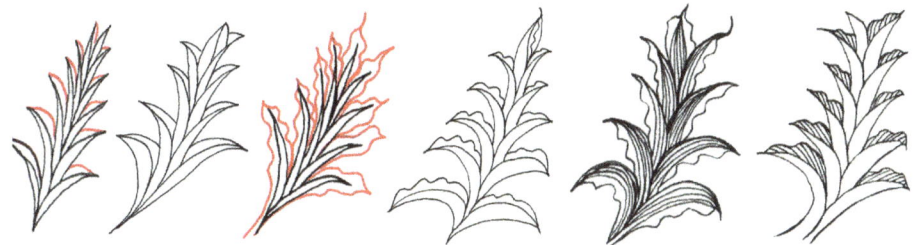

▲ Each "what if" will inspire the next "what if." What if I add an extra arc, outline with undulating line, or combine undulating lines with repeating line fill?

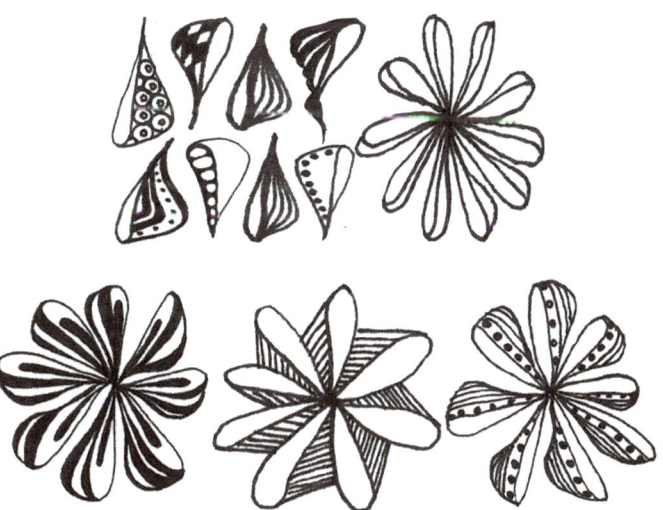

▲ Petals and blooms: Adding repetitive strokes to a petal creates a stylized option.

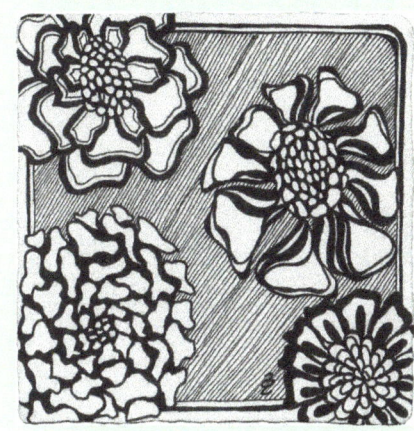

▲ Dancing blooms step onto the dance floor, joining the "what if" in repetition and variation of triangle-esque shaped petals.

Journal Study and Practice Tips

- Use intuitive logic to fill in the blank X: "What if I change X? What happens if I use X, create with X, explore X, limit myself to X, add X?"
- Remember, tap into "first thought, best thought" while staying open to the next idea that is germinating, waiting to morph and emerge as a new variation.
- Later lessons and chapters offer additional visual vocabulary for line and shape enhancements, patterns, color, shading, paper choice, composition, and design, each geared to help the dancing duo with "what if" questions.

Chapter 1: Find Your Rhythm with the Dancing Duo

LESSON 5

The Team Dance: Define and Refine

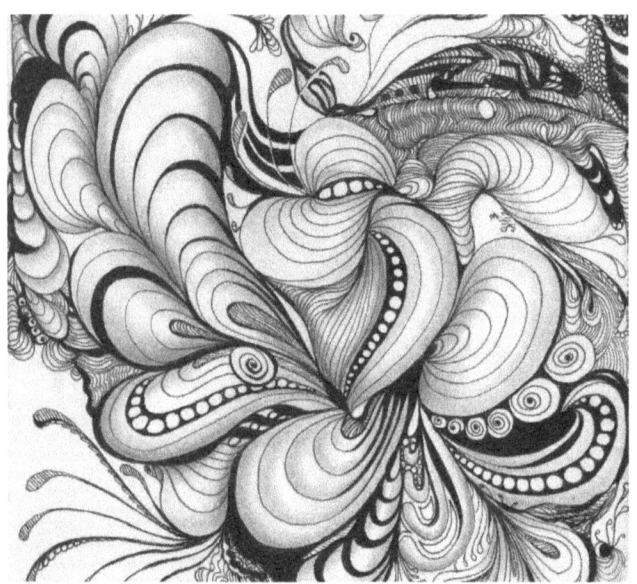

When intuition and logic forge a partnership it encourages spontaneous creativity. My intuitive muse unearths inspirational ideas by exploring "gut feelings" and "first thought, best thought" reactions. I find myself occasionally singing out loud while tangling in the air or on paper with gentle movement or wild abandon as I capture the pattern's vibration.

My logical muse enjoys the challenge of figuring out creative ideas by doing research and using visual vocabulary to help me refine and define new botanical ideas and turn them into patterns. Refining a pattern happens when drilling down to the basic strokes and shapes needed to deconstruct the step-outs. Once complete, I can revisit again and again, and each new visit offers an opportunity to morph the pattern into new variations.

Help your muse define and refine your creative dance by dividing ideas into easily understood categories and using them to help you frame "why" questions.

THE DANCING DUO'S CHOREOGRAPHER FRAMES

POSSIBLE CATEGORY AND STYLES	POSSIBLE LINE AND PATTERN DIVISIONS
Tangle patterns	Grid
Inspired by	Straight lines
Free-form pattern	S, C, and hook curves
Inspired by an artist using repetitive pattern	Sparkle, circles, orbs, pearls
Shade, shadow influences	Between two lines
Color influences	Dimensional or directional

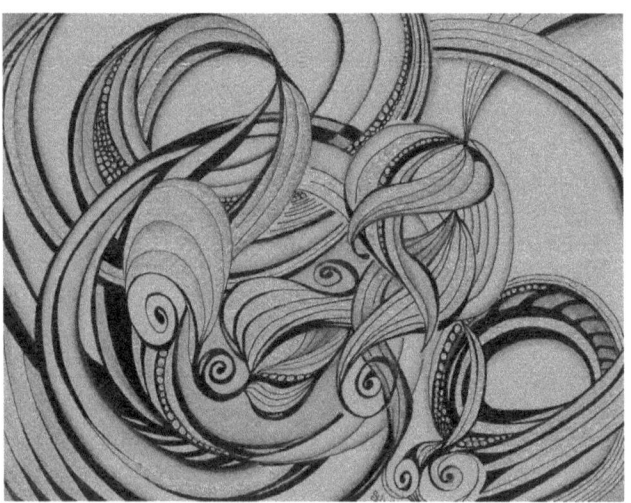

▲ SharlaRella Series spontaneously morphed from practicing Indy-Rella into SharlaRella, a go-to tangle of mine found in almost every botanical piece I do.

28 Tangle-Inspired Botanicals

THE "WHY" QUESTION

- "Why" questions prompt *descriptive answers*. There are no right or wrong answers, just possibilities and flop-portunities.
- The practice of asking and answering "why" engenders confidence for even more creative exploration.
- Resist asking questions with "yes/no" answers that leave a flat feeling with no insights, possibilities, or creative inspiration.
- Frame questions to include tangle choices to explore strokes that can be used for variation, ideas for adding swag and enhancements, and options for exploring the expressive use of mixed media.

EXERCISE: Practice the Team Dance: Define and Refine

1. In your journal, describe the differences between Examples A and B using "why" answers that are descriptive and insightful. "Why" questions will help define and refine your unique interests and style choices by sparking new ideas and areas of interest that merit further research and exploration.

2. Describe, label, and categorize by style, strokes, backgrounds, and mixed-media choices.

3. Describe what you like or dislike about each example. Why?

4. Does one example appeal to you more than the other? Why?

5. Begin to use intuitive logic to define and refine design and composition. More information will be offered in later chapters to help. For now, answer the following:

- Do the strokes and forms feel pleasing, balanced, jittery, messy? Why?
- Are these examples of "less is more" or "more is more" or "just right" or "something in between"? Why?
- Does the composition feel balanced or off-kilter? Is it dense or open? Heavy or light and airy? Why?

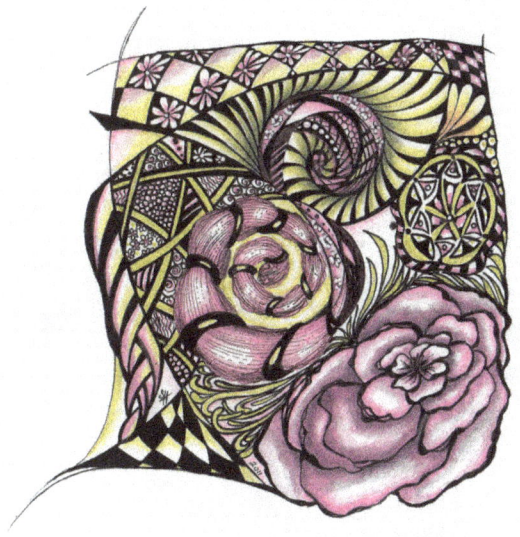

▲ Example A: Stylized botanical inspired by the letter S, 2012, black pen, watercolor technique using an ink puddle as paint from a gel pen

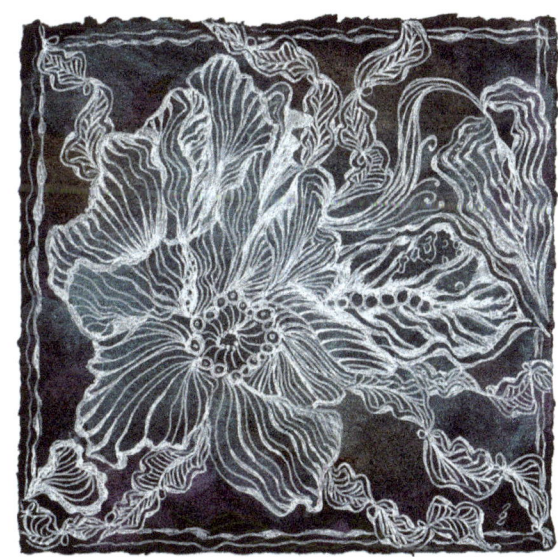

▲ Example B: Undulating Line Floral Series, 2014, white gel pen, black Stonehenge printmaking paper, Twinkling H2Os, iridescent paint

LESSON 6

Invite Curves to the Line Dance

The intuitive logic of botanical patterning dances to create balance and add enhancements.

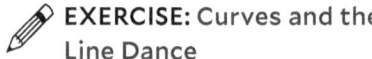 **EXERCISE:** Curves and the Line Dance

1. Research curved line possibilities by reviewing your journals, completed tiles, tangle-inspired works, favorite books, and online resources.

2. Engage in a lively discussion with tangle friends about their favorite curved tangles while absorbing inspirational ideas, suggestions, and thoughts.

3. When done with the research, in your journal, answer "what if," "how do I," "what else can I," and "when do I stop" questions and ideas for mindful focus to join in a synergistic partnership with curves and intuition as you explore:

- "Less is more," "More is more"?
- "Balance," "dense and open," "dark and light"?
- What about skipping structure and the use of intuitive free form? Why would you want to? What is the goal?

▲ Intuitive logic guided this free-form curvilinear journal study, 2012, 6" x 12" (15.2 x 30.5 cm)

4. After completing your questions, explore a minimum of ten to twenty different curve ideas using a neutral color pen in black, gray, or dark brown.

5. Start with the Counting Exercise by repeating the same curve—one—two—three—four—five—six—pause—evaluate—repeat. Take your time and don't stress—many ideas are waiting to join the dance.

6. Then as the rhythm sets in, let the "what if," "how do I," and "why" questions flow.

7. With a tutored intuition as your guide, explore the possibilities of creating a free-form design.

Your synergistic partnerships are waiting. You are trained to refine and define curves and lines into a unique, creative dance. Most of all, enjoy your newfound confidence and helpful friends in mindful focus, study, and practice.

LESSON 7

Is the Dance Over? Time to Stop?

▲ A good start with subtle coloring acts as a foil on the tan tile. More shading and color layers are needed.

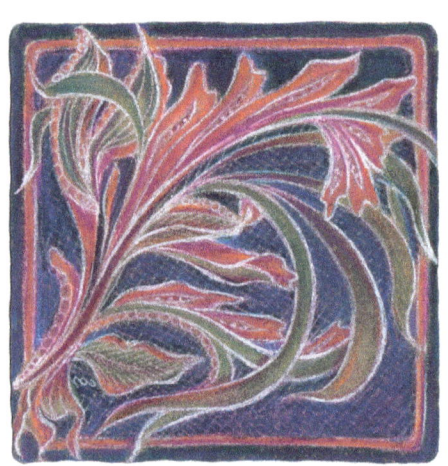

▲ Should I have stopped? Perhaps I filled in too much background texture and color.

Intuition can and *will* get bogged down in "what if" questions and can easily go past a pleasing "more is more" phase to "Oh dear, what have I done?"

HOW DO I STOP FROM TAKING A PROJECT FROM GREAT TO OOPS?

In all honesty, I am a "more is more" tangler and enjoy the "what if" questions. Therefore, knowing when to stop can be challenging. Over time I have found the following tips helpful.

- Projects "need" time to rest. Why? Because later, I am able to come back with a clearer vision of what to do next or whether I should stop.
- I put the project someplace where I capture a quick glance while passing through a room, having a conversation, or even watching TV. Why? The mind is caught off guard and is able to see the work with a fresh perspective. More often than not, the project is *much* better than I thought.
- Stop and *sleep on it*. I usually wake with "aha" thoughts and feelings, answers come to mind with insightful clues, the nit-picking is gone, and I am eager to start again or call the project finished.

✎ EXERCISE: Time to Stop?

Using the "projects need time to rest" questions below, evaluate a work in progress that you feel is close to finished. In your practice journal, record answers to each one to help determine if you are done or if the work needs more.

1. "Is it time to stop?" When intuition asks, logic often shouts: "Stop!"
 Advice: "Give in and just quit."

2. When the "what's next" questions slow down, it is time to take a step back.

3. Ask one more time: "Is it done? Why? What's next? Is there a next?"

4. A lack of response means it is time to set the project in a location that offers a quick-glance evaluation.

5. Then trust yourself that you intuitively understand when the tile is finished.

Trust logical intuition to help frame questions: Is this piece at a stopping point? What if I leave it at the slightly unfinished stage? Does it need more shading? How much? Every section? Shade a bit more but leave the background as line only? Is it balanced? My intuition says leave it—with a caveat—maybe add a tiny bit more shading in the foreground—be very careful not to overdo.

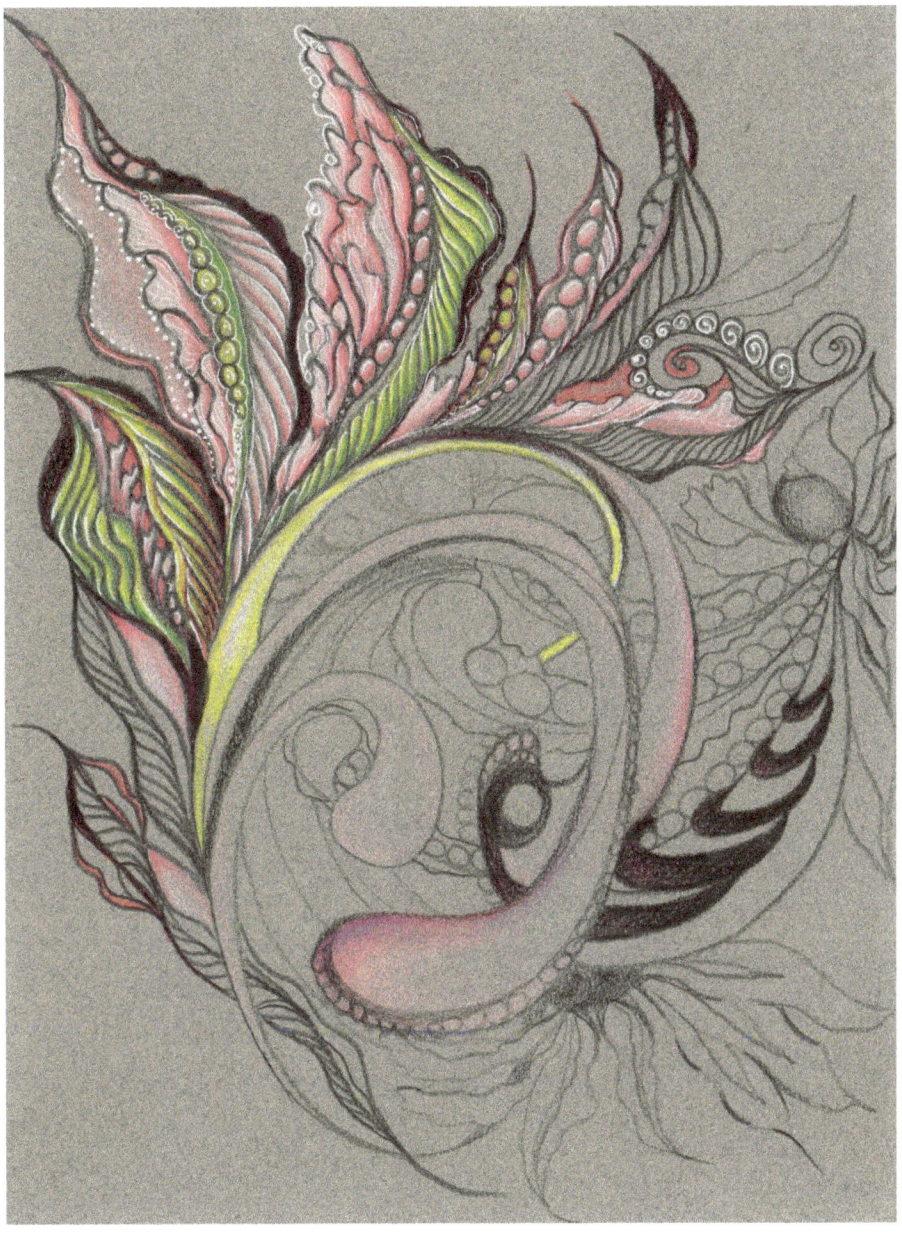

▲ Tangle in progress, 2015

| LESSON 8

The Tripoli Dance

▲ Painful learning curve of Tripoli. These are two pages of a four-hour practice marathon from 2011. Note the irregular spacing and size of the pointed, not rounded, triangles.

The most joyous and productive part of the creative dance is the learning curve. If fearful feelings arise, keep on dancing. Use practice to develop muscle memory, confidence, and accept that "perfection is not required." Embrace your unique style of mark making.

Tripoli was directionally challenging for me. After a four-hour practice marathon, the mud cleared when I realized my *irregular* and *pointed triangles* would align only part of the time. I accepted that that was the best I could do. I understood that "perfection was not required!" Then and only then did *Tripoli Explosion* emerge with its interesting irregular shapes. Today, with over six years of practice, I can now create a quasi-rounded triangle that is not perfect but it works.

▲ *Tripoli Explosion* emerged from determination and practice that offered command over the triangle. I accepted that *perfection was not required*.

Chapter 1: Find Your Rhythm with the Dancing Duo

LESSON 8

◀ Tripoli, a design by Maria Thomas, Zentangle founder

▲ Tripoli presents a botanical dance of "what if": I use triangles to create posies? Exaggerate the petals? Use a continuous line to draw triangles? Use an undulating or a double line? Create a stylized bloom cluster?

TRIPOLI TIPS

- The center can be five to eight triangles.
- When adding the next layer of triangles, think parallel lines for better consistency.
- If shapes grow too large, it is okay to stop, realign, and start again. (See *Tripoli Explosion*, page 35.)

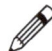 **EXERCISE 1:** The Tripoli Dance

1. Use the Counting Exercise on page 22 to practice Tripoli triangles in your journal.

2. Once mindful focus invites you to the creative dance of "what if" thinking, allow the strokes to evolve—morph—emerge.

3. Find your unique botanical variation of Tripoli. Practice is necessary. Perfection is not required.

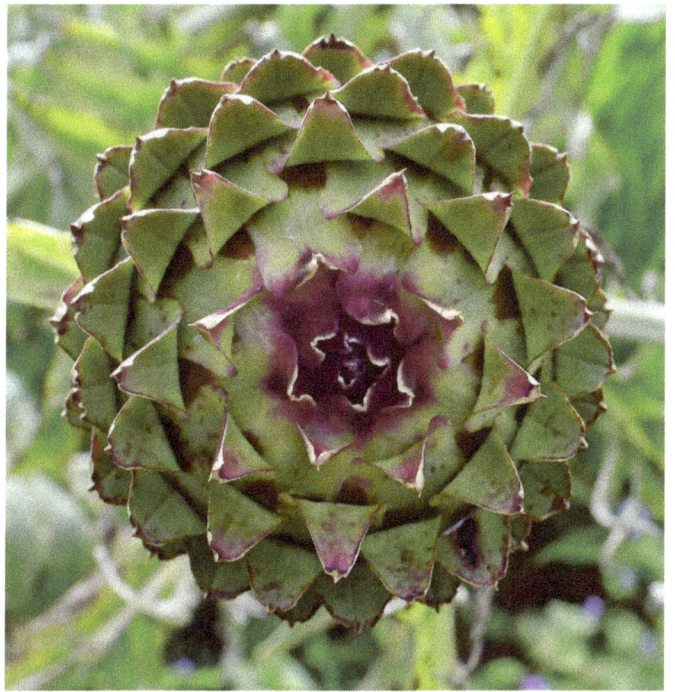

▲ Tripoli inspiration in nature: the artichoke and the succulent.

HOW PRODUCTIVE OR REALISTIC IS COMPARISON?

Try not to block creativity with negative self-talk, fear, or comparison. My scenario below shows that comparison is apples and oranges.
- I am directionally challenged and have dyslexia.
- For forty years, I have been an apprentice in training, learning, and teaching.
- I have tangled almost daily for more than six years.
- I did not study art until my thirties.
- I felt privileged to attend college and never missed a day without cause. I was old enough to know what I did *not* know and knew the questions to ask. I had professors as mentors who allowed me to repeat classes as independent study to hone my skills.

 EXERCISE 2: Your Tangled Journey

Take the time to look at your tangle journey to offer insight into why you are where you are now. Create an art timeline:
- When did you discover you wanted or needed to have art in your life?
- How does repetitive patterning fit into your art story?
- Include profound moments of joy and discouragement.
- Include key learning opportunities and insights.
- Include your fears and emotional highs and lows.

Chapter 1: Find Your Rhythm with the Dancing Duo 37

LESSON 9

Glide Through S and C Curves:
Point, Hook, and Spiral

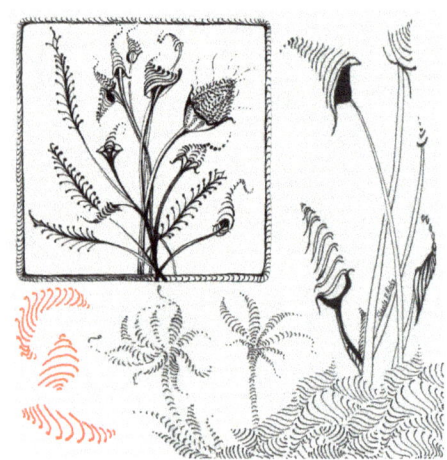

▲ Insight: Indy-Rella, a pattern by Molly Hollibaugh, CZT, is a C curve pattern.

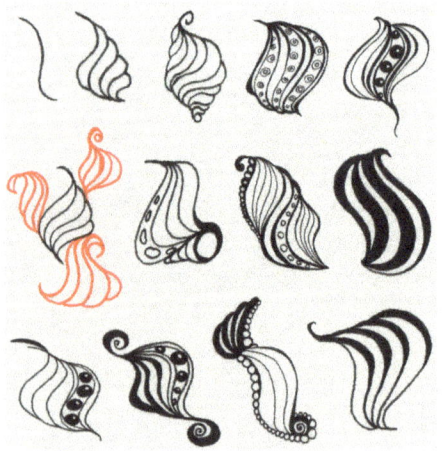

S and C curves are universal forms that stretch across all cultures through millennia. Each is unique and yet shares common elements. The same is true in tangling: Many curve-esque patterns appear similar but have the unique signature of the designer. Explore C and S curves to find your style and forms.

The S and C curves easily morph into petals, leaves, standing tall florals, shells, water, waves, rolling hills, and mountains. For variation, change the shape, spacing, and length.

✏️ **EXERCISE:** Explore the Basic S and C Curves with Hook and Spiral Accents

It is time to explore more creative dance partners that tap into your visual memories. Use mindful focus, intuitive logic, and "what if," "how do I," and "why" questions to help find your unique curve style.

1. Research and review S and C curve patterns to define your personal preferences. Use "why" questions to help understand the appeal of one pattern over another as you drill down to refine your unique vision and style.

2. Using a neutral pen and your journal, create ten to twenty variations for each shape. Begin with the Counting Exercise using curve strokes to invite mindful focus and "what if" and "how do I" thinking. (See page 26.)

3. Tap into your unique botanical memories as the S and C curves hook—spiral—evolve—morph—emerge. Remember, practice is necessary; perfection is not required.

◀ Insight: The SharlaRella C and S curves started as Indy-Rella and morphed into S curves. The hook and spiral strokes are a natural flourish that finish curvaceous forms.

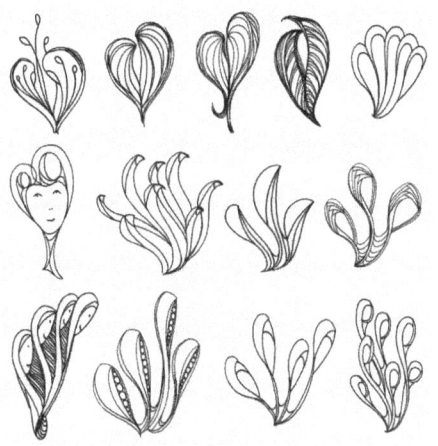

◀ *The Ladies*, Susan Zimmerman, 2016
You can almost hear Susan Zimmerman's shallow S curves asking "what if" questions as they dance across the page. She used free thinking with no expectations as the sweet characters introduced themselves.

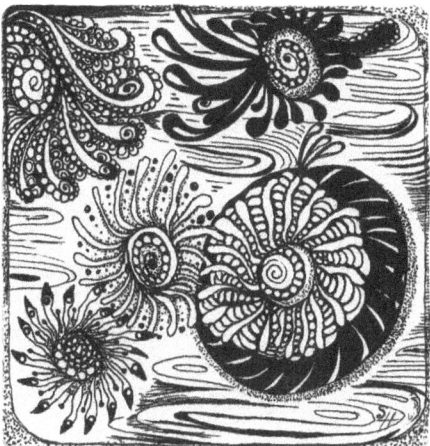

◀ There is a sense of familiarity with this pattern. It is a testament to the fact we are all drawing from the same universal set of strokes that are educating our visual memory.

▲ Journal pages, 2012, 6" x 12" (15.2 x 30.5 cm). Repetitive S and C forms lend themselves to a flowing overall composition that quickly fills a page.

Chapter 1: Find Your Rhythm with the Dancing Duo 39

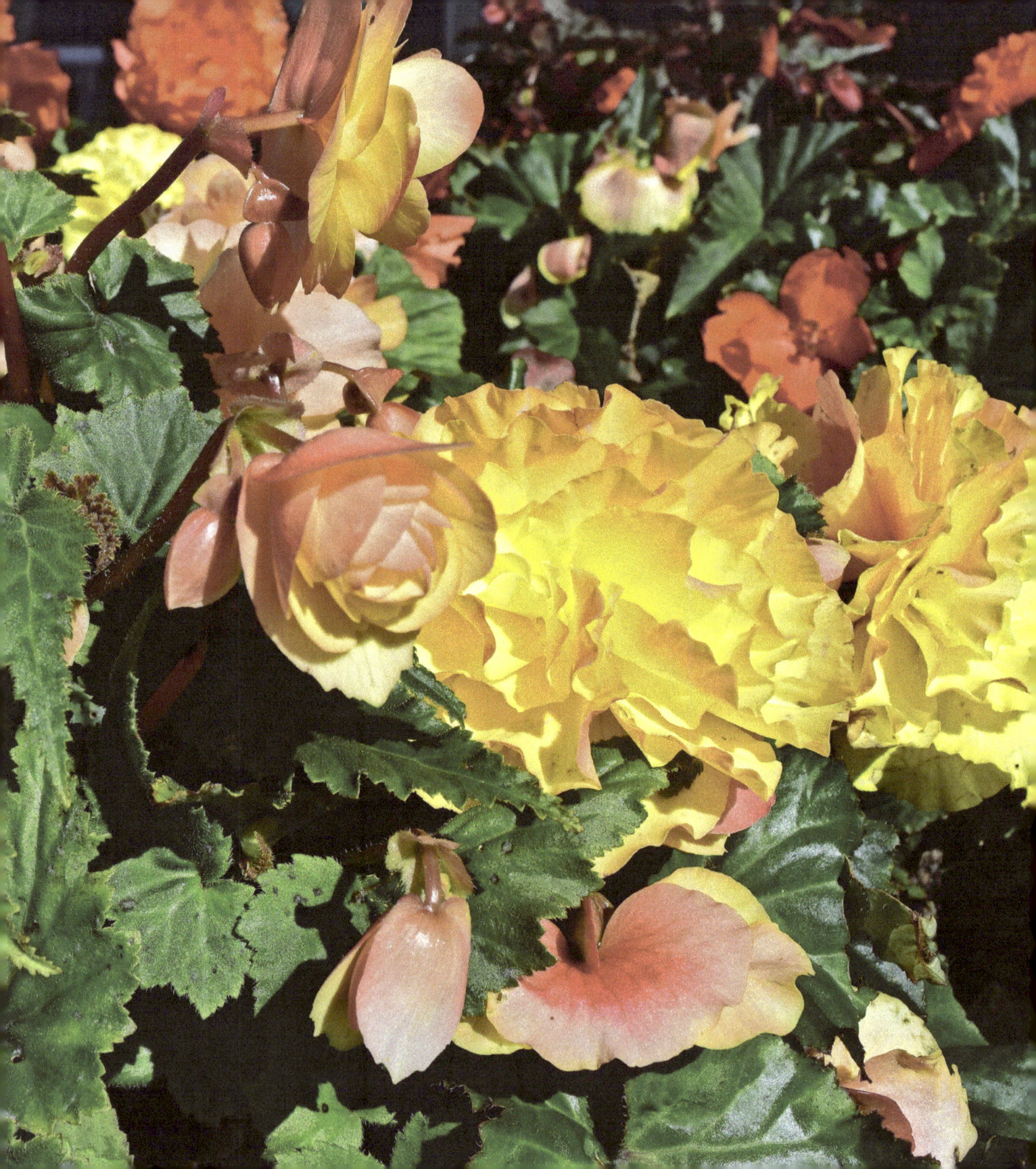

CHAPTER 2

Working in a Series:
Blending Tangles with Expressive Line

Make Your Mark!

"Stop.
Listen.
Embrace.
Engage.
Feel the Essence."

—Sharla R. Hicks, 2016

◀ Begonia, Les Bassacs, Luberon Valley, France

Introduction: What Is a Series?

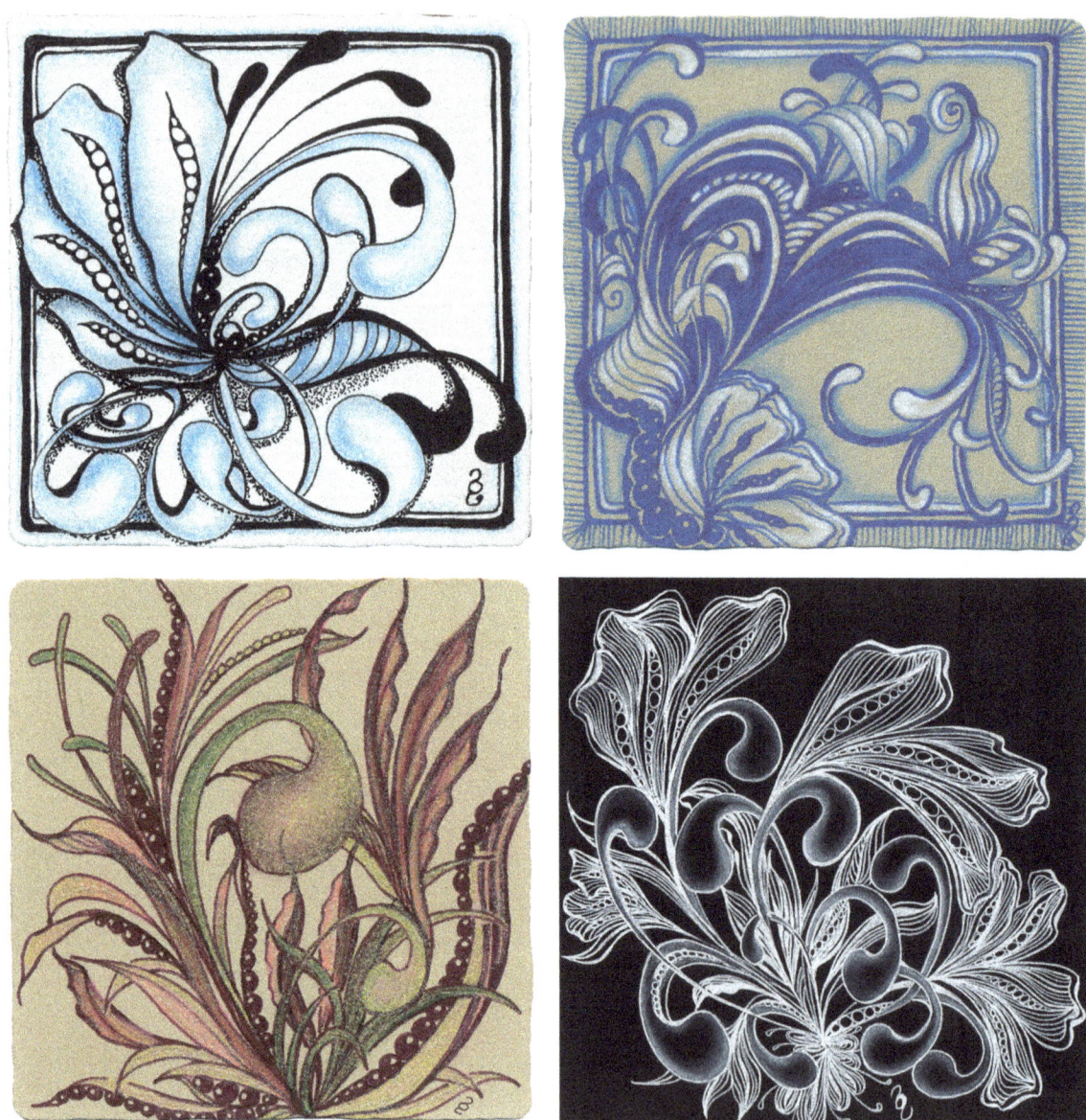

▲ Verdigogh blended with Mooka Blues Series, 2014 to 2016

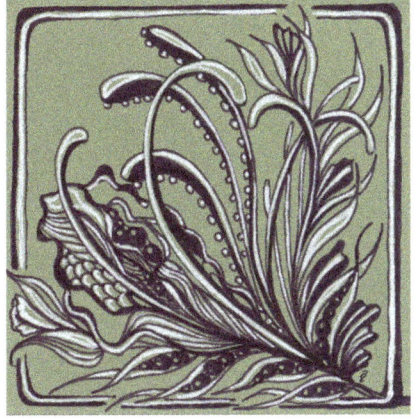 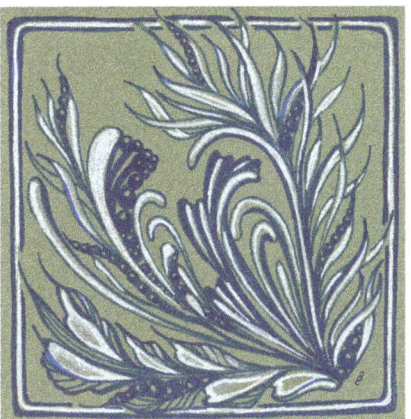 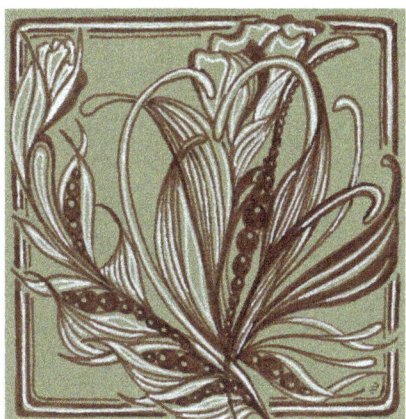

▲ Mooka Blues, Verdigogh Series, 2014

When you have a favorite pattern or stroke you enjoy experimenting with in different configurations, you are working in a series. Common elements are repeated in multiple interpretations: similar themes, strokes, tangles, color, shading, line, background, and more. Working in a series provides an opportunity to take your patterning from simple to complex by exploring line and mark enhancements and blending shapes, forms, expressive line, and tangles that add character and definition. In this chapter, you will develop a series of tiles to explore nature's essence through expressive line, Verdigogh, and Mooka variations.

WORKING IN A SERIES

An easy place to start a series is to limit the number of variables. The above study uses the same background, Verdigogh, Mooka, and white gel pen highlights. The only change is the pen color. A simple study helps refine and define your artistic voice and tangle style. It is not unusual to spend three or four months exploring a set of variables that evolve, morph, and emerge as new exciting ideas.

When you immerse yourself in long-term study of similar shapes and patterns, the strokes become an integral part of your muscle memory. Mindful focus quickly becomes the norm, allowing exponential growth in technique, line control, and design refinement as "what ifs" guide new and exciting ideas that are original to you. It does not matter if later you see something similar; similarity only speaks to the fact that universal symbols and forms are held in the psyche and emerge when working in a series.

The series opposite this page started as an exploration of blue shading on white, moved to changing pen colors on tan, to white on black, and then colored pencil shading. This series is not done: There is more to discover.

LESSON 10

Expression in Nature:
The Essence of the Undulating Line

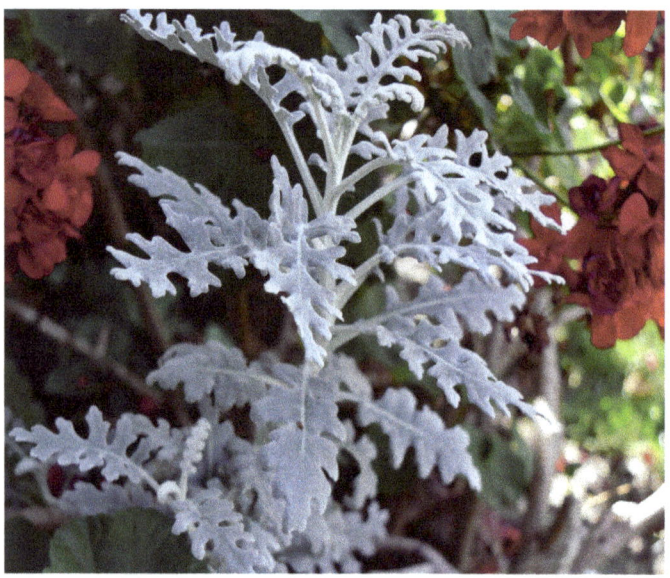

▲ Dusty miller

When drawing tangle-inspired botanicals, the goal is to interpret the essence. Close scrutiny paired with visual memory and vocabulary help define the twists and turns of textured edges, creating new ideas for strokes and patterns.

HOW TO FIND THE ESSENCE OF UNDULATING

Unusual but helpful tools for visualizing are the dictionary and thesaurus. Both will help you deepen your understanding and frame a verbal context that portrays character and increases visual memory.

The *Merriam-Webster Dictionary* definition of undulation is "having a wavy surface, edge, or markings." A thesaurus offers synonyms to help with visualization, the ebb and flow, rise and fall, sway and bend. The act of writing a descriptive sentence or paragraph engrains visual memories.

EXERCISE 1: Use Visual Vocabulary to Build Memories and Find Strokes

1. Study the dusty miller photo then read the descriptive paragraph on the left. Allow each word to create and enhance visual memories that are waiting to emerge as undulating repetitive patterns.

2. Study the photo and read the description again. Then close your eyes, allow the body to move as the essence of visual memories dance from the mind's eye through the muscles, down the arm, to your hand. Use your finger to air draw the imagery.

> The silver-blue dusty miller stands tall with tree-like majesty, branching, undulating, deep groove-edged leaves. Grayed shadows and bright highlights accent each deeply etched pale veined leaf. The geranium's large, voluptuous crimson blooms stretch to kiss the sun with teardrop-shaped petals of bright red and deep burgundy. Overlapping stems weave through the undulating-edged, halo-patterned leaves with shadow-creviced folds, radiating veins, and wavy outlines of rich olive greens held firm on knobby-notched burly stocks.

44 **Tangle-Inspired Botanicals**

3. In your journal, use the Counting Exercise, page 22, to trigger the flow of visual memories that will guide your hand to create repetitive patterns. Use the photo for quick reference only; draw from your imagination. Perfection is not required. It is okay to turn the journal as needed for stroke control.

✏️ EXERCISE 2: Feel and Visualize the Undulating Essence of Leafy Lettuce

Learn how to enhance visual memories that you can call on when developing botanical patterns.

1. Use tactile sensory input to help develop muscle memory. Use your finger to trace the undulating edge of each leaf. Notice when the leaf is broad and wavy or tightly clustered. Moving from one leaf to the next, carefully trace each twist and turn—burrow into the recessed crevices of shade and shadow—and carefully observe length and width variations.

2. Turn to the dictionary and thesaurus for definitions and synonyms to enhance your visual memories of the lettuce leaves' characteristics. In your journal, write a paragraph to portray the essence of the lettuce.

✏️ EXERCISE 3: Drawing the Undulating Essence of Leafy Lettuce

Tangle skills build one on top of the other. Use the method in the rose step-outs on page 20 to portray the essence of the lettuce leaf.

1. In your journal, practice undulating strokes that portray a single or cluster of lettuce leaves. Let visual memories guide your strokes to build the pattern while drawing from your imagination. Ask "what if," "how can I," and "why" questions. If needed, use a quick reference photo to see if your strokes capture the entwining overlap of leaf edges.

2. Move to the next lesson to learn how to use weighted line and marks to add depth and dimension. Shading will be covered in Chapter 4, page 100.

▲ Journal practice, dusty miller and geranium

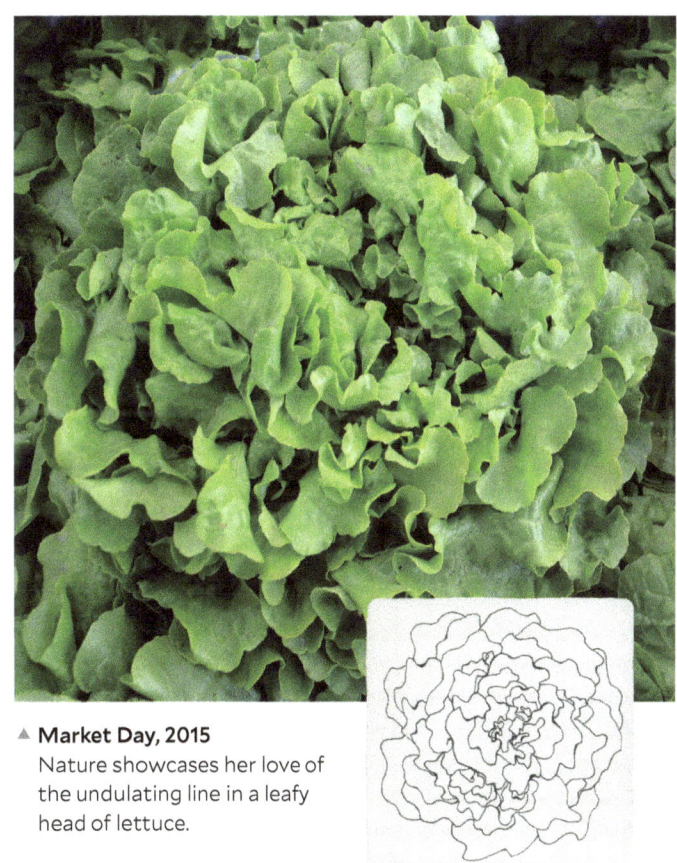
▲ Market Day, 2015
Nature showcases her love of the undulating line in a leafy head of lettuce.

Chapter 2: Working in a Series 45

LESSON 11

Expressive Partners:
Pen Marks and Weighted Lines

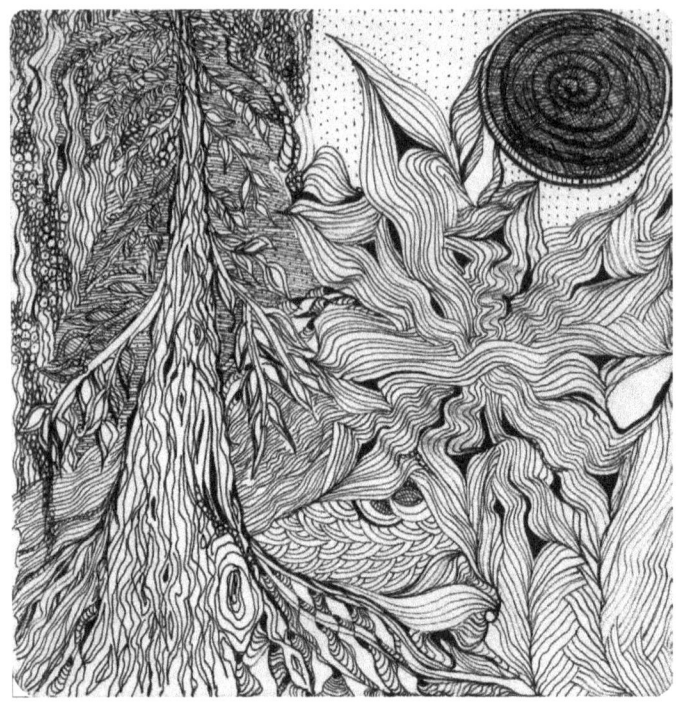

▲ Expressive line landscape. Turn this book counterclockwise and see how the image also reads as a stream or waterfalls. Journal page, 2012.

What imagery and emotions flow through your mind into the body's muscles when you read the following visual vocabulary? Slowly read with emotion, feel the essence, and move your body: undulating, quiet, soft, twist, turn, irregular, jittery, nervous, shaky, quivering, fluid, smooth, creamy, crossover, weighted, light, airy, thin, broad, chunky, spiky, frilly, jagged, zigzag.

 EXERCISE: Feel the Essence When Drawing Expressive Line

Remember, do not overthink; allow expressive lines to emerge from your emotional connection to the descriptive vocabulary and visual memories. There are no rights or wrongs: They are simply personal, unique variations of expressive marks and lines.

1. Select a word or group of words from the list above or choose your own. Deepen your understanding by using a dictionary and thesaurus to find the visual vocabulary that reflects the essence of the word. (See Lesson 10, exercise 2, page 45.)

Expressive marks

Undulating

Crossover

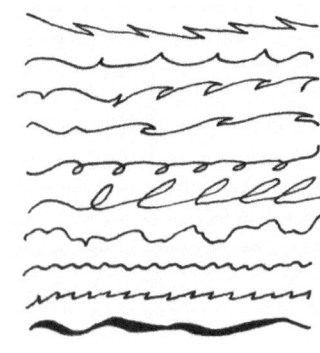

More expressive line

46 Tangle-Inspired Botanicals

2. Journal with descriptive vocabulary and strokes what you see and feel in your mind's eye as the essence of the line flows from your muscle memory into the hand and out of the pen.

3. Explore three to five variations. Add character with shallow weighted curves and divots, deep crevices, and wedges.

4. When ideas slow, evaluate how the marks and lines will develop into your unique vision while tangling nature's beauty and essence.

5. Repeat the exercise with another word or group of related words.

> **Tips for Expressive Line and Weighted Line**
> - Take your time; do not rush.
> - A fresher pen produces an even flow and smoother line. Drier pens leave a more sketchy line with gaps. Both have something to offer when interpreting an expressive line, texture, or shape.
> - White space can be distracting to the eye, so carefully fill the weighted sections—unless you want a break in the black void.
> - Taper the ends of weighted lines for a cleaner look. As you come close to the line end, use an upward motion while lifting your pen away from the paper. See examples below.
> - To taper both ends of a line, start from the middle, ending with the upward stroke. If needed, turn the tile so the stroke is consistent. See example below, left.

WEIGHTED LINES AND WEDGES

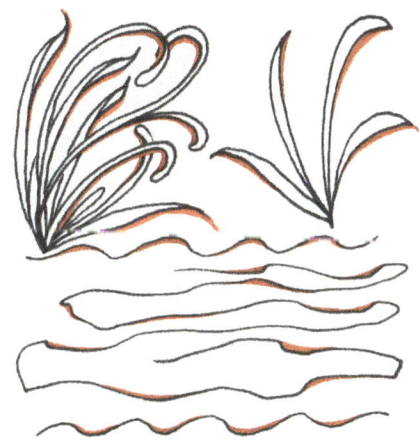

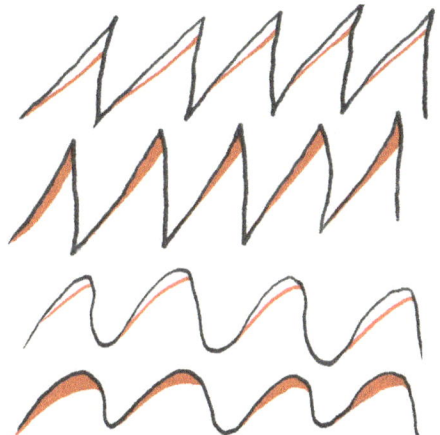

▲ To imply dimension and depth, add a tapered weighted line to the *underside* of forms. Selectively fill gaps, divots, twists, and turns. Not every divot and crevice has to be filled because too much takes away the contrast and balance created by the weighted marks. Check out the photos in the previous lesson to see how nature uses line and shade.

▲ Adding a wedge to the *same side* of a repeating pattern adds a sense of directional light and shadow. Remember, one mark at a time. The strokes create a pattern with space. If you like the open look and feel, blackout is not required. *Tip:* Carefully observe where the red strokes begin and end.

▲ Naturally occuring weight happens with intentionally overlapping lines. Each line starts from the same point or tip and deliberately overlaps previously drawn lines. Overlapping lines pair well with S and C curves.

LESSON 12

The Line Equalizer:
Shade, Shadow, and Dimension

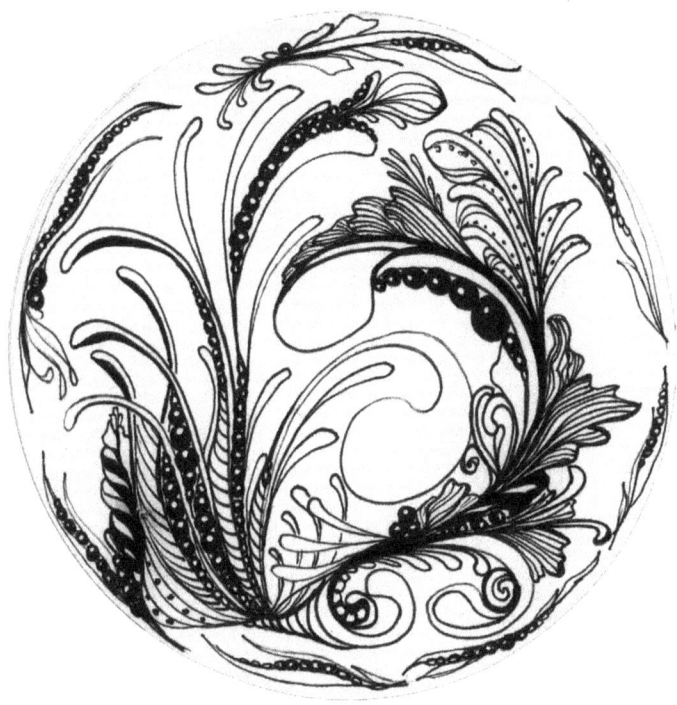

▲ Pen enhancements add definition and character for an interesting composition and can be a standalone choice. Pencil shading or adding color is optional. Here, weighted line, blackout, and hatching are used to imply rounding and shading. Black pearls draw the eye around the design.

Tangling is visually busy and multiple techniques are required to create a calm, overall look and feel. It is also important that the viewer's eye be directed to look at important design elements. Creating implied shade and shadow is the single most important drawing tool that can tame visual complexity.

Shading choices are a personal preference. Shading with pencil offers a softer, rounding effect that can be subtle or bold. Weighted line, stippling, and hatching add a textured look and feel that infers dimension, depth, and form. Blending both pen and pencil shading is a viable choice. Use experimentation and practice to find your personal vision and learn how to express mood and emotion with the help of shade and shadow. Pencil shading is covered in Lesson 29, page 104.

PEN LINE AND MARKS USED TO IMPLY DIMENSION AND SHADE

For those who prefer pen work, shade and shadow can be achieved without pencil shading. The eye blends and interprets pen line and marks as shade, shadow, and dimension. The secondary benefit of adding pen line enhancements is an opportunity to fix "less than perfect" marks as they disappear into the weighted edges, texture, hatching, and other line variations. When comparing the tiles on the right, it is very clear that pen enhancements and pencil shading add definition, rounding, and depth. The choice between expressive line and pencil shading is determined by the look and feel you want for the finished tile, as both are excellent solutions.

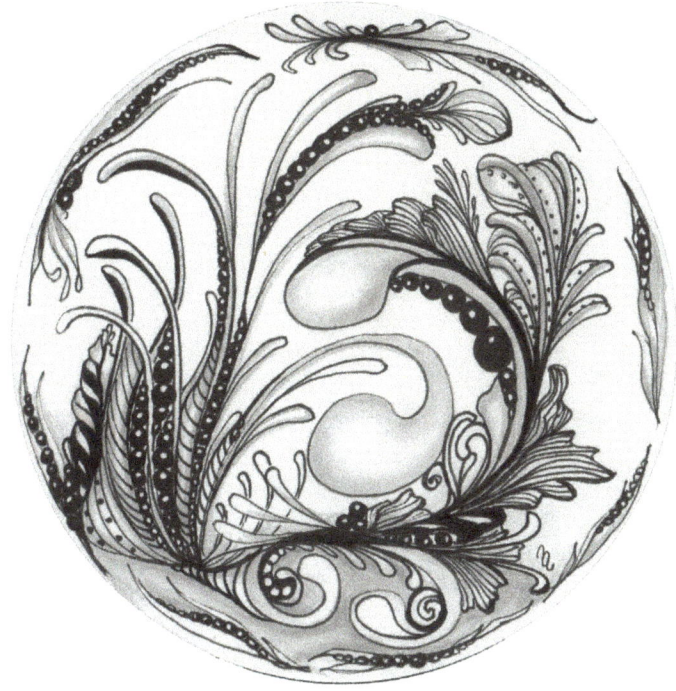

◀ Landscapes are grounded, heavier at the bottom, and grow lighter and less crowded as the line of vision moves toward the horizon or skyward. Pencil shading grounds the overall composition to the bottom of the circle. It makes the large hooks more voluptuous and thin hooks rounder. The curved line hatching takes on more curvature. Note at the bottom how the hooks take on more importance because the shading contrast pushes them to the forefront. (Chapter 4, page 100, covers shading.)

▲ Dense pattern lines without enhancements are visually uninteresting and confusing because they lack contrast and balance. There are no areas for the eye to rest and appreciate the design. The intertwined shapes and forms feel strangled.

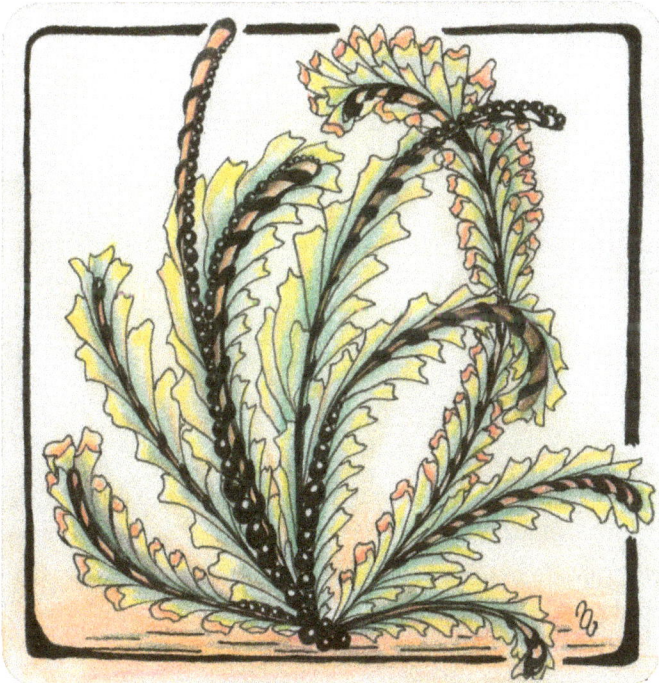

▲ Subtle coloring and weighted line add definition and clarity to the repeating strokes.

Chapter 2: Working in a Series 49

LESSON 12

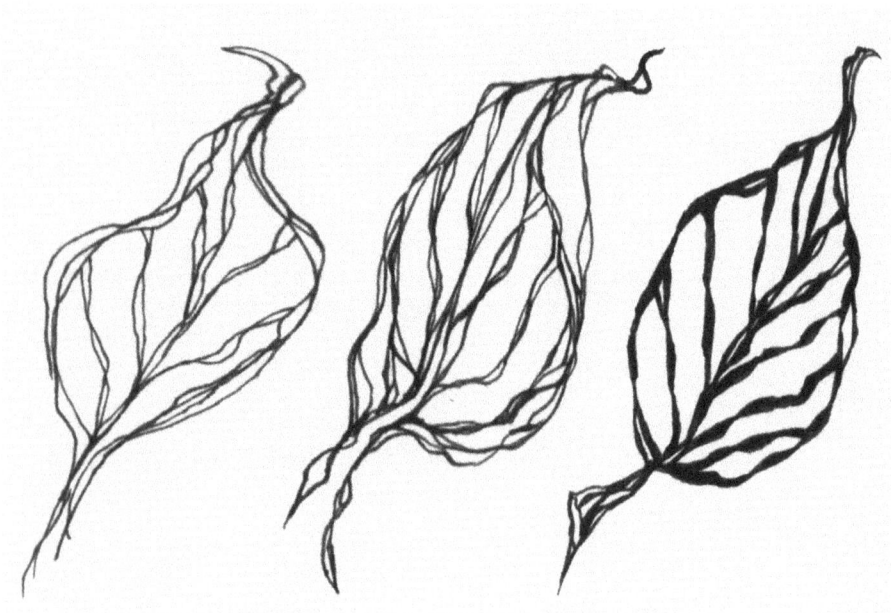

◀ Three different solutions gives each crossover edge its own character.

The first leaf's character is simple undulating crossover lines. The middle uses blackout for emphasis on a few of the crevices and divots formed by crossing lines.

The last example heavily uses blackout. For more expressive emphasis, consider adding strong angular strokes to weighted fill.

 EXERCISE: Working in a Series Using a Single Shape, with Focus on Pen Line and Marks

Working in a series can be as simple as exploring how many ways you can change a single shape. It offers the opportunity to focus on the possibilities without the distraction of working out a perfect design. (See page 46, and review weighted line enhancements in the previous lesson.)

1. Select a single form that you would like to explore. Work to make each rendition unique by using the concepts in Lesson 11, steps 2 to 5 (page 47).

2. To imply a sense of shade and shadow from the sun or a light from an overhead source, add a tapering weighted line to the bottom side of a shape.

3. To imply deep shade and shadow, use blackout, but take care not to overdo it. With blackout, it is important to overlap the pen strokes to eliminate missed white spaces, which can be very distracting.

4. To imply twists and turns, add blackout and tapered wedges to fill divots, curves, and crevices.

5. To imply shade and shadow nuances, add stippling, hatching, and crosshatching.

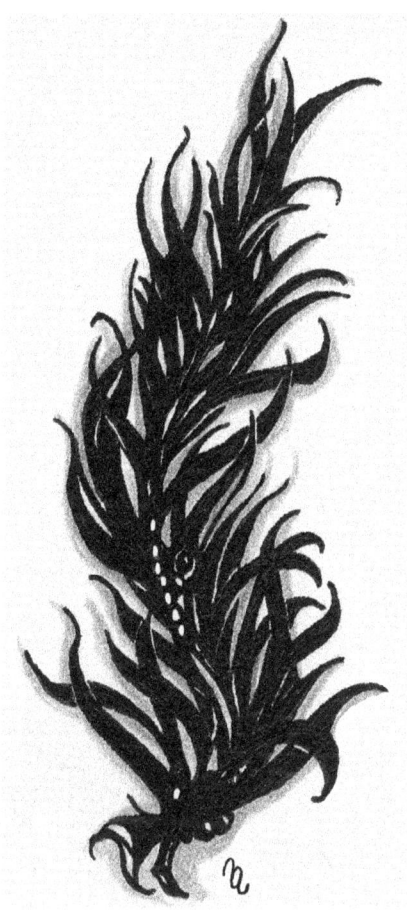

▲ Blackout is the ultimate weighted line. Use it when looking for extra drama or depth, or to cover up that accidental flop-portunity.

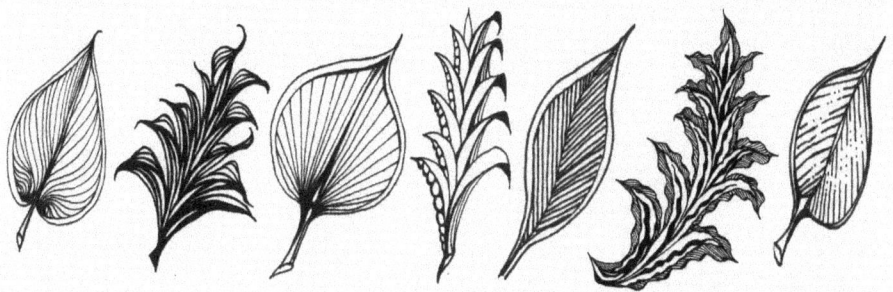

▲ Repetitive simple straight lines and C and S curves filling a form add depth and dimension. The line spacing gives the illusion of darker or lighter shade and shadow. Breaking up the line with dots adds highlights. All pair well with blackout for drama.

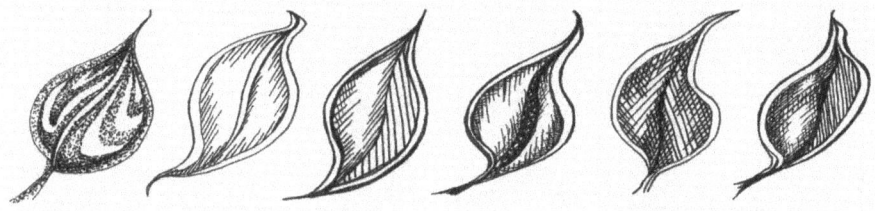

▲ Two methods can be used to create shade and shadow with pen. Stippling is a series of tiny dots. Hatching and crosshatching are a series of closely spaced lines. The amount of stippling and hatching to use is personal preference. Practice will teach you to trust your intuition to find the fine line between too much and too little.

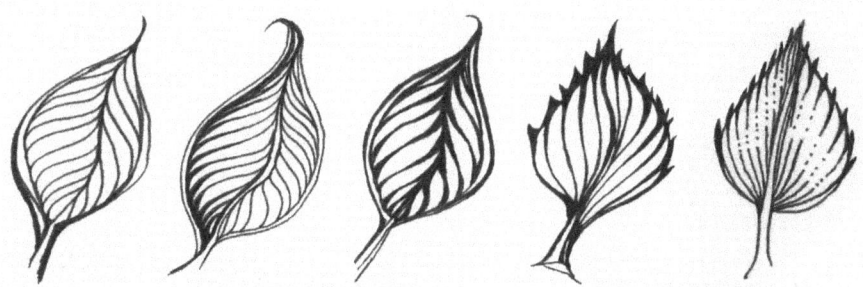

▲ The weighted wedge adds rounding. Blend the zigzag and wedge for an interesting edge.

LESSON 13

The Jazz Dance: The Undulating Zigzag

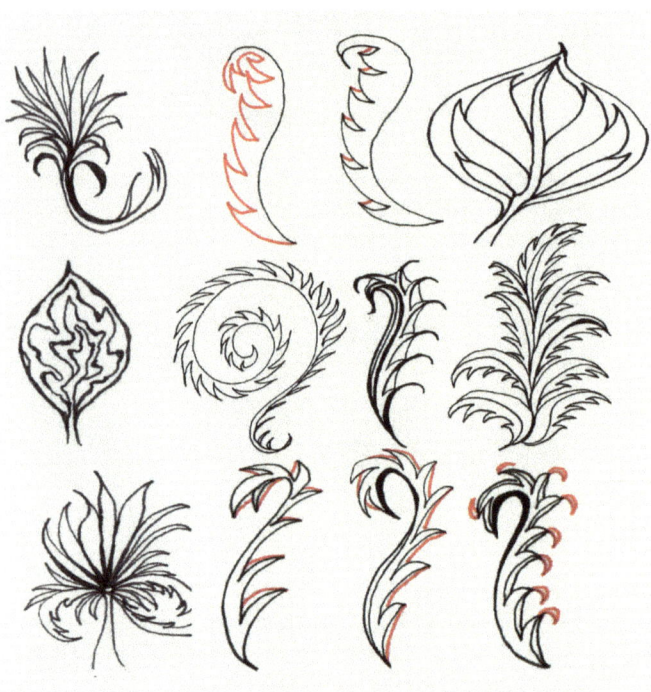

▲ Undulating zigzag patterns. Use visual vocabulary when asking "what if," "how can I," and "why" questions. Do not limit yourself to straight lines; use curvaceous, undulating, spiky, teeny tiny, and leafy zigzags. Trust your muscle memory, visual recall, and intuitive logic.

Study nature's propensity for zigzag paired with undulating shapes. This lesson is not about sketching, but is about recognizing and committing to visual memory the strokes and patterns found in nature.

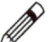 **EXERCISE 1: The Essence of Zigzag Edges**

1. Select one photo and use tactile sensory input to enhance visual memory by tracing possible strokes and forms with your finger. Use this opportunity to think about how you would build a pattern one mark at a time.

2. In your journal, describe what you saw and felt while tracing each form. Use visual vocabulary with as many adjectives as you can. This exercise burns the inspiration into your visual memory.

3. Without referencing the photo, use the essence found in your visual memory to develop strokes that imply undulating zigzag.

4. Repeat for each photo. Create a minimum of ten to twenty different undulating zigzag strokes.

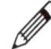 **EXERCISE 2: Explore Botanical-Inspired Zigzag and Landscape Forms**

With the inspiration found in Exercise 1, add a new layer of interest to botanicals by emulating nature's zigzags and undulating shapes, forms, and lines.

1. Begin with the Counting Exercise on page 22. Find ways to build undulating zigzag patterns in your journal from the strokes that emerged when studying the photographs used in the previous exercise.

2. Explore ten to twenty variations, ask "what if" questions, and call on intuitive logic to help the undulating zigzag morph into new and creative forms and patterns.

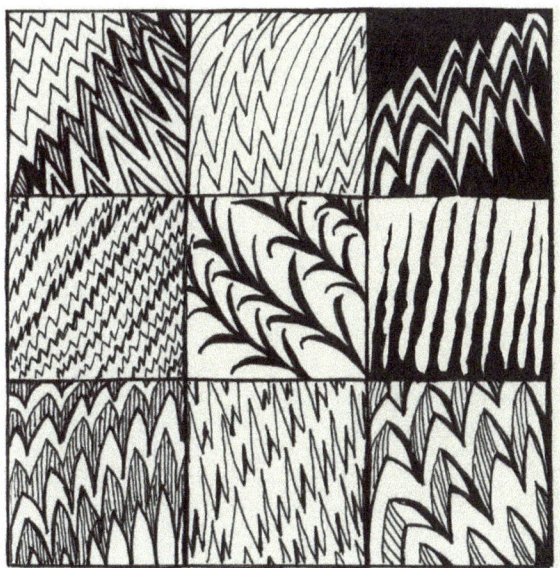
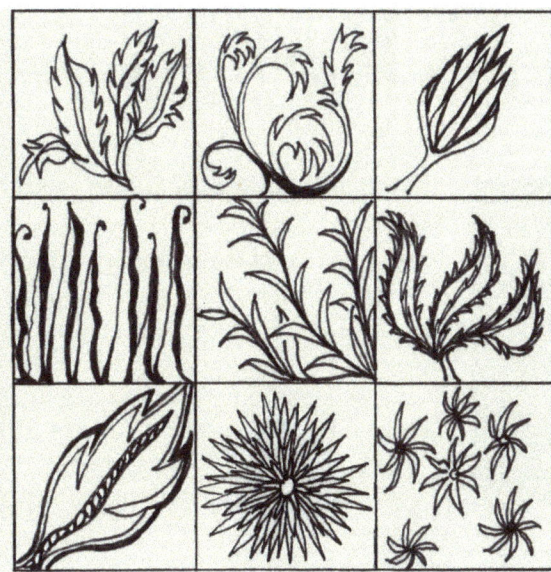

◁ Creating a grid offers a vignette for repetitive strokes and mini designs in each square. Intuition and logic will offer stroke and pattern ideas that will evolve, morph, and emerge into botanical forms.

▲ How does nature use variation to make each grape leaf unique? What can you use for individual stroke and pattern inspiration? How does the zigzag pair with the undulating line to make an expressive leaf? How many patterns do you see?

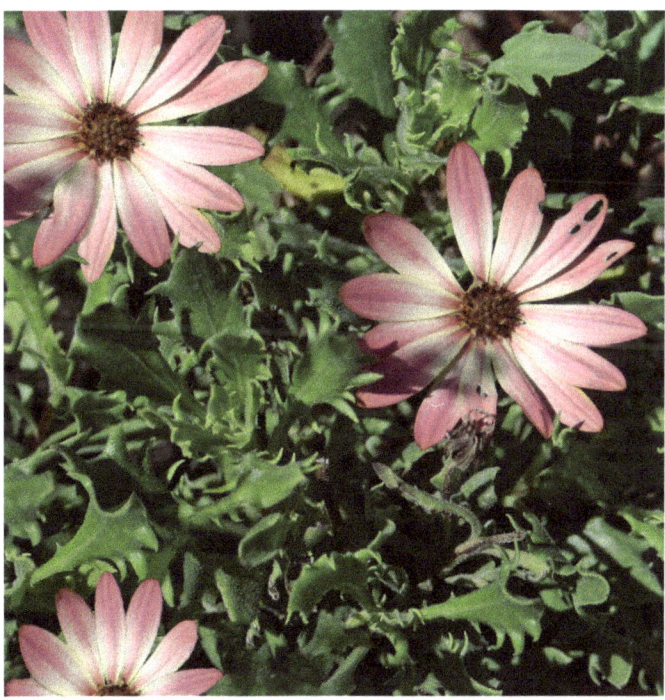

▲ Petals framed by undulating zigzags, oh my! What approach would you use to create an undulating zigzag? Ask "what if I," "how do I," and "why?"

Chapter 2: Working in a Series 53

LESSON 14

Verdigogh's Partner: The Expressive Line

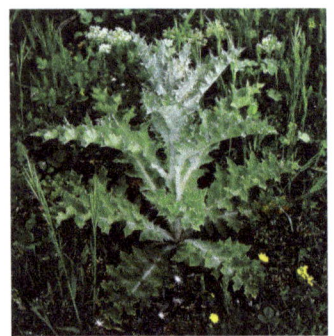

The original Verdigogh introduced by Maria Thomas is a blunt-tipped stroke that feels like a pine bough. The strokes used in Verdigogh can easily morph into leaves. It teaches layered branching paired with drawing *behind* and *crossing under*. Each concept is very important in developing tangled botanicals. Verdigogh adds grace to a tile and can be used as a frame, can stand alone, or can be intertwined through the design, adding cohesion and excitement. It also partners well with expressive line and the Mooka and Flux forms offered in the next lesson. Character enhancements can be added with buds, petals, and berries.

◂ Standing tall with spiky, undulating zigzag branches, these leaves reach for the sky.

◂ Expressive line and the Verdigogh Series, 2016

54 Tangle-Inspired Botanicals

 EXERCISE: Expressive Line and Verdigogh

The Verdigogh basic shapes do not have to be identical. Stroke alignment can be symmetrical or staggered. Pay close attention to spacing and stroke length for each layer. Use "what if" questions to reshape leaves by making them thin, airy, broad, pointed, rounded, jagged, undulating, and more. Look to nature for ideas.

1. Use your journal and/or tiles to explore ten to twenty variations. Begin with the Counting Exercise on page 22.

2. When underlapping occurs, the eye notices when the line does not emerge at the correct point on the other side. (See the fourth and sixth images in the step-outs below.)

Tip: Use air drawing: Draw to the line, lift the pen slightly off the paper, and air draw across the form to find where the line will emerge on the other side.

3. Foreshorten the third layer of strokes to imply perspective in the open space. (See "Tips for Foreshortening," right.)

4. Complete steps 4, 5, and 6 from the step-outs below. Practice drawing Verdigogh until you are comfortable with the crossing under and foreshortening.

5. Then, for variation, use expressive line, weighted marks, and wedges to imply depth.

Tips for Foreshortening

Foreshortening is a drawing technique that implies perspective with images that are coming toward or away from your line of vision. The illusion is accomplished by drawing shorter strokes that face forward, toward the back, or slightly sideways.

To understand this concept, stand in front of a mirror with your arm extended in front of you. Then move your arm to the side, behind, down, and up. Carefully observe how the arm appears to change length, width, and shape, even though you know it has not.

Study the photographs in this book to see how growth patterns visually change depending on the position in relationship to the stem or branch. This study will become part of the visual memories you will call on as your personal flair develops.

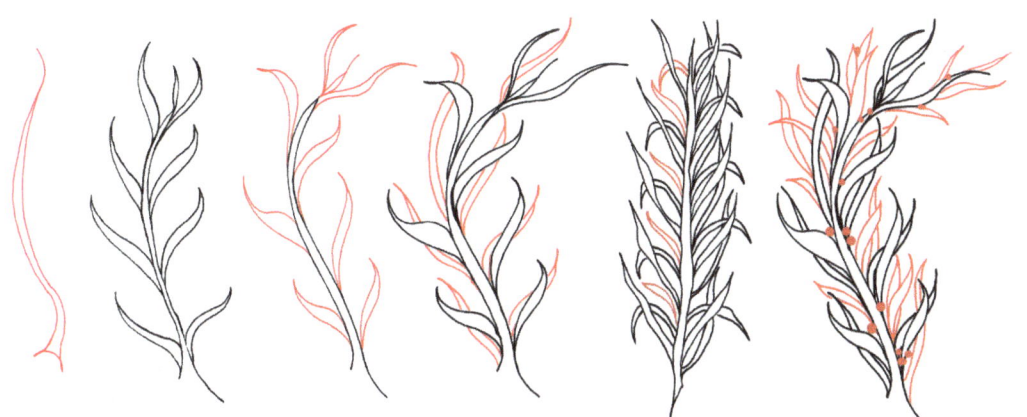

◀ Verdigogh step-outs

Chapter 2: Working in a Series

LESSON 15

The Mooka Botanical Dance:
Form a Hook and Cross Under

My favorite saying is "don't stop at ugly!" The 2012 version (below, right) was a nice letter design, but something was missing—a flop-portunity? I could feel the potential; it had a lovely background. My "aha" moment came in 2014 while I was working on a Mooka-Verdigogh series: I realized the open, airy hook and expressive line enhancements would be the perfect foil and contrast to the heavy letter patterning.

Mooka is a hook stroke monotangle and the quintessential foundation for tangled botanicals. Mooka's continuous motion induces mindful focus quickly. If you already have Mooka skills, blend with Verdigogh, add expressive line, and create variation with new shapes, forms, and strokes.

 EXERCISE 1: Explore Mooka-esque Forms

Each person has his or her own sense of rhythm and may not draw Mooka hooks using the same direction as the arrows in the step-outs (opposite, right). That is okay; what is important is to consistently draw all hook and

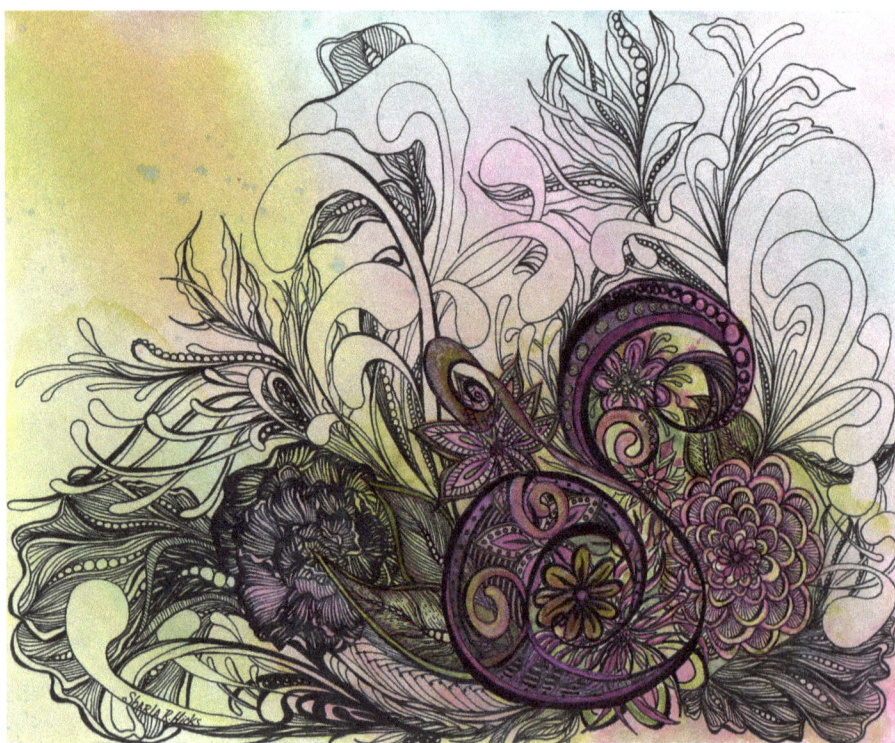

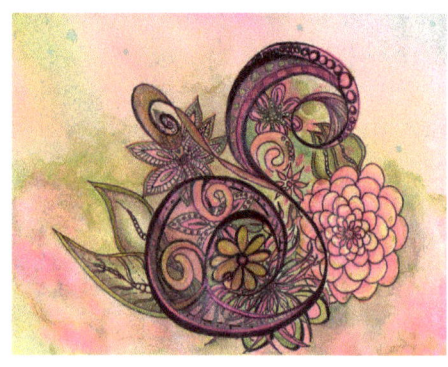

◂ *S is for...* 2012 (above) and 2014 (left), watercolor background enhanced with glaze, gold metallic gel, and black fine line pen, 11" x 14" (28 x 35.6 cm)

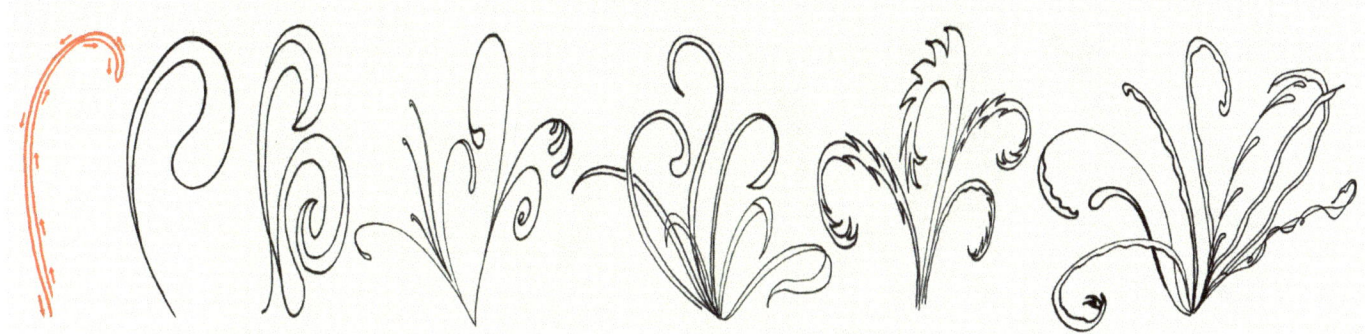

▲ Mooka hook and expressive line variations

variations in the same direction to develop the muscle memory for the sweeping motion needed to draw Mooka's continuous line.

1. To make learning easier, first practice the C hook stroke in your journal. When comfortable, add expressive line for variation (see above). Use the Counting Exercise on page 22 to find your rhythm.

2. Build the Mooka monotangle using the continuous motion shown in step-outs 1 through 3 on the right. Practice will quickly offer mastery. For a more botanical feel, begin and end the stroke at the bottom tip.

3. Once you have mastered Mooka, practice adding the Verdigogh technique and shapes for drawing behind or under strokes. Remember to use air drawing: Draw to the line, lift the pen slightly off the paper, and air draw across the form to find where the line will emerge on the other side.

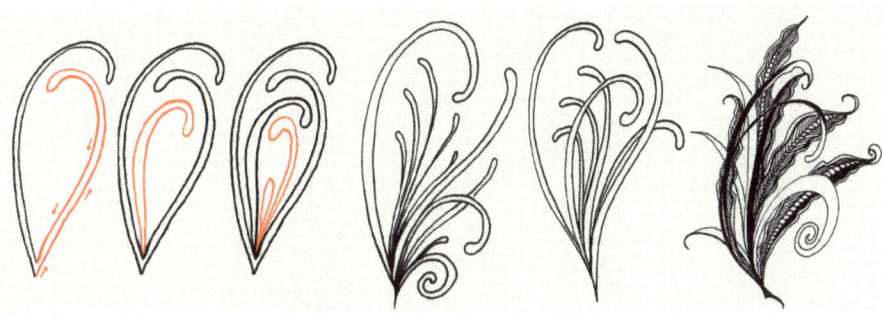

▲ Mooka step-outs. Expressive line Verdigogh and Mooka hook cross-under strokes form interesting combinations.

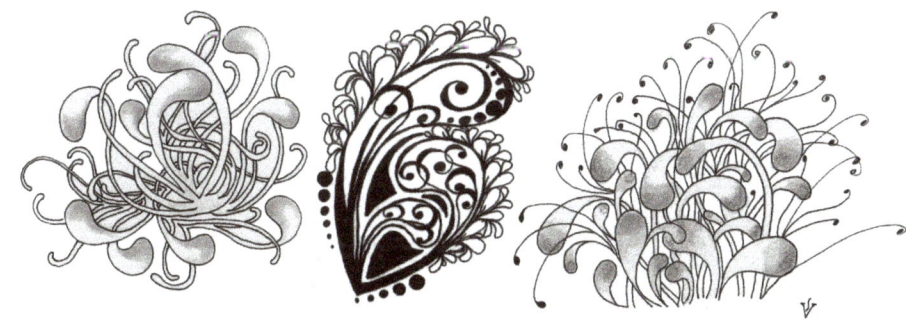

▲ Susan Valentino is a master of twists and turns, creating over-under Mooka hook variations with curlicue flourishes. In the middle example, Flux (teardrop and paisley shapes) adds character to Mooka's edges.

LESSON 15

◀ Exercise 2, Step 1

◀ Exercise 2, Step 2

 EXERCISE 2: Working in a Series: Blend Mooka with New Forms and Shapes

1. To enhance Mooka, experiment with embellishing between two hooks. Explore ten to twenty variations in your journal.

2. Create ten to twenty variations using Flux, a pattern by Maria Thomas. Note how the Flux teardrop and paisley strokes shown above in the examples for Exercise 2, Step 2 climb a line. However, they vary when climbing the Mooka hook, as Susan Valentino shows on the previous page. A natural evolution is to exaggerate the Flux even further, creating buds and elongated petal shapes.

 EXERCISE 3: Working in a Series: The Mooka Dance

Create five tiles using a neutral pen and white tiles measuring 3½" to 6" (9 to 15.2 cm) square.

The in-depth study of Mooka is an exploratory journey to find your unique tangle style. Keep your focus on using quality line control, do not rush the process, and allow creative and exciting compositions to flow. Incorporate the skills learned from previous lessons with attention to deliberate, carefully drawn strokes, weighted marks, expressive lines, undulating zigzags, and drawing behind techniques. To refresh your visual memories, flip through your practice journal and tiles looking for inspiration. Ask

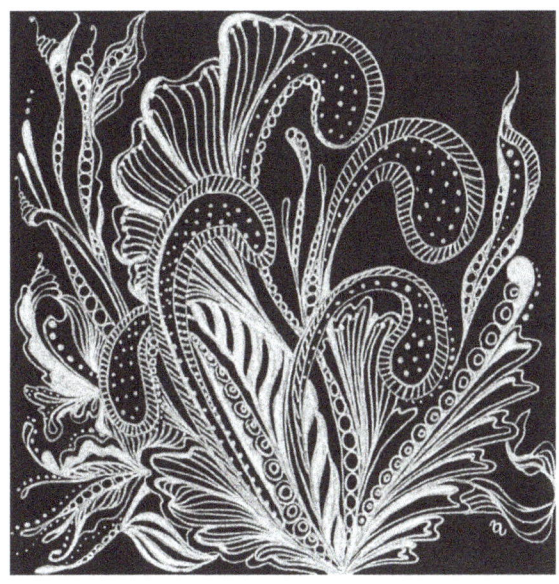 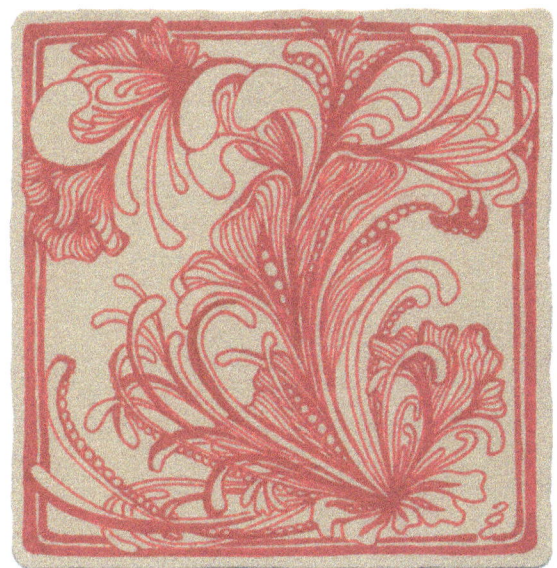

Mooka Series, 2015 and 2014 Add whimsy with dots, weighted lines. Develop designs with weighted tapering line for petals and pearls.

"what if" and "how do I" questions to invite intuition and logic to the Mooka dance.

Exaggerated shapes that climb the decorative hooks partner for a whimsical look and feel. Add character in the Vs—or valleys—between hooks with petals, using leaves and inspiration from your practice journal, tiles, and visual memories.

When working in line only, it is important to add overlapping weighted lines, wedges, and blackout for depth and dimension.

Exaggerate the Mooka hook with spiraling undulating zigzags. Consider adding Verdigogh-inspired pods and budding hooks. Shading will be covered in Lesson 29, page 104.

Consider replacing the hook with underlapping S and C curve strokes that create buds and blooms explored in Lesson 9, page 38. See Mooka on Tan Series (right) for an example.

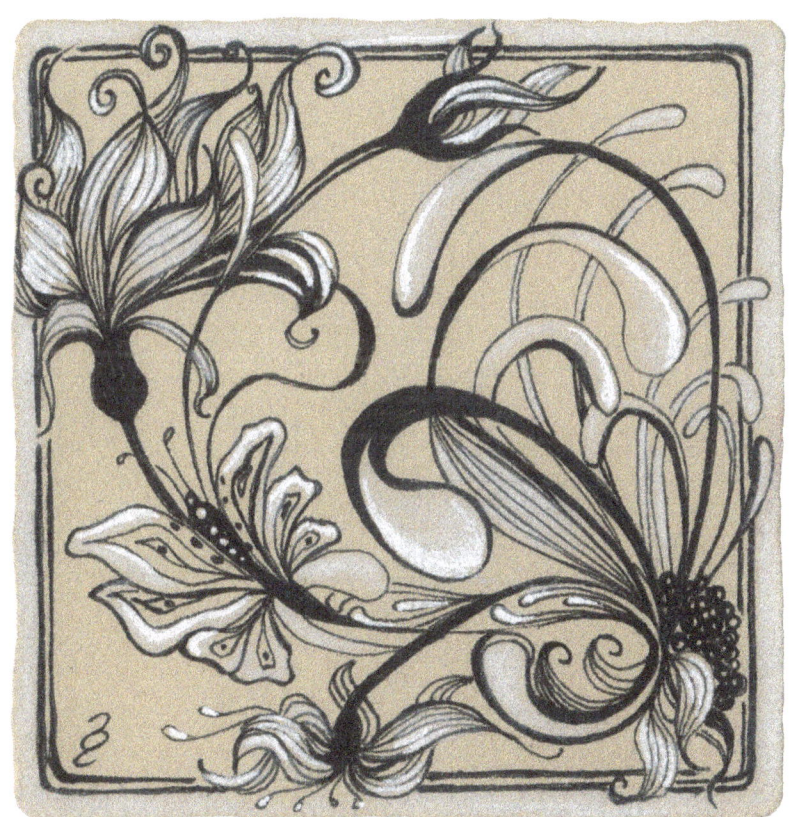

▲ **Mooka on Tan Series, 2016**

Chapter 2: Working in a Series 59

LESSON 15

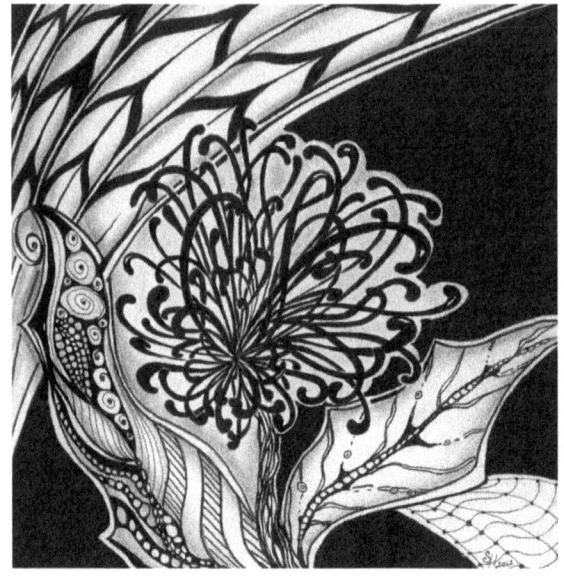

▲ Journal page, early 2012

Working in a series offers the opportunity to try out various interpretations of the same theme. The Chrysanthemum Series is an exploration of petals that started with the Mooka hook and undulating line. Each cluster of petals captures a unique variation on the essence of the mum.

✏ EXERCISE 4: The Mooka-Influenced Chrysanthemum

1. Using an outline form helps the pattern take shape. Draw a few basic petals around the center. Ask "what if" to find your unique variation of the mum. As you can see in the examples, dense line patterning needs shading and weighted line for definition of each petal. (See Lessons 11 and 12, pages 46 and 48.)

2. Use a practice grid or fill the page with the following variations on the chrysanthemum. Create a minimum of ten to twenty variations per concept. Use the Counting Exercise on page 22 to tap into intuition and "what if" questions to prompt experimentation.

▲ Journal page, 2013

Tangle-Inspired Botanicals

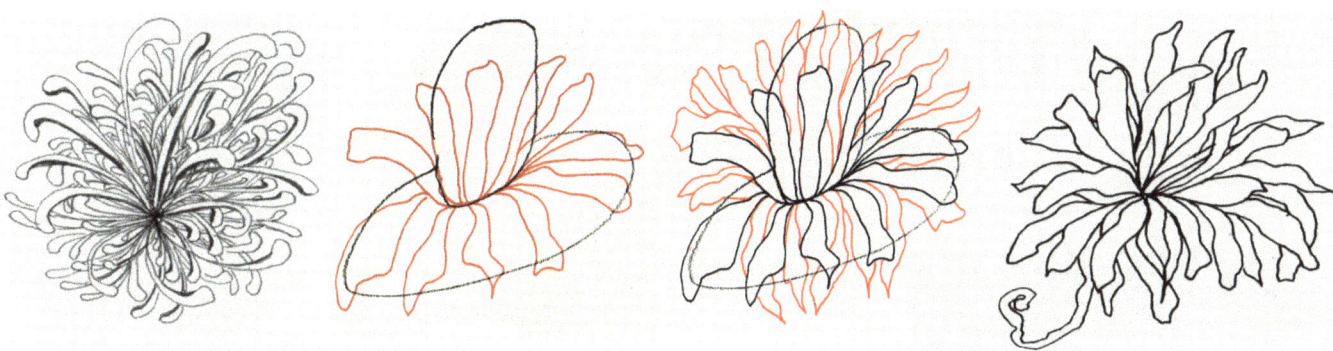

INTUITION WORKS BEHIND THE SCENES

Learning the full potential of a tangle or shape requires working in a series over a long period of time. Intuition is quietly absorbing new inspiration from nature, photography, art, life, and more. Each little tidbit is waiting to evolve—morph—emerge into a treasured botanical.

Early 2012 was the first time I turned the Mooka hook into a mum. I continued to play with the shapes and forms. A year passed and I found inspiration on a teacup showing me how to make broader hook-esque petals and buds; the 2013 chrysanthemum was born. Another example of the Chrysanthemum Series can be found in Lesson 18, page 71.

▲ Journal page, 2013

Tips for Using Gaps

Compare the differences between leaving a gap and carefully drawing to the line. In a *dense* pattern, the gap is visually distracting. The line needs to meet all intersecting points for visual continuity. The gap technique is okay to use on less dense designs that need an illusion of depth or separation.

Chapter 2: Working in a Series

LESSON 16

Magical Pens and New Backgrounds
Partner with Expressive Line

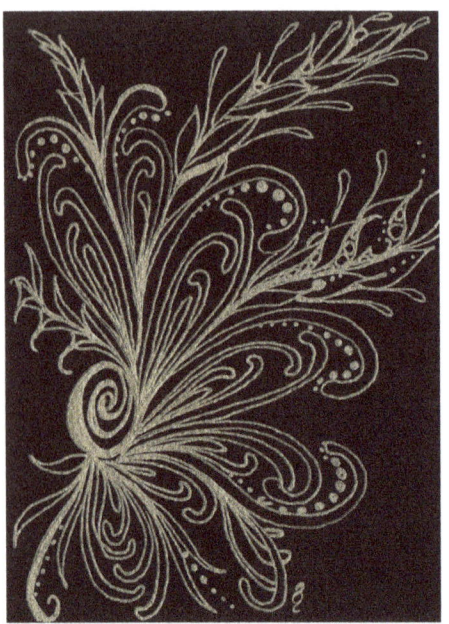

▲ Mooka Series, 2016, gold metallic on dark background

Discovering the magical alchemy of the right pen for expressive line adds the titillation factor that keeps the viewer engaged. Use expressive line and creative pen choices to turn leaves, buds, pods, and more into showstoppers. Turn dots and small shape enhancements into highlights or glistening diamond accents.

TIPS FOR TANGLING WITH THICKER WHITE, OPAQUE, EMBOSSING, METALLIC AND SPARKLE GEL PENS

White, opaque, metallic, and sparkle gel pens come in a medium point (.06 to .08), so the line is thicker. Each dries slowly. Avoid dragging your hand through the wet ink. Embossing pens come in matte or glaze and are a very wet ink that takes a long time to dry. Metallic inks have a creamy, smooth flow. White and opaque are the thickest and dried ink will build up on the tip, so wipe it off regularly. Wiping the tip will soon become a habit and you will not even notice yourself doing it. The sparkle pen's mica content can rub off on your hands, but is a delightfully subtle enhancement that adds to any tile.

To activate an even ink flow, use light hand pressure and hold the pen straight up, not at the usual slant. Then, barely touch the ballpoint to the paper. Draw *slowly* for a smooth, even line. Pressing hard stops the flow of ink. For a more expressive sketchy line, draw quickly. With thicker inks, tapering the ends of a weighted line with an upward stroke prevents a blob. Overlapping wet ink lines will usually smooth them out. Drawing over dry ink can mar the line.

White and metallic pen on black and dark backgrounds are excellent standalone solutions when paired with expressive line, marks, hatching, and tapered wedges. Overlapped lines in white and metallic create an illusion of depth with the weighted line. (See Lesson 11, page 46, and Lesson 13, page 52.)

SUPPLIES
- Black, tan, and gray backgrounds
- Multiple dark-colored pens
- White, metallic, transparent, and opaque gel pens

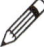 **EXERCISE: The White Pen and Expressive Line**

1. Black tile and white pen: Expressive line and enhancements are very significant for adding character to a white line.

2. Tan and gray paper and metallic and dark-colored pens: Neutral-toned and dark backgrounds come in a wide range of values and shades. Each takes a metallic pen and optional highlights very well. Experiment with dark-colored pens first—black, browns, dark burgundy, dark purple, and blues—and then with metallic pens—gold, silver, and copper.

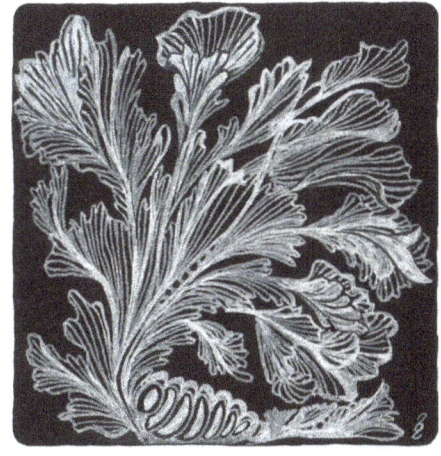

◂ SharlaRella on black, 2012, 4" x 6" (10 x 15.2 cm); see white shaded version in Lesson 32, page 113

No Two Pens Are Alike!

Before jumping into an artwork that requires an investment of time and materials, test your pen choice on the paper or tile. Each brand's ink has its own formula that affects coverage with varying degrees of opacity, transparency, and vibrancy, with instant dry or smudge, and permanent or water-soluble qualities. Another important variable is the paper's composition, which affects absorbency and dry time. (See "Pens and Paper," page 14.)

▸ Mixed-media monoprint, 2014, 11" x 14" (28 x 35.6 cm)
 Black printmaking paper, print inks, colored pencil shading, and fluorescent opaque gel pens add the spark of expressive line and marks. Note the landscape shading with the darker shapes and shading at the bottom of the composition.

LESSON 17

Expressive Guidelines
Partner with Verdigogh and Mooka

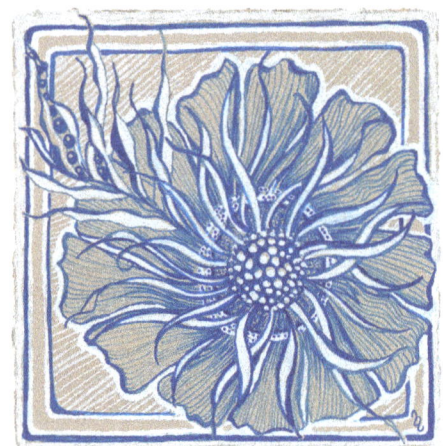

▲ **Example A:** The floral center and petals use highlights, weighted line, black pearl contrast, and background texture to create a juxtaposition of light, medium, and dark line texture that translates into dimension. Breaking the frame adds emphasis and pushes the floral forward.

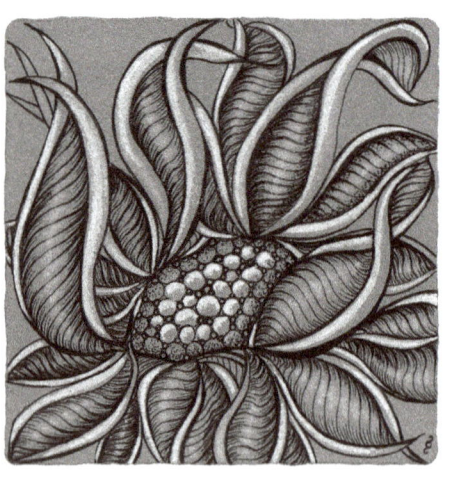

Working in a series is easier when you understand the guidelines and rules that act as signposts and point the way for exploring expressive lines, enhancements, and shading. Previous chapters and lessons offered the building blocks in bits and pieces. The question that remains is how, when, and why to apply design choices. The Foundation Guidelines (see below) offer the logic behind design choices to help intuition make informed decisions.

 EXERCISE: It's Your Turn

1. Review the Foundation Guidelines below.

2. *Before reading example captions*. In your journal, use the guidelines to define how intuitive logic guided design choices for shape, form, and added enhancers expressing character with line, marks, highlights, dimension, shade, and shadow.

3. For additional insight, compare your answers to the captions and, if needed, add additional notes.

FOUNDATION GUIDELINES FOR EXPRESSIVE CHARACTER

1. Repetitive variation adds interest. A change in line weight and color offers visual relief. Contrast placement moves the eye around the overall design and adds importance to detail.

2. Shade and shadow add dimension. Shape and form are created with texture, stippling dots, overlapping expressive curvilinear line, and soft pencil shading.

3. Darks come forward and lights recede. White outline contrasted against the darker weighted line of the petals adds importance and depth to the edges. See examples A, B, and D.

◀ **Example B:** Verdigogh's cross-under S strokes form each petal of this large floral that fills the tile for emphasis. The S stroke, striping, weighted line, white highlights, and shading create a juxtaposition of contrast that adds depth and dimension.

64 Tangle-Inspired Botanicals

▲ **Example C: Mooka on Tan Series, 2014**
Petal outline and the curvilinear overlapped lines inside the petals create darker weighted line that take on nuanced value and color shifts, creating the illusion of deep shadows, twists, and turns.

▲ **Example D: Verdigogh Series, 2014**
Repetitive variation using expressive line, hatching, blackout, and white highlights combine to add definition to a complex design.

4. The lightest light against the darkest dark creates the greatest glow. Highlights paired with the darkest contrast adds eye catching emphasis to petal shape with dimensional depth. See examples A and B.

5. Shape partnered with weighted, repetitive line fill implies dimension. Tapered wedges add dimension and weight to outline and repetitive curvilinear strokes to create an illusion of rounding, twists, and turns. Striping can add importance to the overall effect.

6. Very close line density on petal edges adds dimension. Closely spaced curved lines when contrasted against weighted line and line striping adds a sculpted rounding to petals. See example B.

7. Background textural density recedes. White lined background pushes the floral forward by softening the tan so it plays a lesser role. See example A.

8. Juxtaposition of contrasts creates dimension. The contrast of a dark, bold, weighted outline against thin, curvilinear lines adds petal dimension.

9. The frame stops the viewer's eye. Frames draw attention back to the center. The trick to breaking the frame is always added after the initial tangle is drawn close to the edge. See examples A, C, and D.

10. Emphasis showcases importance. Breaking the frame pushes an image forward, adding a visual element that compels the viewer to see a large floral coming forward. In example B, the single edge-to-edge floral creates an implied frame, adding importance.

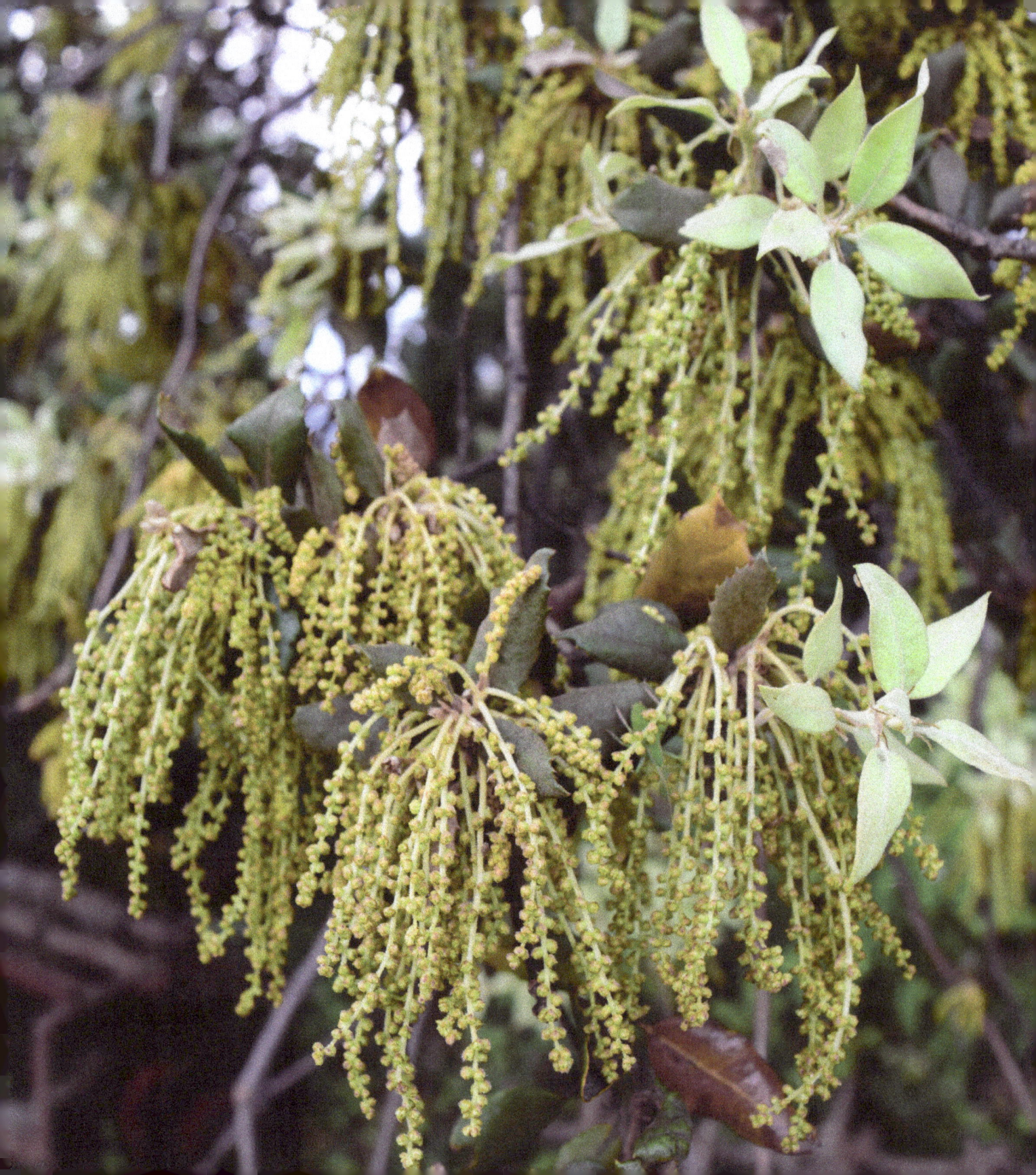

CHAPTER 3

The Alchemy of Texture and Line Embellishment

Make Your Mark!

"orb, check, stripe
 shade, shadow, highlight
 evolve, morph, emerge"

—Sharla R. Hicks, 2016

◂ Efflorescence, Les Bassacs, Luberon Valley, France

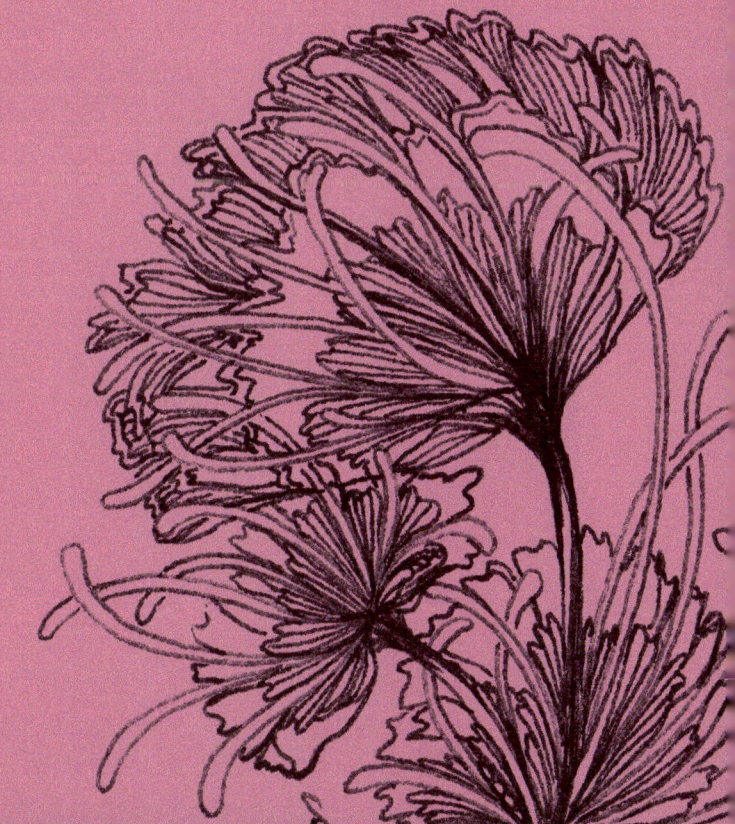

Introduction
The More is More Factor: Natural Textures and Patterns in Nature Offer Inspiration

Nothing—absolutely nothing—equals the magical power of textured and expressive line and pattern enhancements to take a piece to the next level. You have heard "less is more." In tangling the opposite is often true: More can be more. Nature dresses her botanicals and foliage in teeny tiny accents of dots, pollen, buds, seedpods, spikes, and thorns. You can do the same! If a tangle feels like it is missing something, the addition of repeating enhancements will lend a special touch of contrast and balance that only simple accents and teeny tiny forms can bring.

This chapter will explore the alchemy of enhancements to clean up "less than perfect" line, while adding a juxtaposition of finery, contrast, and balance. Often shade and shadow are the final touches of finesse.

Watch for exercises under each enhancement for ideas on how to turn a lackluster work into something better with magical enhancements. Take notes in your journal to synergistically tap into logical intuition by fusing the verbal language with the enhancer's transformative power to add nature's jewels to your design.

▲ My visit to the Desert Botanical Garden in Phoenix, Arizona, in 2013 offered many examples of how nature uses enhancers and visual memories to call upon for inspiration.

Chapter 3: The Alchemy of Texture and Line Embellishment

LESSON 18

The Heavy Lifters:
Blackout, the Background, the Frame

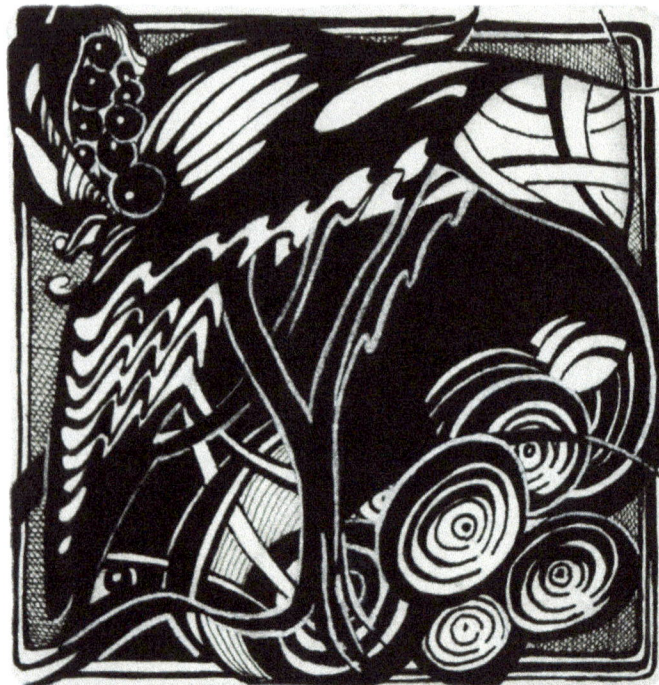

▲ Example A: Illusion through blackout

Blackout, background, and frame are heavy lifters in the tangle dance. They are modest but often have a dramatic flair, yet they always push their patterned partner into the limelight. Their character is complex and varied. To understand how vital this deferential partnership is to a successful design, notice how one or more play a role in almost every example in this book. Do these heavy lifters work every time? No, but more often than not, they do!

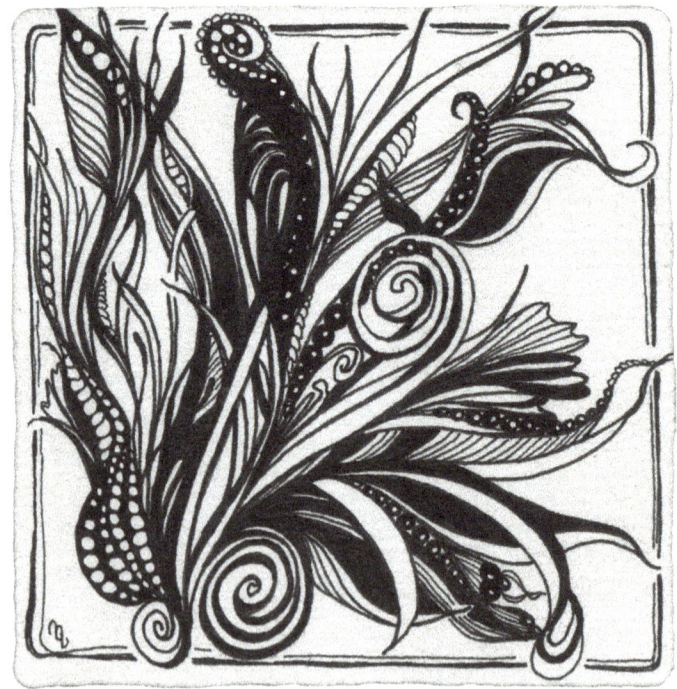

▲ Example B: Blackout intentionally used to add drama

> **Tip**
> Use deliberate overlapped line strokes for blackout. Missed white spaces are very distracting to the eye and take away from the beauty of a black-filled shape.

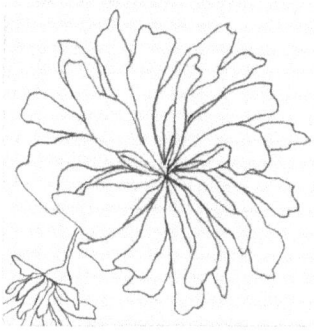

▲ Example C: The mum, an example of dense line that needs enhancements to differentiate between petals. See step-outs on page 61.

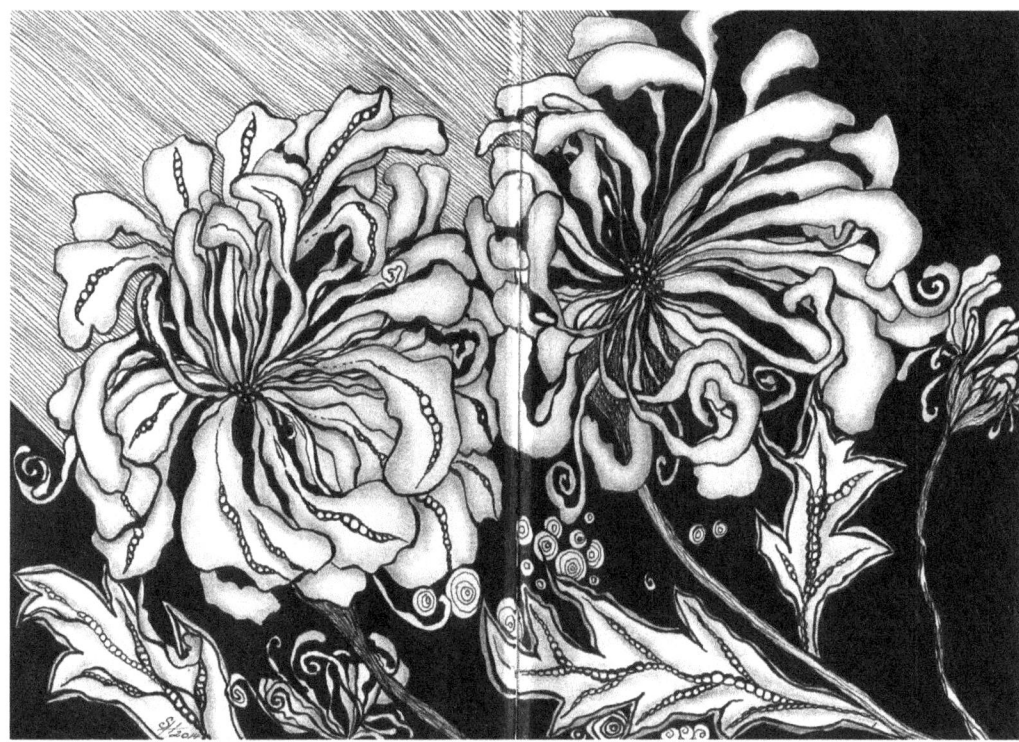

▲ Example D: *Alchemy in Black*, 2014. Blackout background has a calming effect. Here it was a flop-portunity that covered visually busy hatching in the background that distracted from the mums. The blackout creates an implied frame (see page 74).

BLACKOUT

Blackout has four design functions:

1. Blackout offers a positive-negative design opportunity to create an illusion that makes the viewer wonder whether it is on a black or white background, as shown in example A.

2. Blackout helps delineate shapes and forms and can be an intentional design element for drama, such as in example B.

3. Blackout can be the equivalent of a pen eraser that removes unwanted lines.

If a design feels iffy, it is a flop-portunity for blackout to add a calming element as in example D.

4. Blackout can create an implied frame as in example D.

THE BACKGROUND

Adding a background to a tangle has two functions:

1. When elements are crowded together, a background adds definition by pushing the individual elements forward and toning down the paper, allowing it to recede.

2. Backgrounds are a "more is more" opportunity. When adding more, take care. Backgrounds need to be quieter than the patterns in the foreground. Review examples A and D above and H on the next page.

Chapter 3: The Alchemy of Texture and Line Embellishment 71

LESSON 18

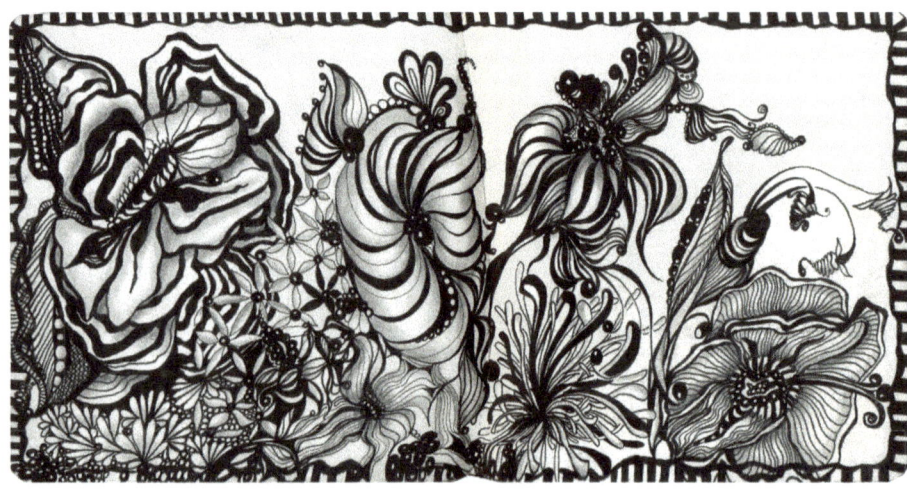

▲ Example E, journal page, 2012, 6" x 12" (15.2 x 30.5 cm)

> **Tips for Tangled Frames**
> - When adding a tangled frame, take care not to use an overwhelming pattern that demands more attention than the overall design.
> - When complete, if you notice the frame first, it is drawing too much attention to itself.
> - Don't worry, this is a flop-portunity to use blackout or dense hatching to make the frame a secondary design element. Practice will improve your frame choices.

THE FRAME

The frame has five major functions:

1. Adding a frame offers visual confirmation that the tangle is finished or needs further enhancement. Consider adding a frame when you do not know what to do next but the tangle feels unfinished.

2. The frame is unifying and adds cohesion, which hold the overall design together.

3. The frame holds the viewer's attention inside the frame to linger longer on the design.

4. A fragmented frame adds magical alchemy. When the tangle elements are drawn close to the edge, the eye wants to see a continuous frame line. This is done by drawing frame fragments between and behind the existing pattern. See examples A, B, E, and H.

5. The frame is a "more is more" opportunity to add a tangle. Simple repeating lines can do the job, but if tangling the edge is desired, look to the primary design for inspiration that incorporates similar strokes, shapes, and forms.

 EXERCISE: Blackout, Background, and Frame

1. *Before* reading the insight captions for examples F, G, and H, answer the following questions in your journal. When done, review and compare your answers to the captions.

2. Example F: Blackout was used to counterbalance the exaggerated Mooka hook; was it successful? Is it too dominant, just right, or somewhere in between? What is happening when looking at the pointed leaves and petals? Is the design finished or is it suggesting something more is needed? If something more is needed, what would you add?

3. Compare examples G and H: How does the frame change your perception of the blackout hook, pointing leaves, and teeny tiny petals? Is there more balance? Are any elements more noticeable? Does the design feel finished? What about the "more is more" factor?

4. Compare examples G and H: With the addition of the hatched background, what do you see first? Which elements recede or come forward? What is your per-

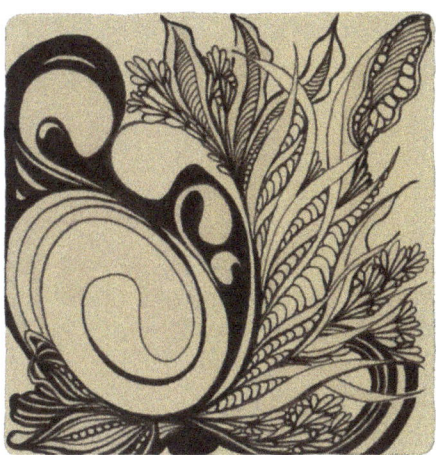 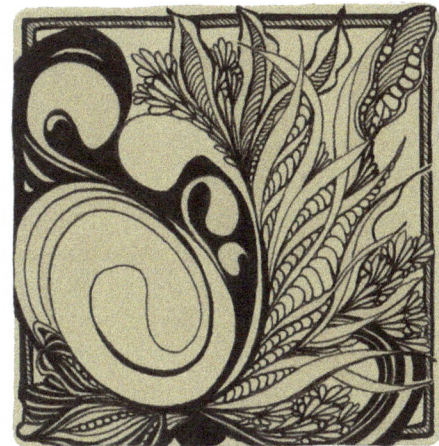 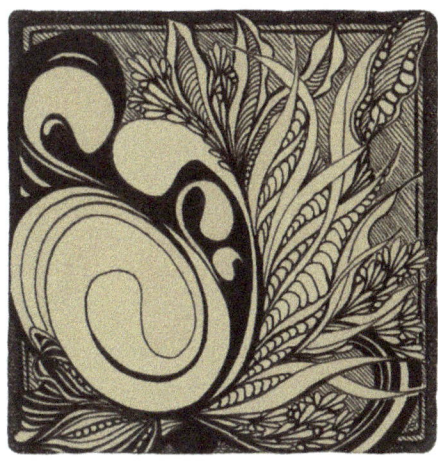

▲ **Example F, intentional blackout**
Insight: A flop-portunity has arisen; the exaggerated hook feels lopsided. The Verdigogh leaf strokes add an airy contrast to the heavy blackout. Unfortunately, the pointing leaves lead the eye away from the tile. The teeny tiny petals and orbs are barely noticed.

▲ **Example G, adding a frame**
Insight: The frame pulls the eye back into the design, asking the viewer to linger longer. The lopsided imbalance seems to have melted away with a better ratio of open space and pattern. The teeny tiny petals and orbs are a little more noticeable but still quite dense.

▲ **Example H, adding a background**
Insight: The hatched background and darkened frame invite the viewer to linger and enjoy the detail. The background becomes a receding shadow that modestly pushes all other tangle elements to the foreground, showing off the smaller leaves, berries, and tiny florals. Adding the hatched background and frame created a denser, darker piece that may not appeal to you—it is a matter of personal style and preference.

sonal reaction to the addition of the background hatching? Is the design enhanced? If yes, why? If no, what would you have done differently?

5. What other patterns or techniques could have been used to enhance the design and background? Answering this question will help you define your own unique vision for tangling.

Tips for Adding the Heavy Lifters

After the initial tangle is complete, determine whether you want line only or to add shading. If the piece is still not working, time for the heavy lifters. Evaluate after each addition for a sense of completion.

1. If there is an obvious flop-portunity, consider using the "more is more" opportunity with additional enhancers covered in this chapter. Evaluate.

2. Add a frame. Evaluate.

3. Add a background. Evaluate.

4. Add blackout. Evaluate.

LESSON 19

The Implied Frame Engages the Audience

The implied frame is a visually cohesive way to keep the viewer engaged on primary design elements and can take on many forms, as illustrated in the examples by Deborah Goldman, CZT. She uses a very specific style in her 6" × 6" (15.2 × 15.2 cm) practice journal. She tangles on the right side of a two-page spread and challenges herself to make each page cohesive and visually pleasing by looking for ways to pull the practice elements together using implied frames. The four examples (left and below) show how her frame choices are inspired by tangle elements on the page.

▲ Large repeated tangles create an implied frame.

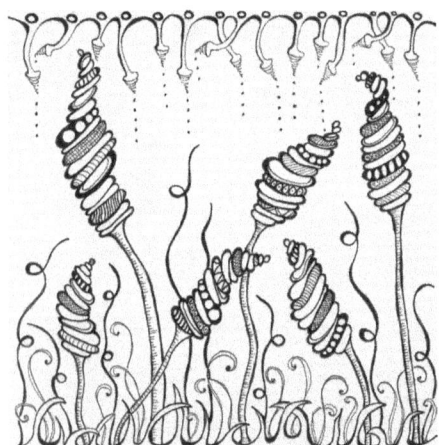

▲ The standing tall Quabogs are the inspiration tangle for the small Quabogs, Fescu, and curlicue tendril frames at the top and bottom of the page.

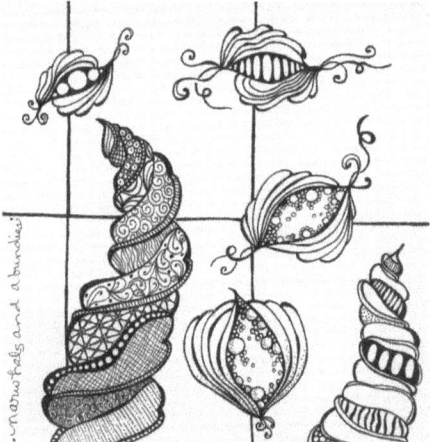

▲ The grid, drawn last, ties the tangle elements together with an implied frame. Note the documented tangle names, Abundies and Narwhals, follow an edge that creates an implied frame.

▲ This simple design becomes precious by adding creative framing that uses variation of size and an improvised Fescu-enhanced vine.

74 Tangle-Inspired Botanicals

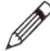 **EXERCISE 1:** Practice Creating an Implied Frame

Go through your practice journal and find ways to change ho-hum pages to wow with implied and creative frames using tangles and grids. Look for inspiration in the tangle strokes that could be used to create a simple frame.

 EXERCISE 2: Create Designs That Use an Implied Frame

Working in a series is not replication: It is about using practice to gain experience and build confidence.

1. Create three to five tiles that use strong shapes, background elements, dense patterning, or a combination to create an implied frame. Review the examples for ideas.

2. Use intuitive logic. If you are good at visualizing, air draw a frame idea. If you need more concrete information, create a few sketchy compositions with frame ideas in your journal. These are not tangle renditions, but are quick sketches that imply placement of a form and frame.

3. When tangling, a light pencil line can be used to remind intuition to include strong elements like a C curve or a circle.

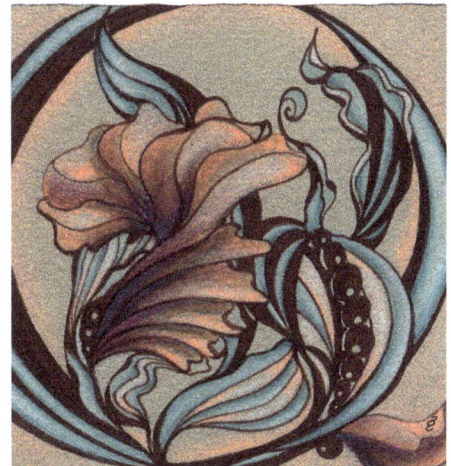
▲ The large circle is an implied frame that focuses the eye on central design elements. C curves, hearts, triangles, squares, and more will act similarly.

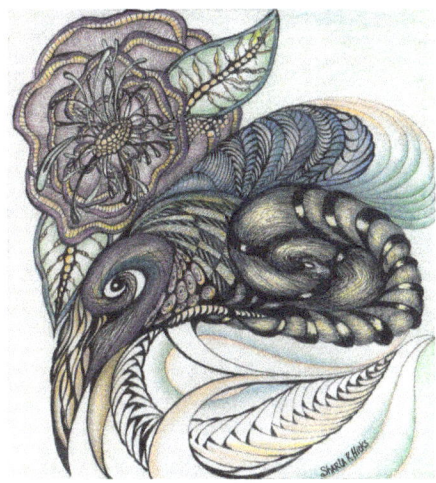
▲ Strong design elements that hold your attention create a powerful implied frame.

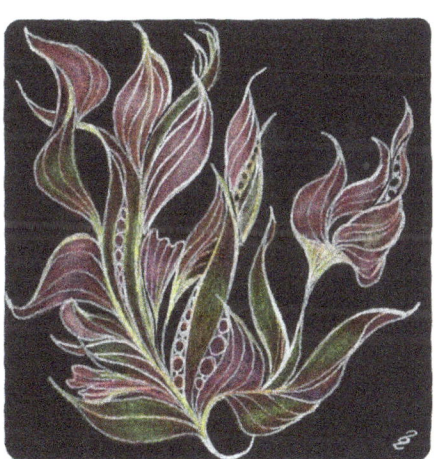
▲ A dark background acts as an implied frame.

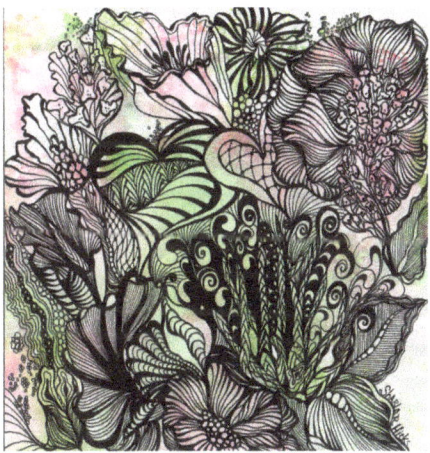
▲ *The Tangled Botanical*, 2013, alcohol ink monoprint, black pen, 8" x 8" (20.3 x 20.3 cm)
An edge-to-edge design serves as its own implied frame.

Chapter 3: The Alchemy of Texture and Line Embellishment

LESSON 20

Circles, Orbs, Pearls

Unequivocally, the alchemy of the humble circle, the orb, and the pearl is its versatility. It is the ultimate enhancer, with magical powers and unlimited "what if" possibilities. The hardest part will be deciding which type of circle to use: large, medium, small, teeny tiny, blackout or blank, with or without sparkle, clustered together or used to line a shape, and don't forget about graduating sizes, spirals, and concentric circles. Tipple, Perfs, and Purks designed by Maria Thomas are excellent practice to explore the potential of the circle as a design element.

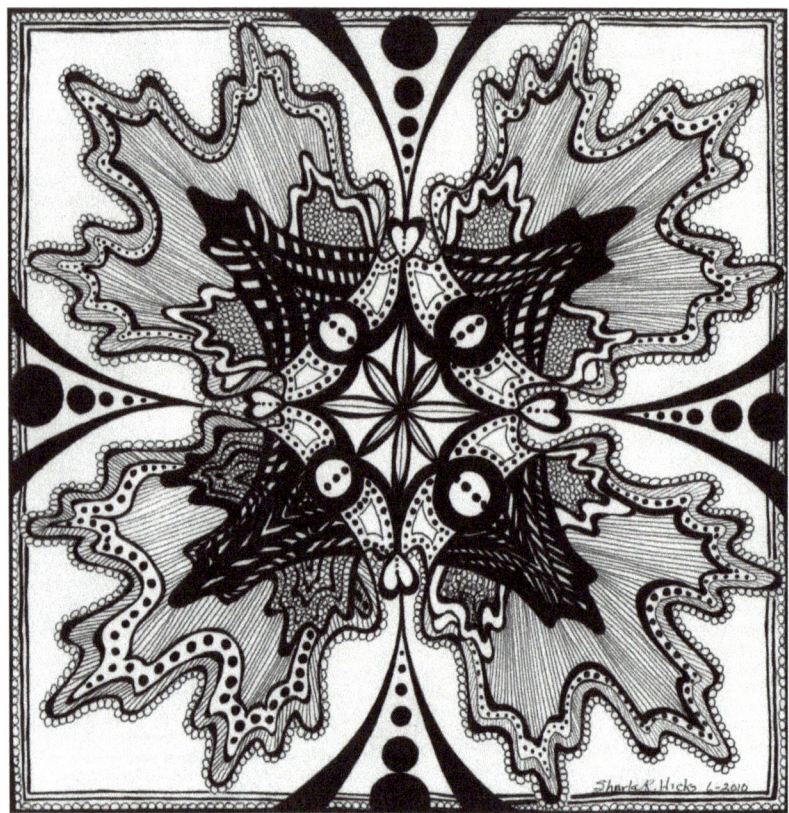

▲ Perf-enhanced mandala, 2011. Perfs are the tiny circles outlining the leaves and frame.

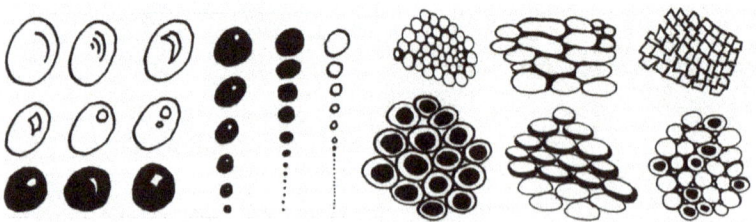

▲ For variation, elongate the humble circle into an oval, graduate circle sizes, change up the sparkle, and use blackout. How many variations can you think of?

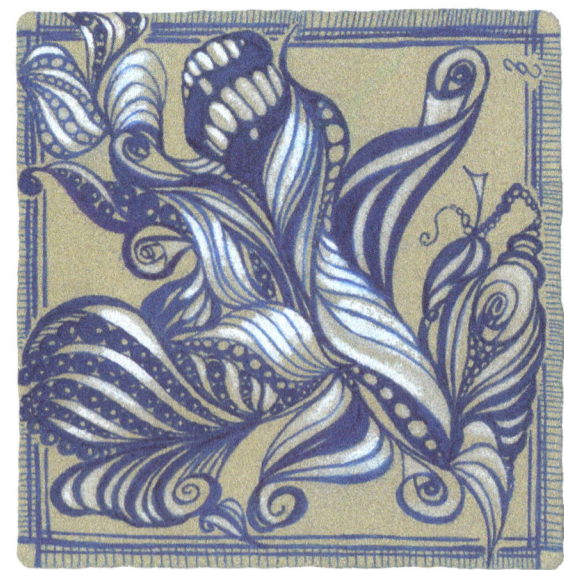

▲ Blue on Tan Series, 2014

EXERCISE 1: The Humble Circle and Orb

1. In your journal, create a practice grid or fill a page with repeating variations on Perfs, circles, concentric circles, pearls, and spirals. Ask "what if" questions.

2. If you are filling a journal page with practice shapes, pull the page together with an implied frame; see Lesson 19, page 74.

3. Browse through your journal and tiles looking for "more is more" opportunities that can be enhanced with the humble orb and circle.

THE POWER OF THE DOT

Dots and Spirals was a ho-hum piece where my favorite admonition of "don't stop at ugly" from page 124 played a large role. I returned to the piece multiple times over a couple of years as it evolved from a color monoprint into a landscape-esque work. It continued to morph through several colored pencil renditions exploring shade and shadow—pretty but lacking something. I began exploring how florescent dots and lines would add wow and panache. Finally, the potential I knew was there emerged!

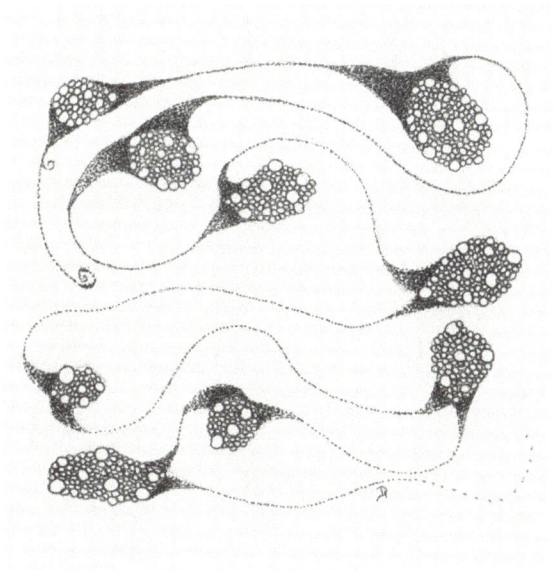

▲ Donna Hicks, © 2014, 4" x 4" (10.2 x 10.2 cm)

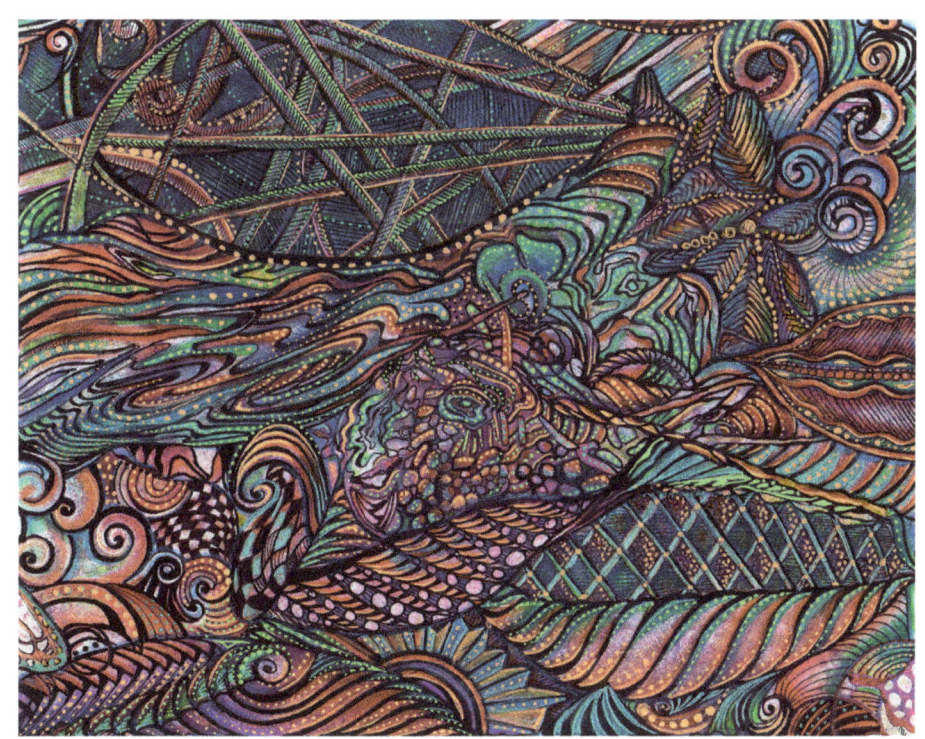

◀ *Dots and Spirals*, 2011 to 2015, print-making ink, black pen, colored pencil, fluorescent gel pen

Chapter 3: The Alchemy of Texture and Line Embellishment 77

LESSON 21

The Double, Triple, Quadruple Outline

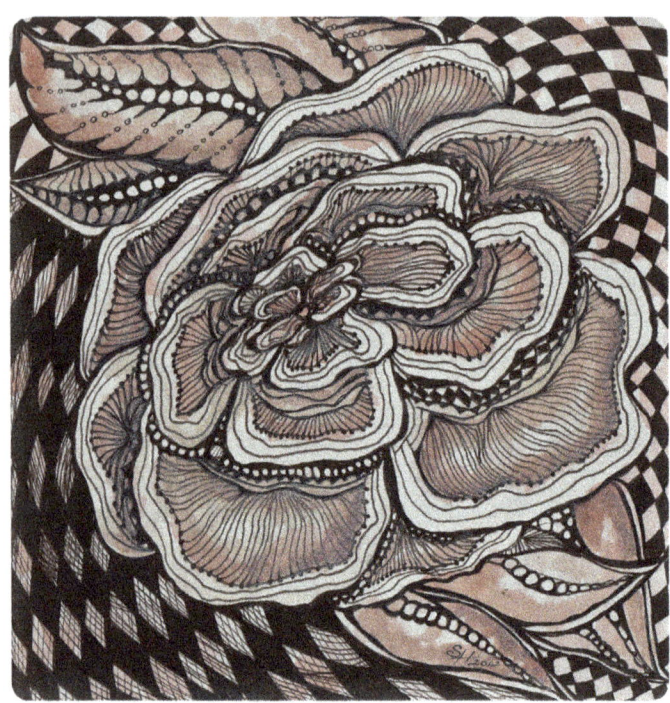

Extreme Aura, journal page, 2012, 6" x 6" (15.2 x 15.2 cm)
Each petal has four outlines enhanced with dots and C curve hatching. They create a strong contrast, deepening the cast shadow created by the tiny checks, dots, and two more lines under each petal. Watercolor shading offers counterbalance to the implied frame created by the hard-edged checkerboard background.

The outline is a functional, utilitarian enhancement that offers extraordinary potential to add importance with the simple alchemy of a double, triple, or even quadruple outline with or without blackout to the inside or outside of a stroke, shape, or form. Variation is key for a unique look and feel.

 EXERCISE 1: Explore Outlines

The simple posy is the perfect form to explore outlines. (See Lesson 25, page 90.) Study the lesson examples for interesting pen and outline combinations.

1. Explore five to ten compositions with three to five posies per design. Use tan or dark-toned tiles or work in a tan journal using a practice grid or fill a page.

2. The goal is to make each posy unique. After drawing the three to five posies, add the outline. Change up the inside and outside of each petal with weighted line, fine-line no-gap, double, triple, or quadruple outlines.

3. Finalize the journal pages and tiles by determining whether blackout, a frame, or background is needed to pull the designs together. (See Lesson 18, page 70.)

4. Return to earlier designs in your practice journal and tiles looking for shapes to enhance with the outline.

SUPPLIES
- Tan or dark-toned tiles or journal
- Black, white, and gold metallic pens (see "Pens and Paper," page 14, and "Magical Pens," page 62)
- Dark-toned paper, 8" x 10" (20.3 x 25.4 cm), 10" x 10" (25 x 25 cm), or A4 (8" x 11.7", or 20.3 x 30 cm)

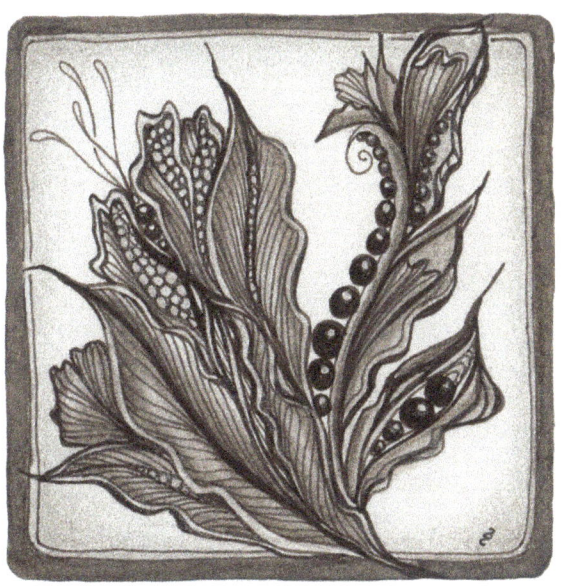

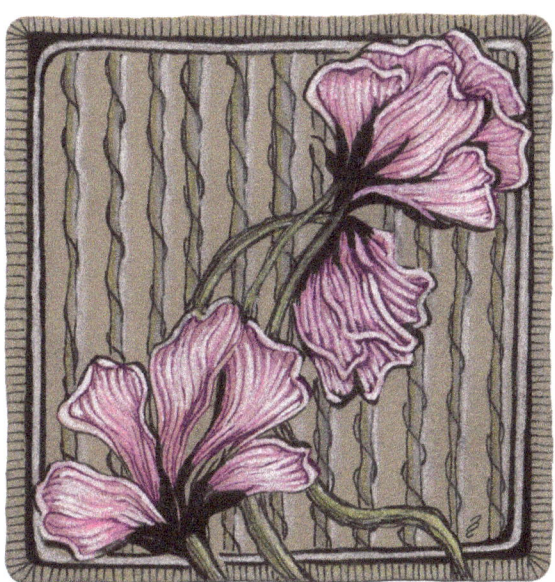

◀ When a leaf, petal, or form does not feel finished or lacks character, adding a double-line outline almost always dresses it up with sophisticated charm.

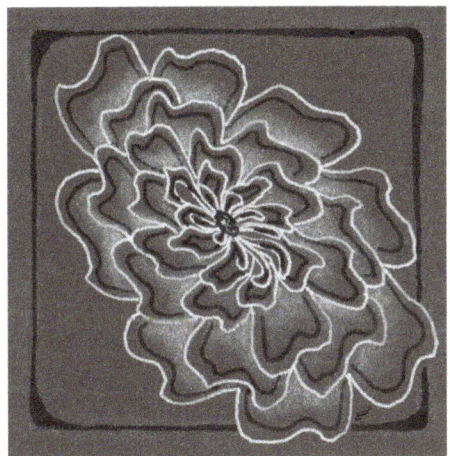

▲ Black ink and white outline with a generously wide gap are dramatic partners on dark-toned papers.

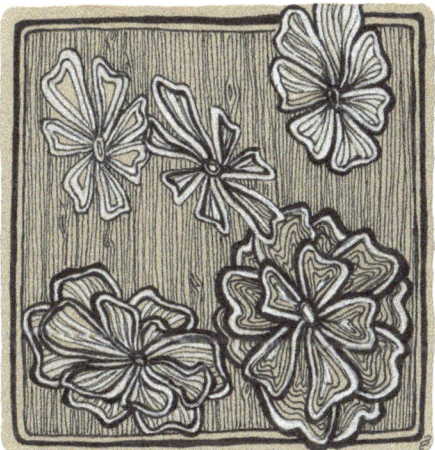

▲ To create a unique look for each posy, use black and white for the initial line drawings. Add double, triple, and quadruple outlines. Enhance with weighted line and fine-line no-gap outline or striped hatching. Adding a background helps each petal and posy pop.

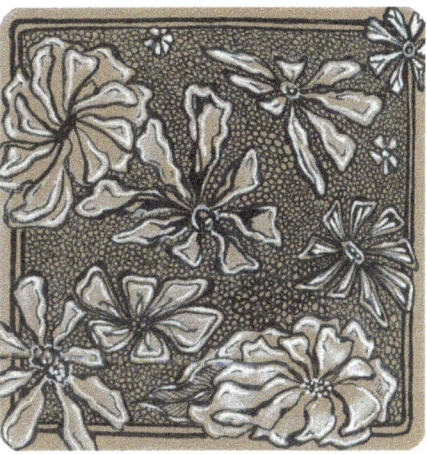

▲ Undulating posies. Another variation is using a *partial* outline. This double-line change-up creates a stronger highlight. Weight the petal edges with marks and divots for extra depth and dimension.

LESSON 21

▲ *Irises*, 2016, 8" x 10" (20.3 x 25.4 cm)

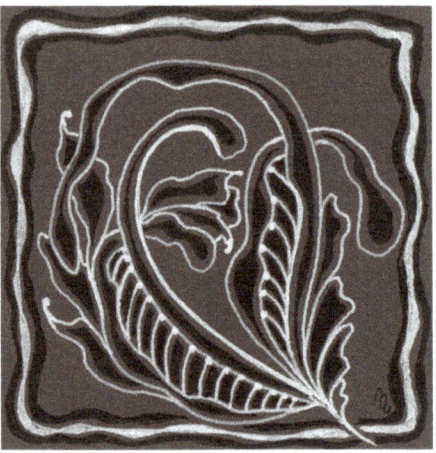

▲ The shapes created by the outline are filled with blackout for a distinct look and feel.

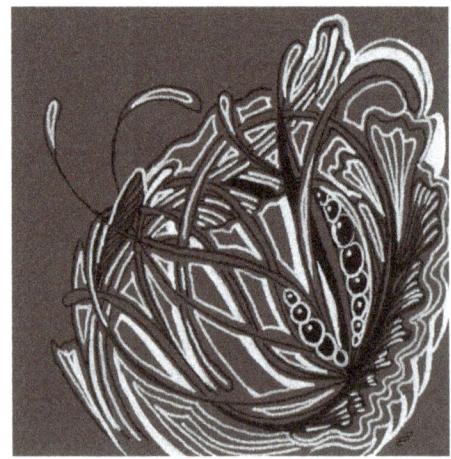

▲ For a unique look, use white outline around every form. Fill larger shapes with concentric outlines. Weighting one or two edges adds another level of importance.

 EXERCISE 2: Combine Enhancements with Double, Triple, and Quadruple Outlines

Irises (opposite, left) is an example of a larger design. Larger-sized paper is a good choice to accommodate enhancers between outlines. Use this large format as an opportunity to continue exploring your own unique style.

Gold pen is excellent on white and mid-tone paper. If using dark paper, draw the initial design with white pen; enhance with white, gold, and black outlines.

1. Create a design that uses two, three, and four outlines with varying gap widths. Make the gaps large enough to enhance with dots, stripes, hatching, blackout, whiteout, simple tangles, and more.

2. Determine whether a frame or background is needed to complete the design. (See Lesson 18, page 70.)

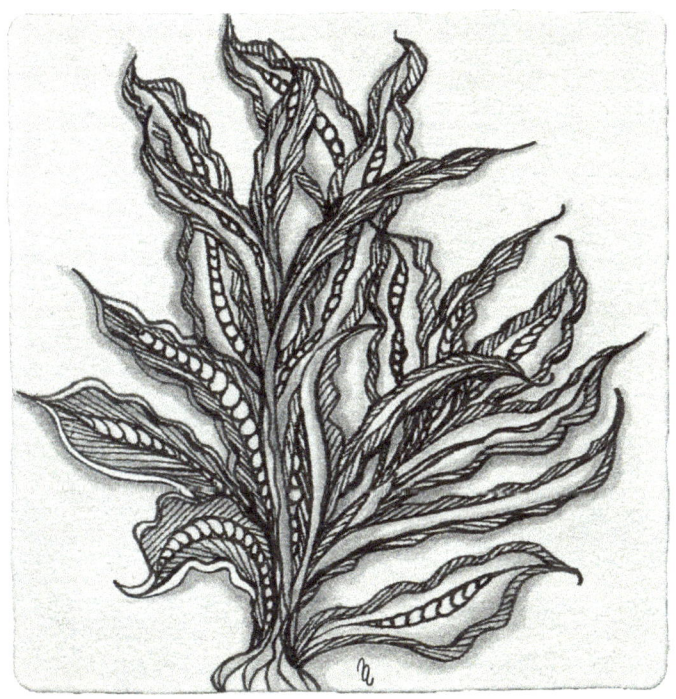

▲ Add enhancements in the gap created by the outline. The example uses line, but dots, stripes, simple tangles, and more can be used.

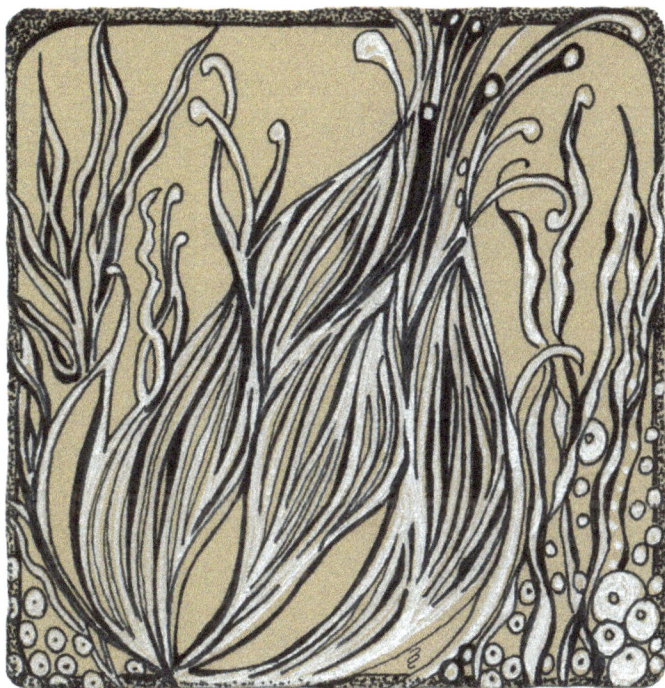

▲ A unique outline drawn with a fine, dark outline right next to thicker white strokes, leaving no gap. It is difficult to tell what was drawn first. Enhance with weighted line for a dramatic new look and feel.

Chapter 3: The Alchemy of Texture and Line Embellishment

LESSON 22

The Stripe

Striping is sometimes an overlooked enhancement. If that is the case with you, take this opportunity to introduce it into your repertoire. Striping is a chameleon depending on the crowd it is hanging with.

 EXERCISE 1: "More Is More" Reeds and Weeds

In the example on the right, thin expressive line paired with striping creates a quiet yet dynamic background framed by a striped border. The focal point is the bold, blackout-striped reed with sparkle and dimensional bump-outs. The other striped forms are secondary design elements.

Find nine or more striping variations that offer balance and contrast in the image. *Hint*: Look inside shapes and forms, including the circles, and study the frame and background.

In the image to the right, blackout striping adds bold drama that pushes itself to the forefront, saying, "Notice me." When using blackout striping as a major focal point, be sure to add black enhancers in other areas to draw the eye around the design.

On the far right, softer blue pastel striping formed by C and S curves adds an overall curvilinear feel. Note how the checked or striped frame stops the eye, compelling you to linger on the central design.

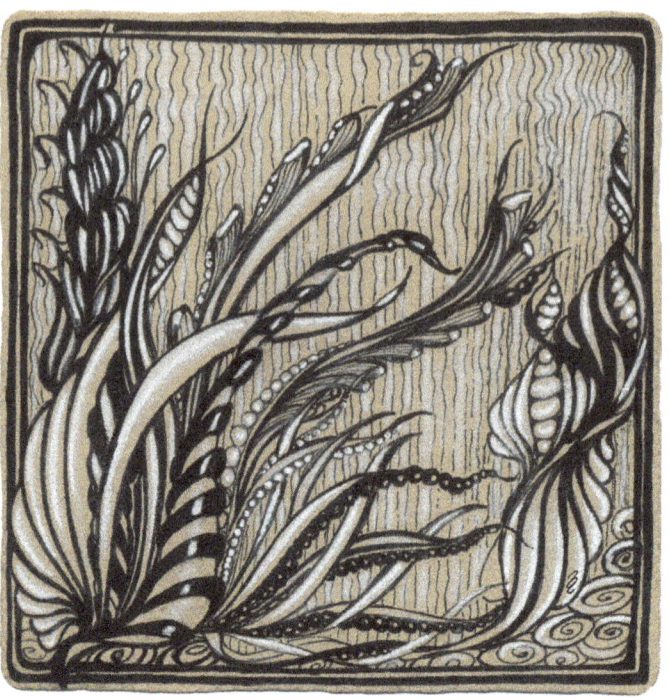

◀ Reeds & Weeds Series, 2016

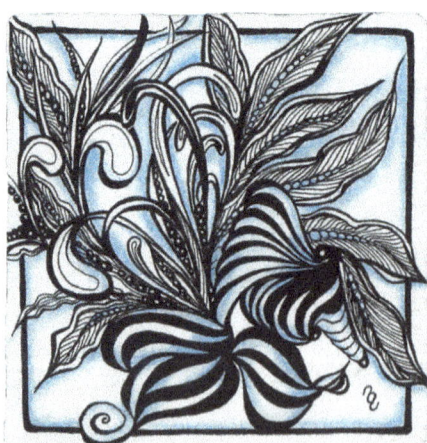

▲ Mooka Blues, Verdigogh Series, 2014

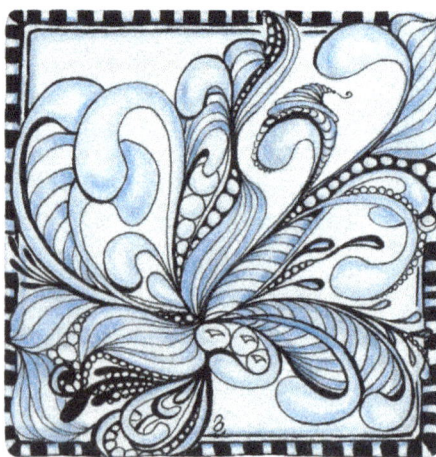

▲ Mooka Blues Series, 2014

> **Tips for Striped Highlights**
> - Add highlight placement marks before you start blackout as a reminder not to fill in.
> - For a soft-edged hightlight, use a ragged zigzag sparkle. For a shiny object reflection, use a straight edge. (See the examples on the right.)
> - For blackout, use careful overlapping strokes to keep the shape free of distracting tiny white spaces.

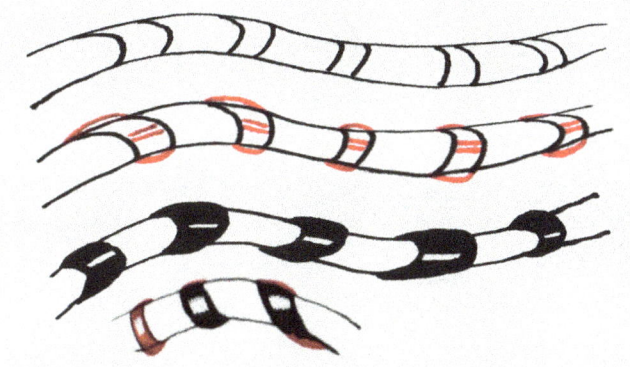

▲ Striping with sparkle. Use a raggy zigzag or straight line to create the stripe's sparkle.

 EXERCISE 2: C and S Hooks Do the Bump

Find rhythm in the stripes using simple repetition. Add a little bump at the edges of each stripe for a more believable ribbon wrap going around the cylinder.

 EXERCISE 3: Explore Striping

Explore the wide variety of ways a stripe can morph. Experiment with bold, quiet, or a combination to see their potential to enhance the look and feel. Add the bump to striped edges when it seems appropriate. Pay close attention to balance in the overall design. When needed, use blackout counterbalance to inject calm areas into the design.

1. Using Verdigogh, Mooka, or your own tangle choices, create three to five tiles, work in a journal using a practice grid, or fill a page with ten to twenty designs.

2. To finalize each tile or journal page, determine whether you need to add a frame or background. (See Lesson 18, page 70.)

▲ Air draw across the form for line placement. The shallow S curve creates a tight wrap against the line.

▲ An expressive S curve with the hook above the line gives a dimensional look. If desired, add hatching or pencil shading to imply a shadow on the back of the ribbon.

LESSON 23

Checks, Checkerboards, Grids

Checks, checkerboards, and grids have a bold but calming effect on busy work. It sounds contradictory, but it's true. The checkerboard background created by a grid pushes pattern to the front. Alternatively, adding a grid to a form or shape often turns a so-so shape into a focal point. A checkerboard is called Knightsbridge and a blank grid with enhanced corners is Florz, each named by Maria Thomas.

 EXERCISE 1: Grids Come in a Variety of Shapes and Sizes

Exploring multiple variations of any shape, form, or technique is key to finding your personal style.

1. Fill three to five journal pages with ten to twenty variations of the grid. Don't stick to straight lines: Explore circles, wavy lines, one- and two-point perspective, width variation, and more. The potential is limitless.

 EXERCISE 2: Explore Shapes Enhanced with a Grid

Fill a journal page or practice grid with a variety of exaggerated botanical shapes: hooks, leaves, and petals. Fill each form with a grid that follows the inside of the shape. If you need ideas, study the examples.

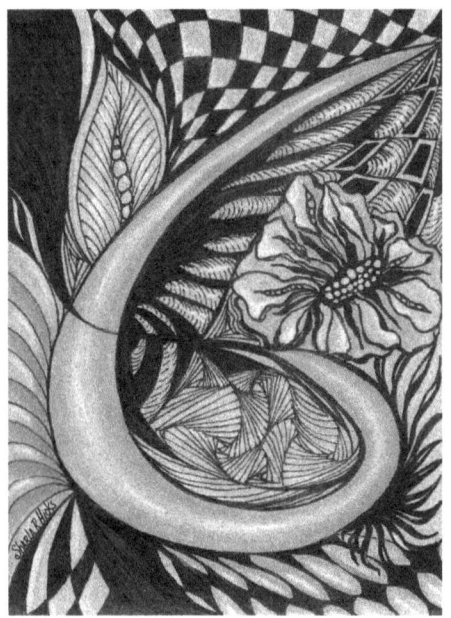

▲ Grid variation is created by drawing each section from a different direction. Add tangle patterns as checkerboard fill. Blackout is an excellent counterbalance to bold checks.

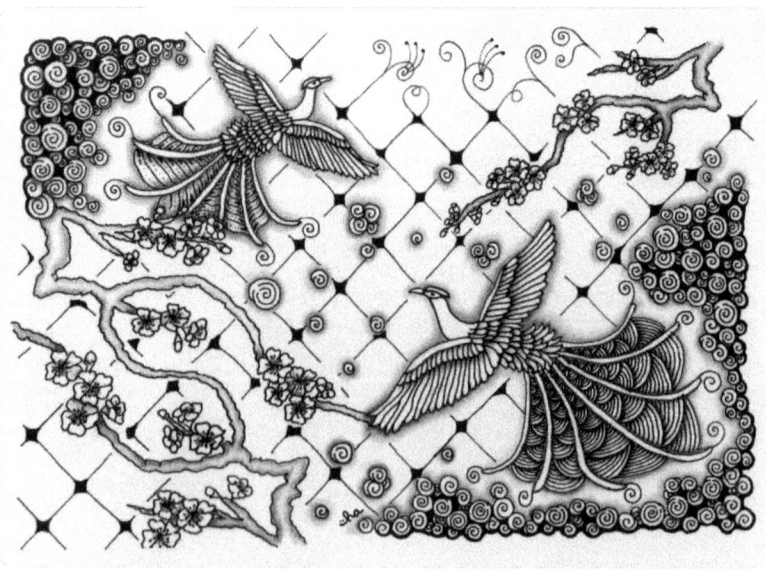

▶ *Phoenix Rising*, Holly Atwater, © 2014
Traditionally, checkerboards are seen as dark and light. An alternative choice is Florz, a blank checkerboard with accented corners for a delicate background or object fill. Note the Printemps spirals form a delicate implied frame enhanced with blackout and sparkle.

Tips for Using Bold Enhancers Effectively

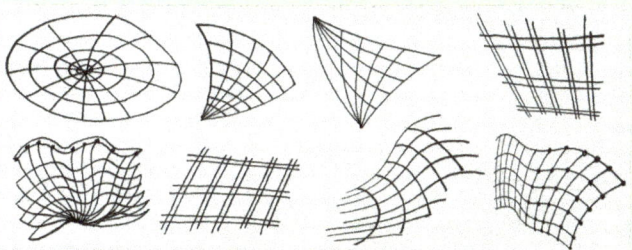

- When using a grid as a shape enhancement, make sure the grid follows the form so it is not distracting.
- A general rule for all enhancements is not to overwhelm the design's look and feel with bold enhancers. Maintain balance and contrast, with similarly weighted enhancers in three to five areas of the design. An exception would be focal point–enhanced shapes.
- When filling in checks, don't lift your pen. Fill one check, move through a corner, fill the next check, repeat.

▲ **Mooka, Verdigogh Series, 2014**
The framed grid hook is a visually calm focal point for the eye to rest before examining the complex detail of the blended Verdigogh-Mooka floral-enhanced C-curved frame.

▲ ***R is for…*, 2011, black ink, metallic and sparkle gel pen, watercolor technique for shading**
Look for grid-based tangles to add excitement to shapes and backgrounds. *R is for…* uses N'Zepple, Fife, Cubine, and improvised check fill to create a one-of-a-kind illuminated letter.

 EXERCISE 3: Creative Checks and Grids

1. Create three to five tiles using the skills learned in Exercises 1 and 2. Do not overload a design; select one or two techniques for each tile.

2. Draw Verdigogh and Mooka shapes large enough to fill with a grid. Make one shape a grid-filled focal point.

3. Add creative grid backgrounds.

4. Dress up blank grid corners with dots, diamonds, tiny florals, and more.

5. Look to tangle patterns for new ideas to fill a grid.

6. To finalize each tile, determine whether you need to use blackout as counterbalance or add a frame or background. (See Lesson 18, page 70.)

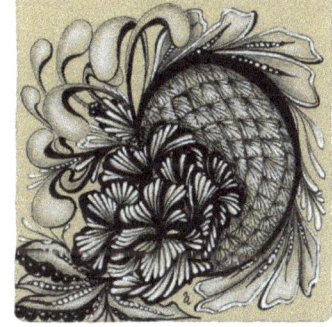
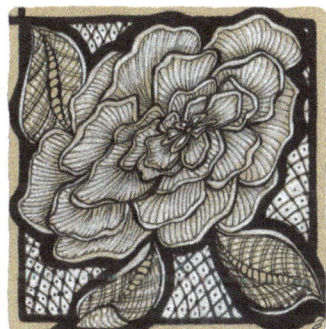

▲ Alternative checkerboard fill choices are lines, strokes, or tangle patterns. In the examples, the same design was used to fill each check, creating a calmer feeling. Also take note how the blackout double and triple outlines act as counterbalance to the pattern-filled grids.

LESSON 24

Teeny Tiny Betweens
and Intentional Intuition

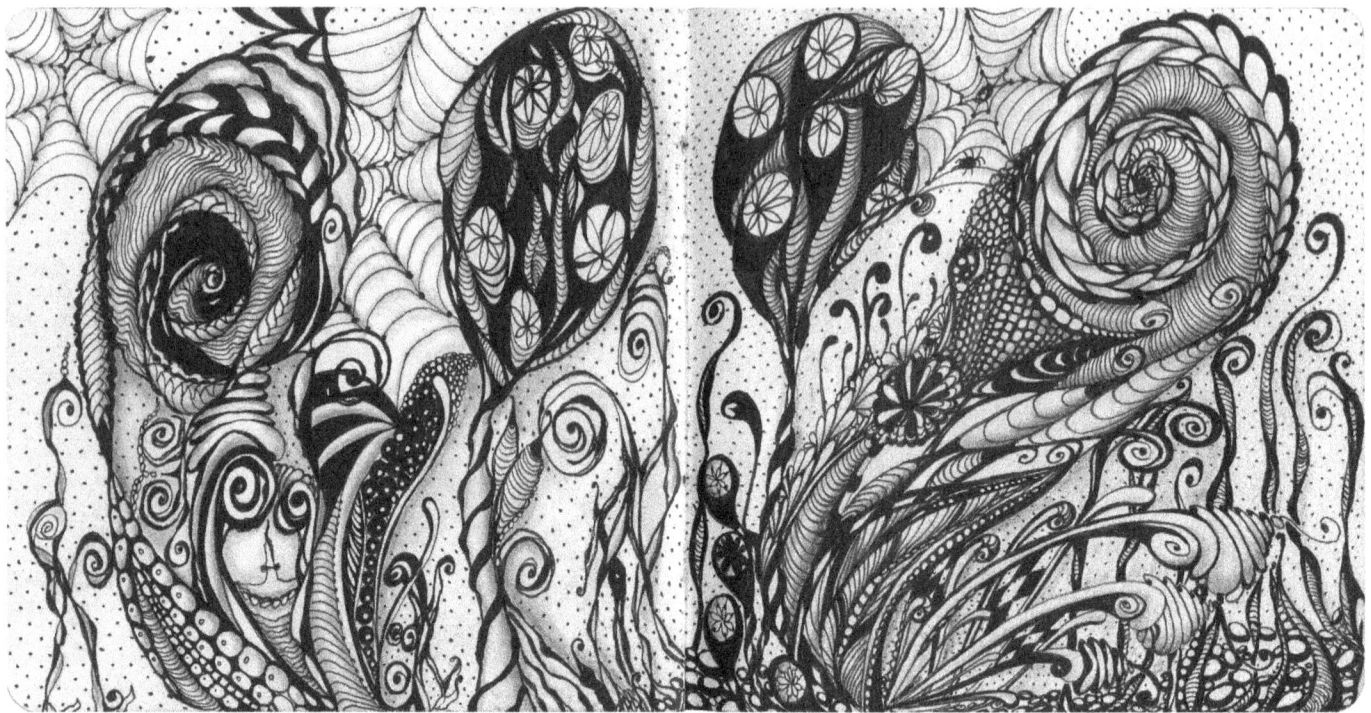

▲ *Haunted Candyland*, journal pages, 2012, 6" x 12" (15.2 x 30.5 cm)

Tucking teeny tiny shapes between two lines and in the Vs—or valleys—adds a sense of precious to the work, compelling the viewer to linger on the details. This lesson will focus on pulling together simple strokes, expressive line, and the magical alchemy of enhancers with intentional intuition to create new miniaturized elements that can add balance and contrast to a design.

INTENTIONAL INTUITION

"Intentional intuition" is a way to label the synergistic partnership of logic and intuition, relying on "what if," "how do I," and "why" questions to help find and create your unique style of expressive marks. It is important to learn how design delineation is achieved through repetition and variation in partnership with balance and contrast.

This all sounds complicated, but it is not. You have been relying on intentional intuition to arrange furniture and get dressed for years, each time looking for the right sense of balance and presentation. Creating a piece of art is the same. Trust that tangle practice paired with intuition are the stepping-stones to good design.

The rhythm of balance and contrast is achieved by creating a cluster of elements counterbalanced by similar but contrasting groups across the design. When things feel too similar, there are no areas for the eye to rest. The eye also wants to be led through the work with directional elements and alternating groups of large to miniature, light to dark, and dense to airy elements across the design. The next exercises will continue to develop your visual vocabulary skills by using "what if" and "why" questions to help with design choices when mingling tiny details with larger elements to create balance and contrast.

EXERCISE 1: Use Visual Vocabulary to Help with Design Choices

Review these examples to see how large to miniature elements contribute to balance and contrast.

1. In your journal, take notes on how variation and repetition of size and directional placement partner with balance and contrast, contributing to the overall look and feel of a design.

2. Answer the following:
- List the elements repeated multiple times.
- Are some elements more successful than others? Why?
- How does variation make the design more interesting?
- Which elements keep the eye moving through the design?
- What is your favorite element? Why?
- What is your least favorite? Why?
- Which strokes and patterns would you use? Why?
- What would you have done differently? Why?
- Look at the framing and background choices, do they contribute to or distract from the composition? Why?

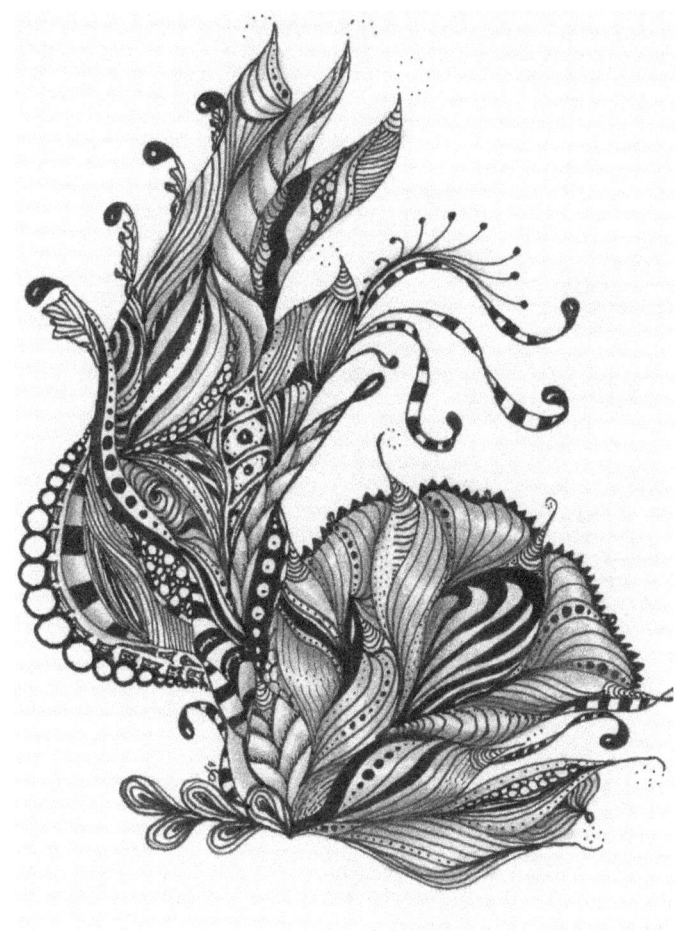

▲ Donna Hicks, © 2014, 4" x 6" (10.2 x 15.2 cm)

LESSON 24

▲ *Black Pearls*, journal pages, 2012, 6" x 12" (15.2 x 30.5 cm)

 EXERCISE 2: The Alchemy of Miniaturization

Use the magical alchemy of miniaturization to create teeny tiny betweens in your unique tangle style. Miniaturize favorite go-to tangles. Review past exercises and lessons for additional inspiration. Include C and S curves; use expressive, weighted, and dimensional line; add Fescu- and Flux-shaped teardrops and paisleys. Consider how to enhance your teeny patterns with orbs, dots, checks, stripes, and outlines. Improvise shapes to create buds, leaves, and anything else you can think of.

1. Fill a journal page with ten to twenty teeny tiny betweens in a pleasing composition using intentional intuition. Consider how placement on the page contributes to a balanced composition as the page evolves, morphs, and emerges.

2. As the design process winds down, determine whether a frame or grid form is needed to cohesively hold the practice elements together. (See Lesson 18, page 70.)

▲ Teeny tiny betweens

▲ Teeny tiny betweens

✏️ **EXERCISE 3:** Teeny Tiny Betweens Enhanced Design

1. Create three to five tiles. Use intentional intuition to build the design.

2. Start each tile with three to five large exaggerated organic forms, leaves, petals, Mooka hooks, SharlaRellas, or landscape imagery. Use overlapped and cross-under techniques to create Vs, dips, and crevices to enhance with miniaturized shapes. Use teeny tiny patterns to outline the inside or outside of large-form edges or as standalone patterns.

3. As the design process winds down, determine whether blackout, a frame, or background is needed. (See Lesson 18, page 70.)

LESSON 25

Shapes and Strokes Dance with
the Daisy-esque Posy

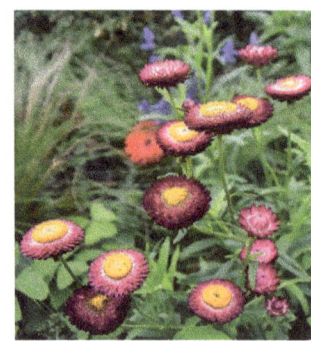

Understanding that nature seldom offers symmetrical botanicals is part of learning to draw the essence from your imagination. The mind's eye often stores a perceived version that is in direct conflict with the reality of the shapes. On close examination, petals and leaves are usually somewhat misshapen depending on the view's angle. The photos here offer insight into how variation is the key to bringing originality to the basic daisy-esque design, a standard shape found in more complex botanicals.

SHAPES AND THE SIMPLE POSY

Doodling the posy has been a pastime for most who feel a need to put our mark to paper. As with any pattern, the goal is to make each step easy. Simple shapes lay the framework for petal-esque strokes that take drawing out of the equation, allowing intuition to offer an expressive interpretation of the essence of the botanical.

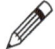 **EXERCISE: The Posy, the Petal, and Variation**

1. Use a practice grid or fill a page with variations on a posy. Create a minimum of ten to twenty variations per concept. Use the Counting Exercise on page 22 to tap into mindful focus and intentional intuition and "what if" questions to prompt exploration.

2. Make each petal tip different using expressive line (see Lesson 11, page 46) and undulating zigzags. (See Lesson 13, page 52.)

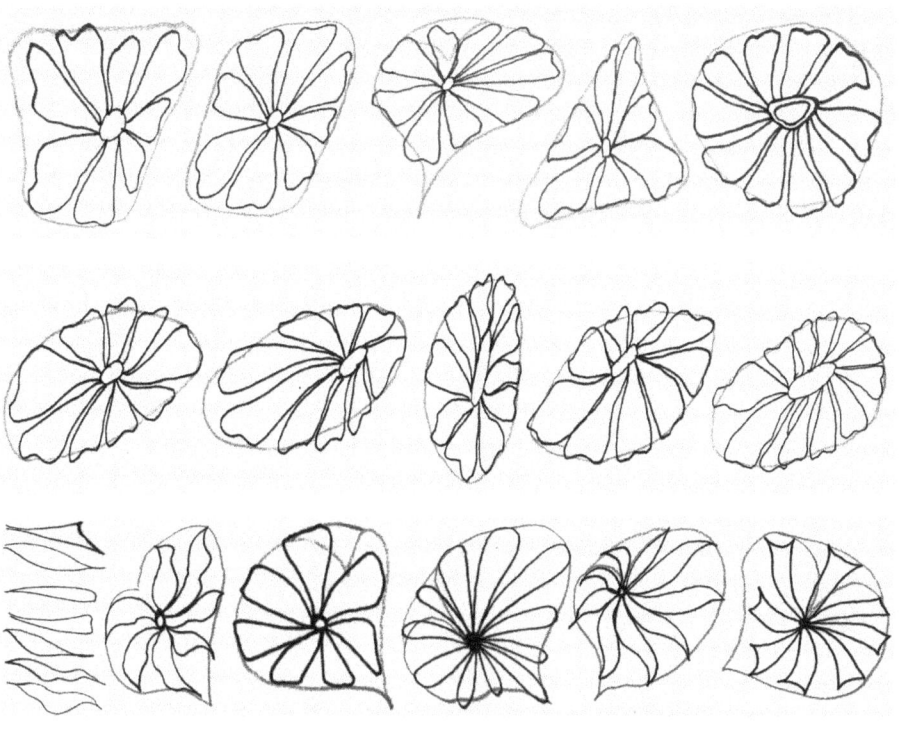

◁ The base form: The simple change of the geometric shape makes each posy unique. Skew the following shapes for more variation: squares, hearts, triangles, circles, and any other wonky shapes you can think of. Draw your go-to petal in each shape.

◁ Ring around the posy: Study the photos to see how a change in the center's position adds a sense of perspective. Using circle-esque shapes, change the position and size of the center to see how that affects the look and feel.

◁ The heart shape: The heart is very versatile and lends itself to exaggeration; push its limits for more interesting shapes, and then ignore the dip and treat it as a paisley-esque shape. If needed, add another line to round out the dip in the heart.

THE POSY SERIES

Explore the "more is more" factor with enhancements and tangles. Undulating and double line brings expressive character to petals, stems, and calyx receptacles, and offers a touch of stylized realism. Line only or shading are both excellent choices.

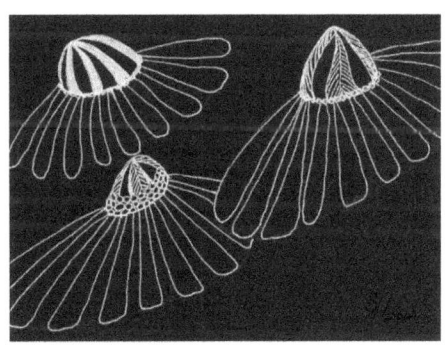

▲ The Posy Series, 2012

▲ The Posy Series, 2013

LESSON 26

The Petals Dance with
Enhancers, Variation, and Exaggeration

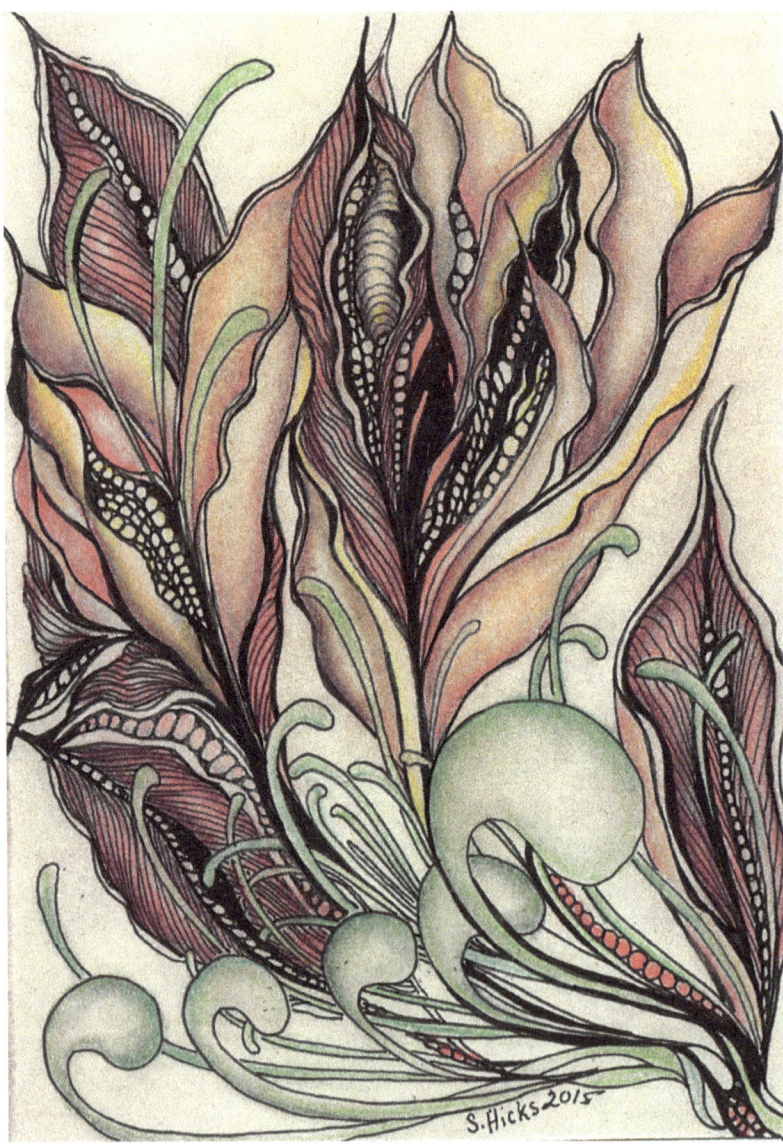

Petal exaggeration and markings have the greatest potential to create expressive botanicals. Returning to the basics of chapter 1 and exploring multiple variations of a single idea break down intuition's tendency to return to comfort tangles and invites logic to the dance. This synergistic partnership is greater than the whole—new ideas will start to flow.

PETAL EXAGGERATION

Petal exaggeration is common in nature. Isolate the lower tulip in the photo below and it no longer resembles the image that the word *tulip* evokes in the mind's eye. The same goes for the hibiscus photo on page 96.

✏️ EXERCISE: Explore Variation and the Petal

Use a practice grid or fill the page with the following variations on the petal. Create a minimum of ten to twenty variations per concept. Use the Counting Exercise on page 22 to tap into mindful focus and intentional intuition, and use "what if" questions to prompt exploration.

◂ Use nature to help you find repetitive shapes. Capture the essence, avoid trying to draw, and rely on stroke repetition.

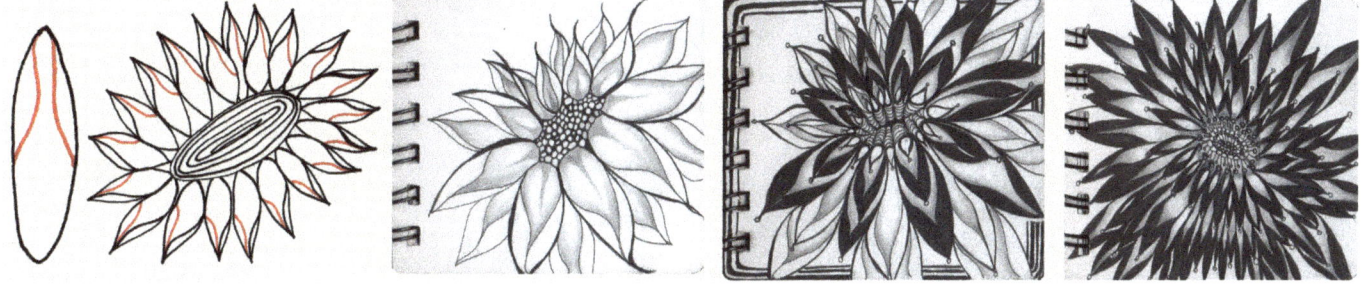

▲ Explore a single petal. See how many interesting variations can be created from a single repeating shape.

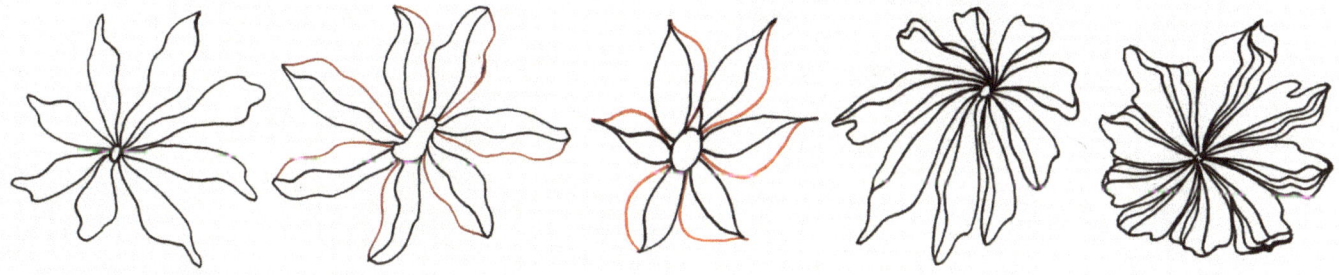

▲ Exaggerate by adding extra lines. Watch for opportunities that imply dimension with lines that create a curl or fold in the petal.

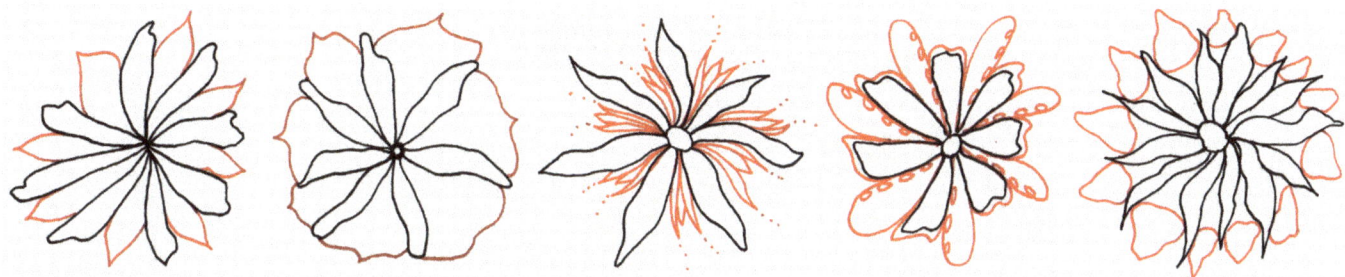

▲ Add extra shapes, lines, and marks between two petals.

LESSON 26

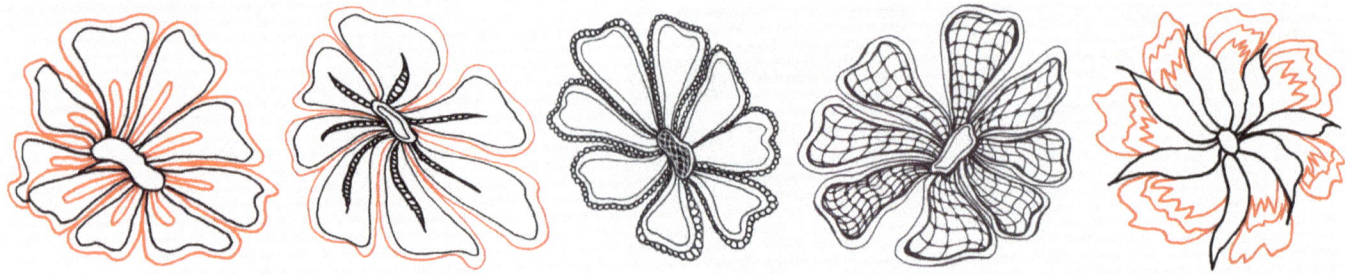

▲ The open space in and around the petal offers the opportunity for the "more is more" tangle-esque factor. Start with simple and complex designs, as they will naturally evolve and morph. Use expressive marks, double line, striping, perfs, pearls, checks, dots, and more.

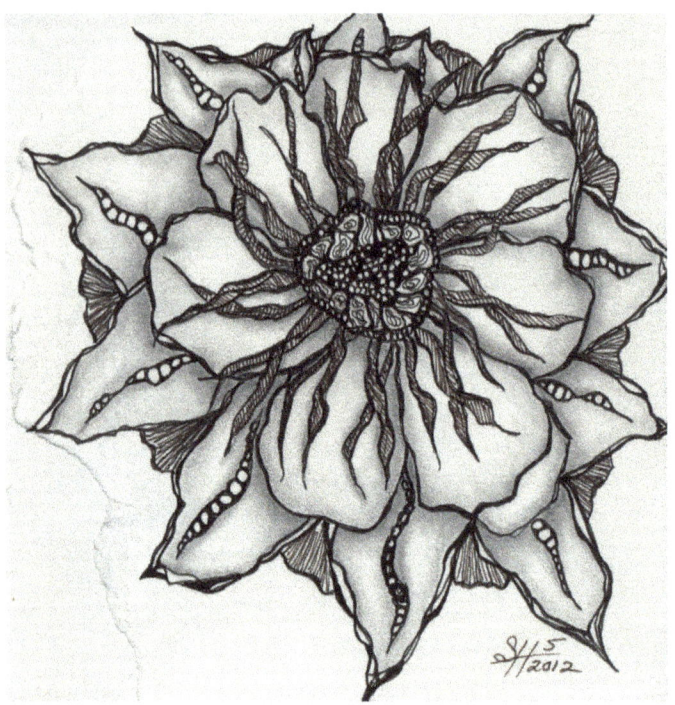

▲ Journal page, 2012, 6" x 6" (15.2 x 15.2 cm)

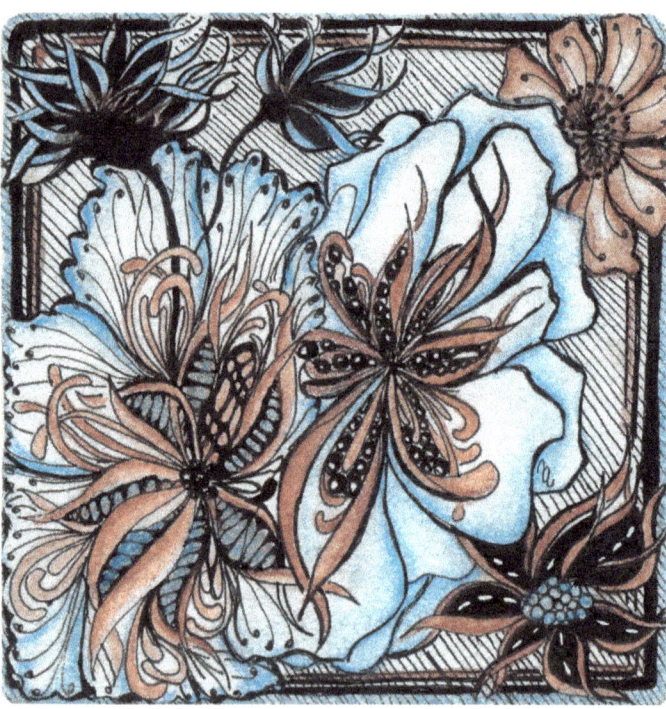

▲ Tile, 2014, 3½" x 3½" (9 x 9 cm)

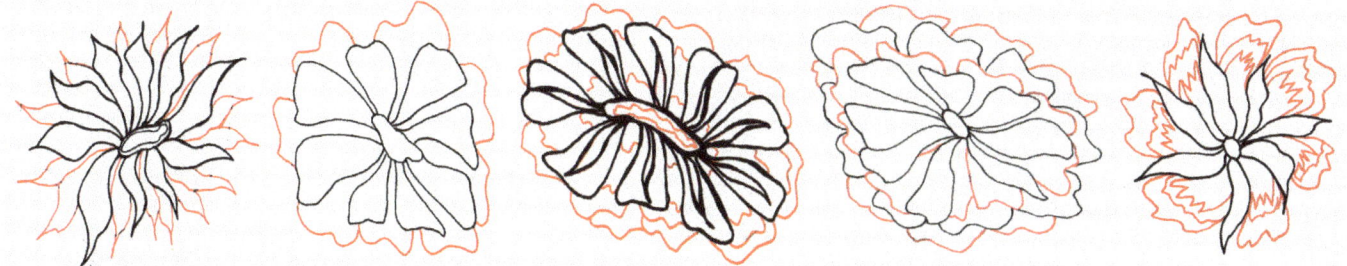

▲ Varying the petal size and adding layers changes the character from a simple daisy-esque posy into a complex botanical.

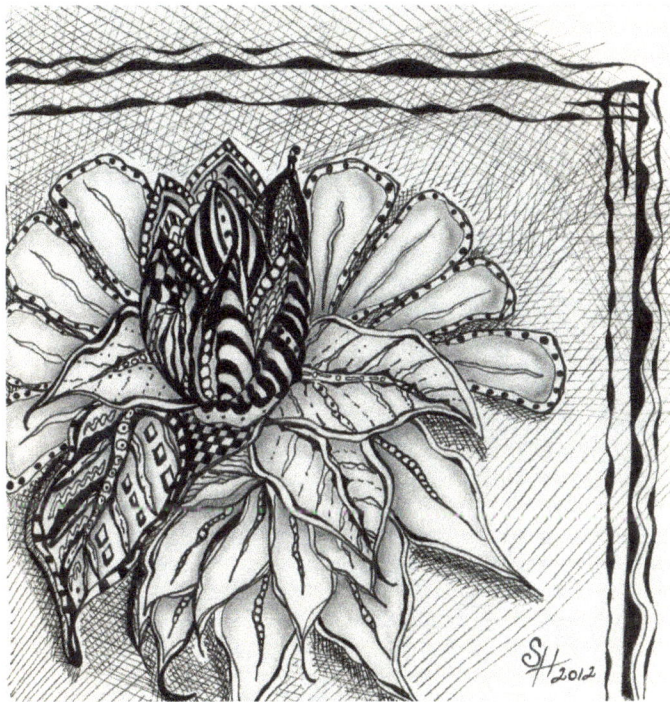

▲ Journal page, 2012, 8" x 8" (20.3 x 20.3 cm)

▲ Tan tile, 2014, 3½" x 3½" (9 x 9 cm)

◀ To make the calyx receptical, use stylized realism and expressive marks or exaggerated tangle-esque strokes. The calyx's nest of petals presents a perfect opportunity for the tangle-esque "more is more" factor.

Chapter 3: The Alchemy of Texture and Line Embellishment

CHAPTER 4

Adding Expression Through Shade, Shadow, and Highlights

Make Your Mark!

"Bright Light
 Dappled Light
 Casting Shadows"

—Sharla R. Hicks, 2016

◀ Hibiscus

Introduction: Shade and Shadow in Nature

▲ Les Bassacs, France. Subtle, even light on an overcast day or light shade produces blended edges with gradation shadows. It is the inspiration for most tangle shading.

▲ Les Bassacs, France. The strong light of a sunny day or flash photography creates crisp, dark crevices and hard-edged cast shadows.

In patterning, as in nature, shading is unsurpassed in its ability to delineate shapes, patterns, and forms. It is the ultimate tangle enhancement and usually added last. Shading's finesse offers the opportunity to express context, content, and emotion.

The key to understanding the shadow nuances is close observation. Bring the synergistic power of visual vocabulary and memories together by carefully labeling the light conditions and their effect on soft gradation, strong cast shadow, and dappled light.

The illusion of shade and shadow is achieved with expressive line and pencil shading. Record in your journal and discuss with friends the variables nature brings to shade and shadow.
- What are the edges and type of shadow produced with bluish light of the morning, midday's true color, warm afternoon light, toned dusk, shadowed evening, or dark night? Are they longer, shorter, softer, darker, crisper, gradient?

- What are the shadow differences under direct sunlight, dappled light, or moonlight?
- Is the day partly cloudy, overcast, or sunny?
- What are the differences when the shape's edge is angled, rounded, flat, or cylinder?
- Look closely at foliage, grass, trees, branches, flowers, weeds, and reeds. Describe the differences when comparing size, density, overlaps, and texture.
- Seasons produce a change in light, shade, and shadow that affect mood and emotion. How would you portray the look and feel of spring, summer, fall, and winter?

▲ Luberon Valley, Provence, France. Dappled light dances through branches and leaves with strong light and soft gradient shade to dark cast shadow. Now imagine how a gentle breeze is an ever-changing layer of shade and shadows.

LESSON 27

Shading Tools and Tips

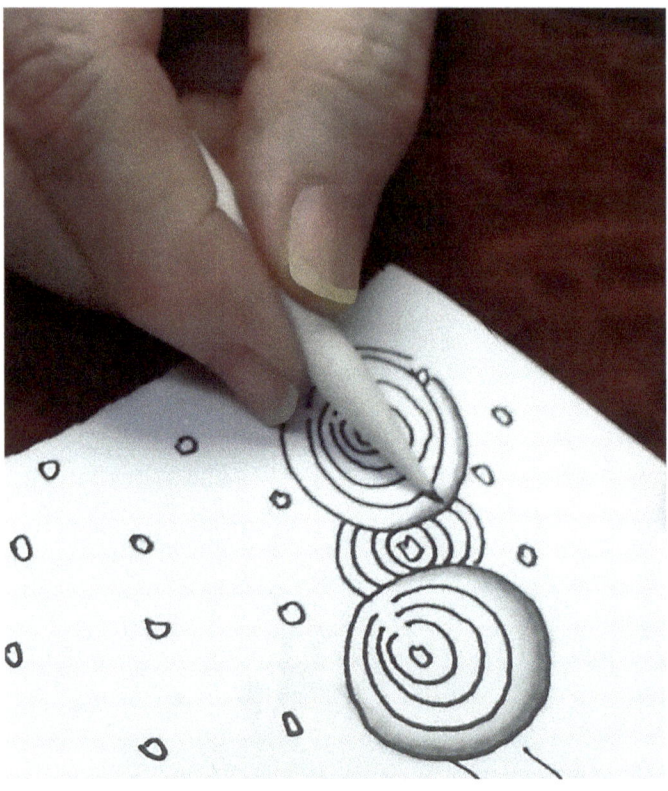

▲ Do not hold the blending tool like a pencil, as this quickly wears out the fragile paper tip. Hold the tool almost parallel to the work surface and, using small circles, blend with the side of the tip. Rotate frequently to extend the life of the tip point.

Shading has a simple formula: select your tools and add layers. The layer-by-layer approach builds confidence quickly. Once the shading fundamentals are mastered, the same techniques are used with colored backgrounds, and pastel and colored pencils.

BLENDING, SMUDGING, AND LIFTING TOOLS

The tortillion is a tube of tightly wrapped paper that forms a tip for shading. If the tip gets smushed, unbend a paper clip, insert it into the tube, and push out the tip.

The stump is a compressed paper cylinder similar to a pencil. To sharpen and remove overly saturated graphite, slide fine sandpaper from the barrel toward the tip. Do *not* use a pencil sharpener.

Both tools come in a variety of sizes. Smaller tips fit into tight corners; larger tips hold more graphite to quickly cover large areas. Try out a variety of sizes to learn the differences.

Use a rag or art chamois to wipe off graphite buildup on the tools. An art chamois can also be used to smudge.

An eraser can also be used as a shading tool; it is perfect to lift and smooth excess graphite.

CHOOSING THE RIGHT PENCIL FOR THE JOB

Each pencil, charcoal, and pastel pencil has its own requirements for a smooth gradation. Paper surface also impacts the look and feel of shading (see more on page 14). Hand pressure is key to a smooth gradation from light to dark. Start with a *very light hand* in a circular motion to lay down a thin layer of graphite. Build a gradation layer by layer.

Use H pencils to make outlines and light layers; these pencils create smooth mid-tone to light marks that makes smudging optional.

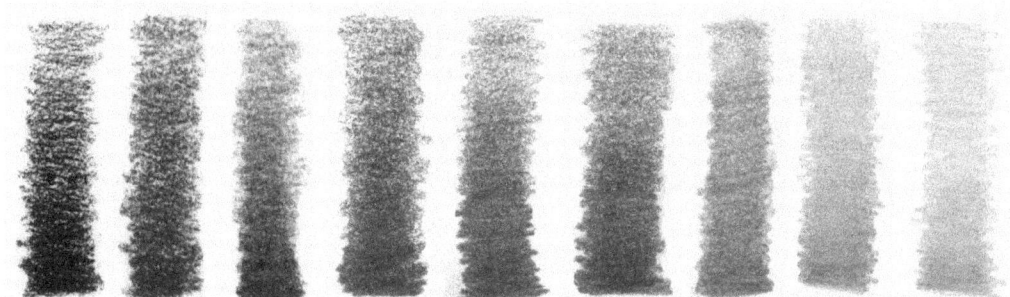

From left to right: two pastels, charcoal, 6B, 4B, 2B, HB, 2H, 4H. The common pencil is a 2H.

Charcoal and B pencils make dark marks and create a textured line. Careful light layering is needed to build a foundation for smooth gradations and cast shadows. Dark layers are difficult to blend.

Pastel pencils have a wide range of colors to experiment with shading and adding color to a design.

✏️ EXERCISE: Create a Pencil Reference Page without Blending

To gain practical experience, try several pencils, charcoals, and pastels on different paper surfaces.

1. Create two gradation charts in your journal. You can refer to these shading exercises in the future.

2. Vary your hand pressure to make light to dark gradations. Note the differences between a layer of soft B and hard H pencil. Repeat until you have control over the gradation.

3. Blend one chart. Leave the other unblended.

4. In your journal, answer the following: Did the paper surface have divots that affected the pencil layer? What differences did you observe between the B and H pencils? Do they have potential to add nuanced shading? How? Do you prefer the look or feel of one over the other? Why or why not?

▶ Expressive botanical, black pen, white and graphite shading, 5½" x 8½" (14 x 21.6 cm)

LESSON 28

The Pencil Partners with
Expressive Line, the Outline, and Blue Pastel

▲ **Verdigogh Series, 2016**
Black pearls and pencil outline only, with no smudging, add a crisp yet soft dimensional weighted line to each leaf, creating subtle contrast in a dense design.

Pencil outline is a subtle enhancer that visually softens the harder edge of a pen line. Use the pencil as an alternative method to add expressive line and marks. (See Lesson 11, page 46.) The outline is also a simple way to create cast shadow or clean up less than perfect tangle lines. Blue pastel adds a touch of color.

 EXERCISE 1: Pen Line Partners with HB or 2H

1. Closely examine each design pair in the sample grid (opposite) to see the differences between expressive line only and combining the pen line with pencil-traced outline with optional light blending.

2. In your journal, use a pen to fill a page or practice grid with pairs of similar shapes large enough to add enhancers, as shown in the example.

3. With pen, add weighted line, hatching, and expressive marks to imply shading.

4. Experiment with using HB and 2H pencils to see the difference between the two marks. Select one shape in the pair to trace over with pencil line and marks. Try both pencils to see the differences.

5. With a shading tool, blend the pencil outline by lightly retracing the pencil line. (Optional)

6. In your journal, document the differences between pen only, traced over marks, and optional blending. Note how you might use pencil line enhancements to add your own unique style to your designs.

SUPPLIES
- Journal
- White tiles
- Black pen
- 2H and HB pencils
- Blue pastel pencil
- Small and medium-size shading tools

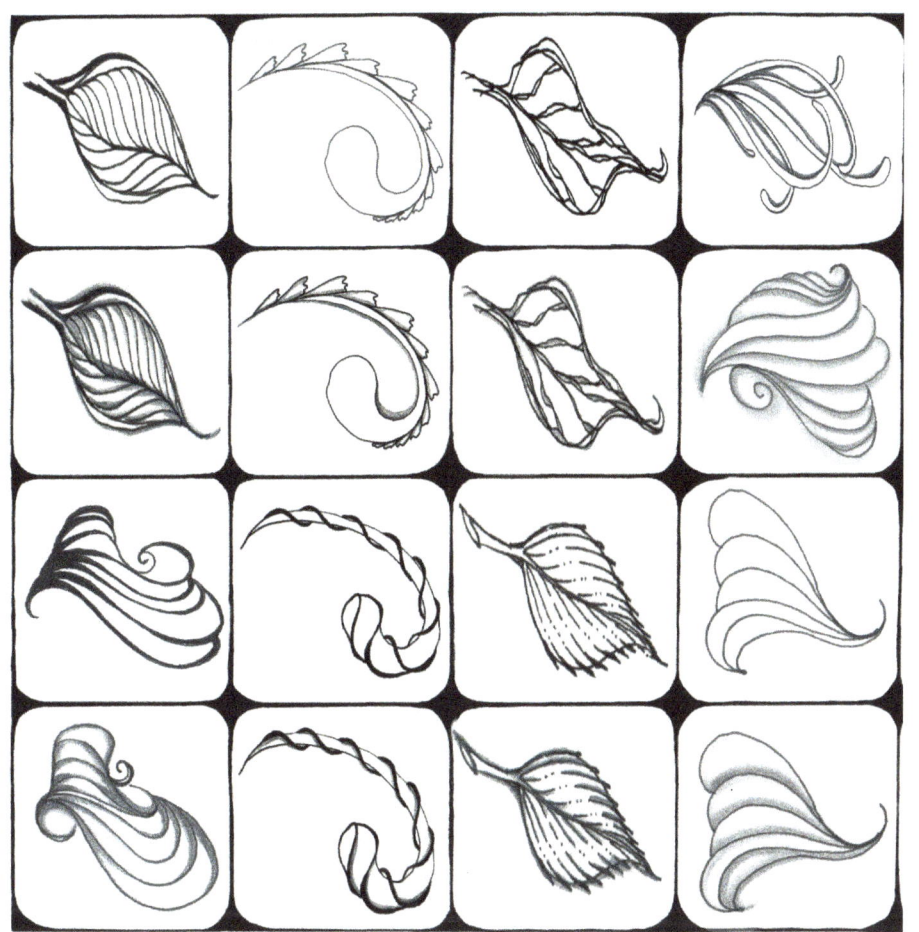

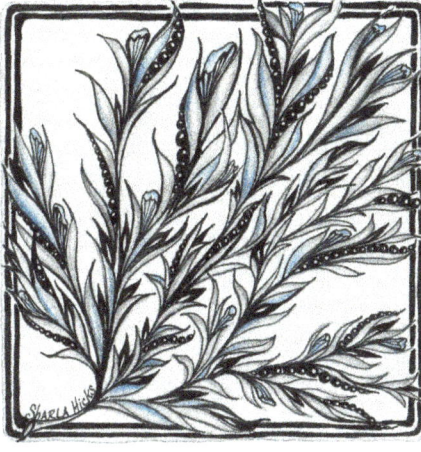

▲ **Verdigogh Series, 2016**
Pencil outline slightly blended at the bottom V adds definition to each leaf. Black pearls and blue pastel hopscotch across the design for contrast and balance.

 EXERCISE 2: Enhance with Pencil Outline and a Touch of Blue

1. Create three different tiles that use Mooka and Verdigogh designs.
- **Tile one:** Enhance with expressive pen marks.
- **Tile two:** Enhance with pencil outline only. Slight blend optional.
- **Tile three:** Add blue pastel accents for contrast. Blend optional.

2. In your journal, summarize the differences and analyze how you can use each style to continue developing your own unique style.

Tips for Using Color Enhancers

Color is a complex variable, and limiting yourself to blue is a good start to understanding how color interacts with the paper and overall design. Blue pairs well with white backgrounds, black pen, and graphite. Not every shape needs blue accents—and too much will take away the contrast—so add a few touches on edges and in deep Vs. The shading skills of adding color are exactly the same as pencil shading. Chalk pastel pencils are the easiest to blend.

Chapter 4: Adding Expression Through Shade, Shadow, and Highlights

LESSON 29

The Circle and the Leaf Meet
Pillow Shading and Cast Shadow

Pillow shading is a simple technique that rounds an object with an overhead light source, producing an even shadow around the edges. This is similar but not always true to the landscape scenario depending on the time of day and the sky conditions: bright sun, partly cloudy, overcast, morning, dusk, etc. When dappled light is factored in, predicting exact shadow placement is problematic at best and pillow shading is a good compromise. When you become more accomplished at shading, you'll want to factor in the direction of the light source.

HAND PRESSURE AND LIGHT LAYERS ARE KEY TO SMOOTH GRADATIONS

To blend graphite, use a blending tool and a circular motion to fill in the divots created by paper texture. Careful blending allows for smooth transitions from light to dark gradation layers.

A heavy-handed line of pencil is difficult to blend because it is ground into the paper fibers, and the effort required to erase, blend, and move the graphite can damage the paper surface. To spot remove graphite from a shaded layer, use a kneaded eraser twisted into a small point or shape. To lighten a large area of shading, use a *clean* flat edge of an eraser and lightly pull it across the surface. These techniques usually require re-smoothing the gradation. Take care not to overwhelm the ability to do a smooth dark to light gradation with a heavy layer of graphite. See "Pens and Paper" on page 14 to understand how paper surface affects blending and shading layers.

 EXERCISE 1: Pillow Shading a Circle with Pencil

The focus of this exercise is learning the skills to create an even, soft gradation of pillow shading and soft-edged cast shadows using the darker B pencils. HB and 2B are the lightest darks; 8B is the darkest dark. (See Lesson 27, page 100.)

Draw the circle with a pen. Start with a minimum size of a 1½" to 2" (3.8 to 5 cm). If you are new to shading, anything smaller is difficult.

Layer 1: Select a 2B, 4B, or 6B pencil. Using a circular motion and a *light touch*, lay down a *very thin* layer of pencil. Start at the line—circle out ⅛" to ¼" (3 to 6 mm)—and then back to the line. Take care not to miss a spot next to the line, as white spots against the dark pen line are difficult to blend out.

◀ Layer 1

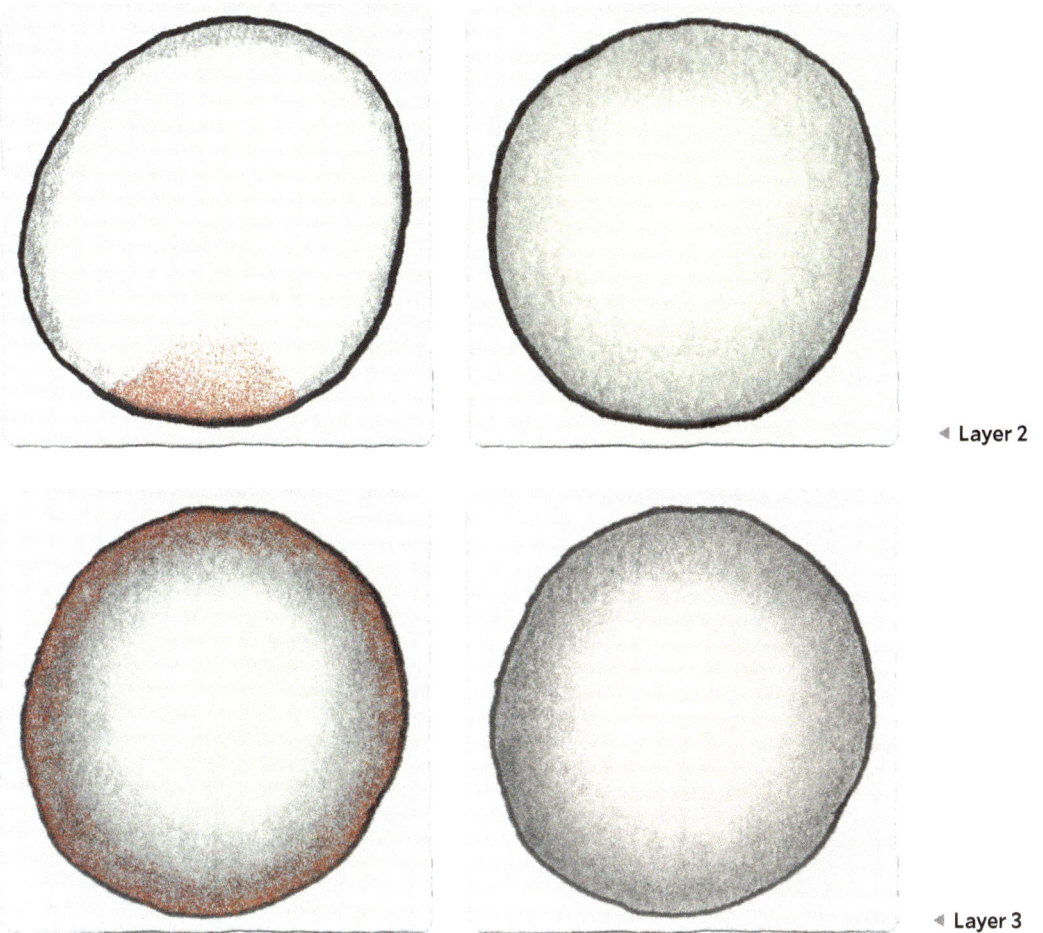

◁ Layer 2

◁ Layer 3

Layer 2: Work a small section at a time. Use the blending tool and very light hand pressure with overlapping circular motions. Pick up graphite starting at the pen line—move toward the center—and fade to nothing for the highlight. Move back and forth between the dark to light gradation until the gradation is smooth. Keep the center clear. If you went too far into the white of the paper, lift out the excess graphite and re-blend. Practice will refine your technique. If white divots are still visible after blending, the paper may be too rough. Try a less textured paper surface.

Layer 3: For a rounder look, deepen the outside edge into the mid-tone range of the blend, but do not move into the lightest layer of graphite. With the pencil and using the same light, circular motions, start at the pen line and fade into and *stop* at the mid-tone layer of the gradation approximately ¼" to ⅓" (6 to 8 mm.) If needed, blend from the mid-tone back to the dark. Varying your hand pressure with the pencil can result in a good blend but does require time and practice to feel the nuances in pressure needed for an even gradation.

LESSON 29

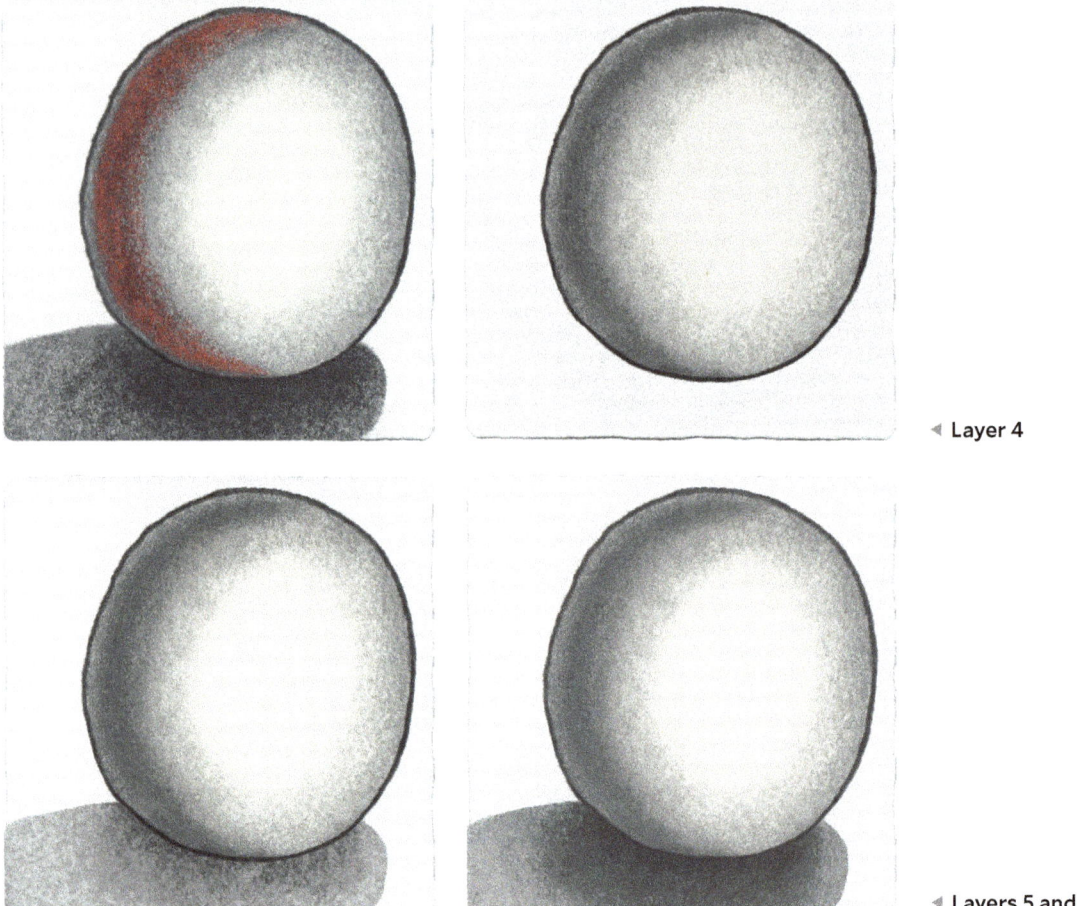

◂ Layer 4

◂ Layers 5 and 6

Layer 4: Reflected light is the slightly lighter edge on the dark side of the circle. Using the pencil, add a crescent moon gradation that starts *slightly in* from the line; note the red in the example. Gradate into the mid-tone layer and back into the dark, stopping slightly in from the dark. If needed, use the blending tool to finesse a smooth gradation.

Layer 5: There are no right or wrong cast shadow shapes: It is about the illusion and an opportunity to personalize your art. Careful observation in nature will reveal how each one differs and often is a distorted version of the original shape. Cast shadows are not drawn in pen; they are a soft gradation with no outline. Using the same circular motions and blending techniques, make the shadow slightly darker close to the ball and lighten as you go out.

Layer 6: This layer is the deepest dark. Add a darker gradation under the circle that blends into the lighter areas of the cast shadow. Vary your hand pressure with the pencil, and if it looks too rough, smooth it out.

✏️ EXERCISE 2: Botanical Forms and Pillow Shading

Observation and study of nature offers inspiration for leaf variation that can enhance designs. Using black ink, create a practice grid or fill a page with a variety of leaf shapes. Use the blending techniques from the previous exercise.

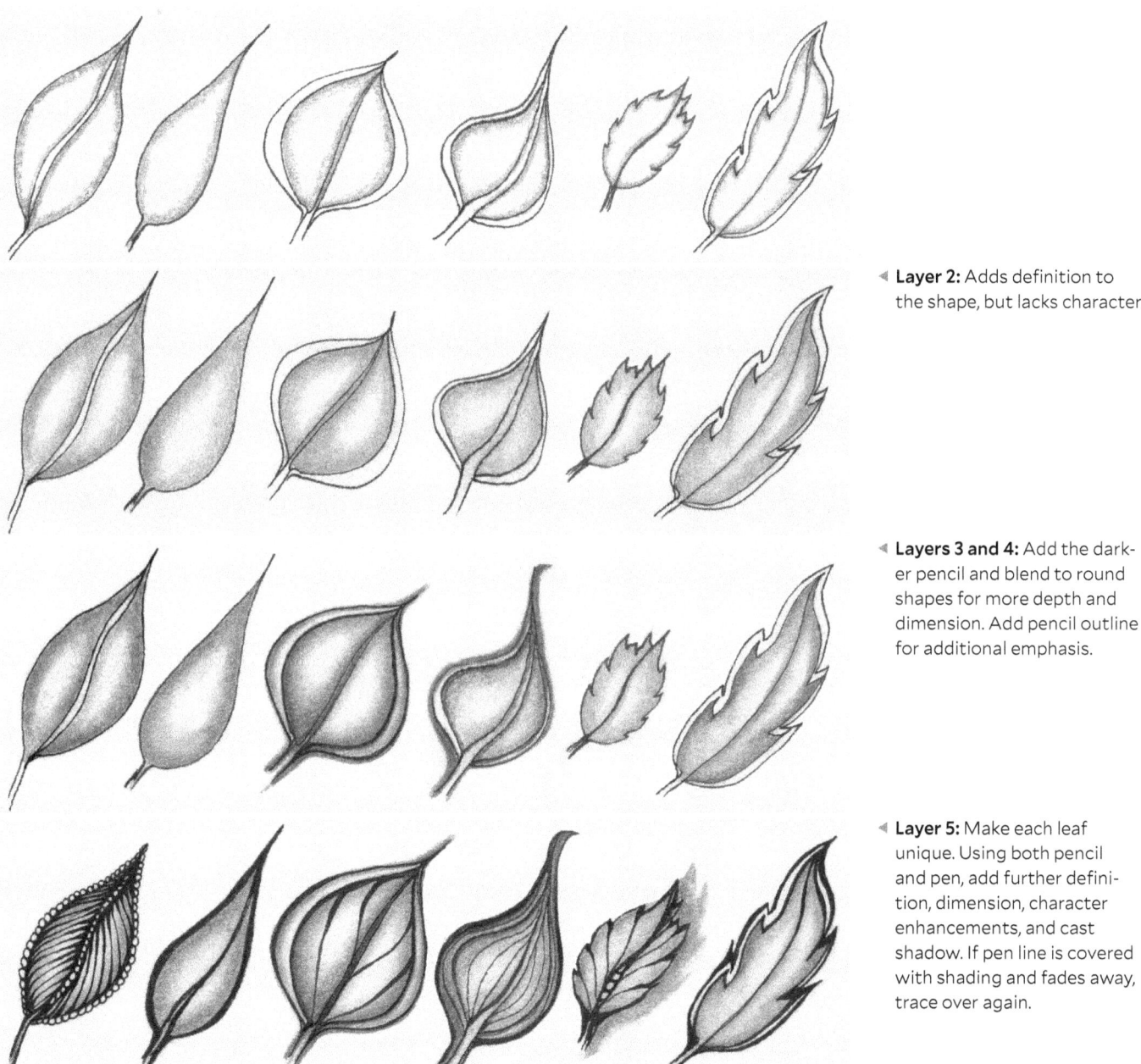

◀ **Layer 2:** Adds definition to the shape, but lacks character.

◀ **Layers 3 and 4:** Add the darker pencil and blend to round shapes for more depth and dimension. Add pencil outline for additional emphasis.

◀ **Layer 5:** Make each leaf unique. Using both pencil and pen, add further definition, dimension, character enhancements, and cast shadow. If pen line is covered with shading and fades away, trace over again.

Chapter 4: Adding Expression Through Shade, Shadow, and Highlights

LESSON 30

Shading Dances with Undulating Line
and Overlapping Shapes

SUPPLIES
- Previously drawn lettuce tile
- HB, 2H, and 4H pencils
- Blending tool
- Kneaded eraser

Botanical compositions are complex overlapping forms that take on a new look and feel when shading is added. This lesson is an opportunity to practice undulating edges, overlapping shapes, and adding shade and shadow to the undulating line.

 EXERCISE: Add Shading to the Lettuce Tile

Revisit Lesson 10 (page 44) and the lettuce tile exercise. Look closely at the photo for shade and shadow nuances. The overall image has a few deep, dark crevices and the lettuce has a limited range of light to mid-tone greens. The hard, light H pencils are the perfect tool, as they lay down an even layer of pencil that usually does not require blending. The light source is overhead, so the approach will be similar to pillow shading.

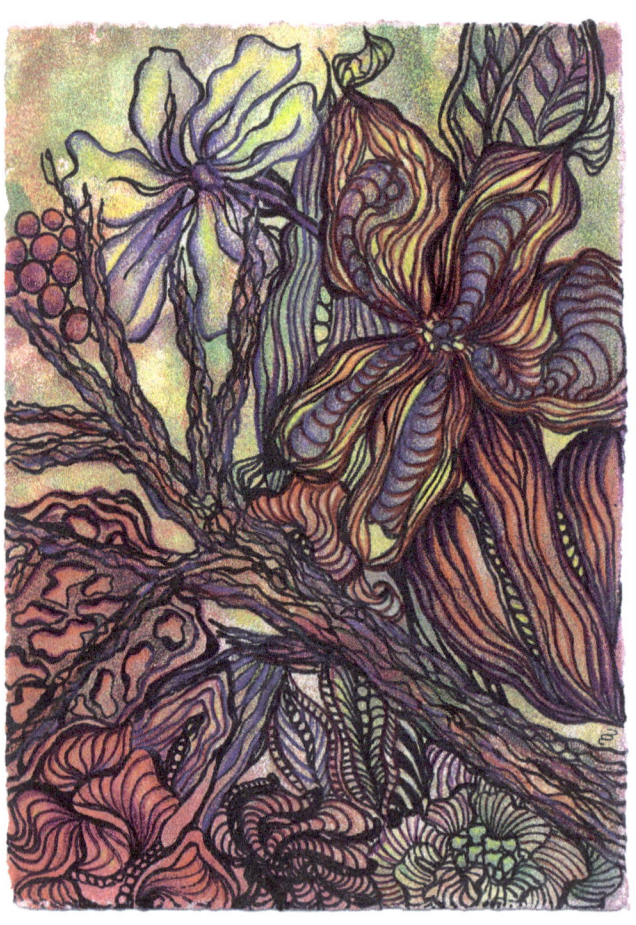

◂ **Study in Red and Green Series, 2014, 5" x 7" (12.7 x 17.8 cm)**
Colored pencil shading uses the same techniques for undulating shading and pencil outline. (See Lesson 29, page 104.)

Tangle-Inspired Botanicals

Layer 1, pen: If needed, add tapered wedges to the divots of the undulating line, as indicated with the red arrows. For variation, skip a few and vary the thickness for each one. (See Lessons 11 and 12, pages 46 and 48.)

Layer 2, 4H pencil: Tuck the cast shadow under each leaf using overlapping circular motions and light hand pressure to control the pencil layer. Take care to keep the leaf edges light. Blend if needed.

Layer 3, 2H pencil: To add more depth, in the deepest crevices under each petal, add a darker gradating layer that fades into the Layer 2 shading.

Layer 4, 4H pencil: Add undulating shadows using the divots as guides to create U-ish and V-ish shadowy ruffles that move back into the cast shadow of Layers 2 and 3.

Layer 5, 2H or HB pencil: Deepen the crevices and undulating shadows.

▲ Layers 1 and 2

▲ Layer 3

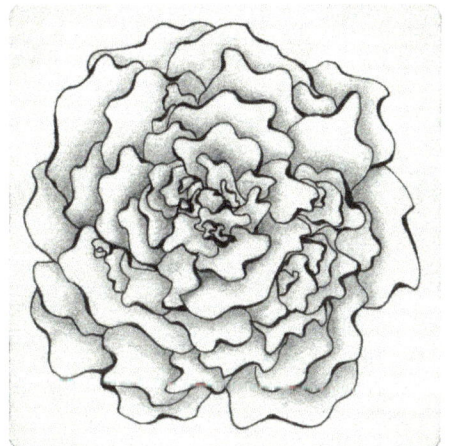

▲ Layer 4

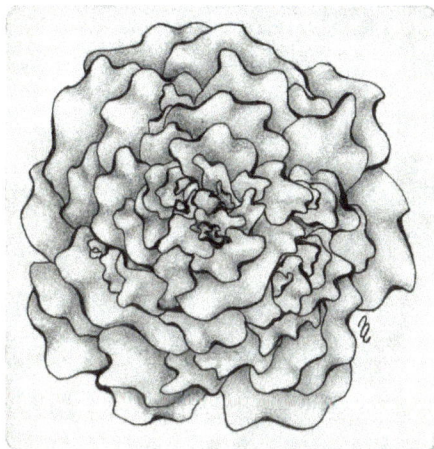

▲ Layer 5

Chapter 4: Adding Expression Through Shade, Shadow, and Highlights

LESSON 31

Grounded Landscape Shading
Partners with Verdigogh and Mooka

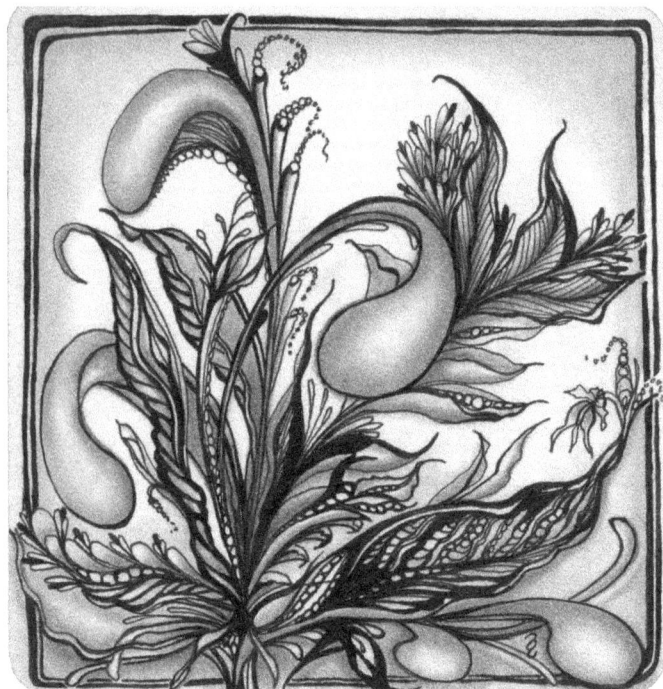

▲ Mixing blue pastel over graphite created a unique, suede-like look and feel. After adding the blue shading on top of the graphite, the balance changed and a frame was needed.

A successful landscape is grounded with visual and physical weight at the bottom of a design and at the base of clusters. For shading purposes, that means dense foliage and botanical elements ground the design with strong foreground imagery splashed with dappled light, dark crevices, and cast shadows. As the eye moves upward, the foliage becomes less dense and more open.

✏️ **EXERCISE: Grounded Landscape to Shade Mooka and Verdigogh**

Create three tiles or go back to ones previously completed. Shade one tile with graphite, another with blue pastel pencil, and the last one with both. (See Lesson 28, page 102.)

Layer 1, pen: Draw the design or select a previously drawn tile with expressive lines, marks, and enhancers.

Layer 2, pencil: Add a layer to the edge with overlapping circular motions. With graphite-only shading and no frame, the botanical feels balanced.

Layer 3, blending tool: Smooth out the pencil.

Layer 4, pencil and blending tool: Add a pencil outline to create cast shadows. If shading in both graphite and blue pastel, use the blue to deepen the depth and rounding. Carefully add light touches of blue to the highlights. Or try the reverse: Shade with blue and enhance with graphite.

Layer 5: If needed, add enhancers, weighted line, and expressive marks. Retrace lines that faded with shading.

Pillow shading is the same whether using pastel or graphite. When using color, more attention is required to keep the white highlights clear. Color is more difficult to remove with a kneaded eraser.

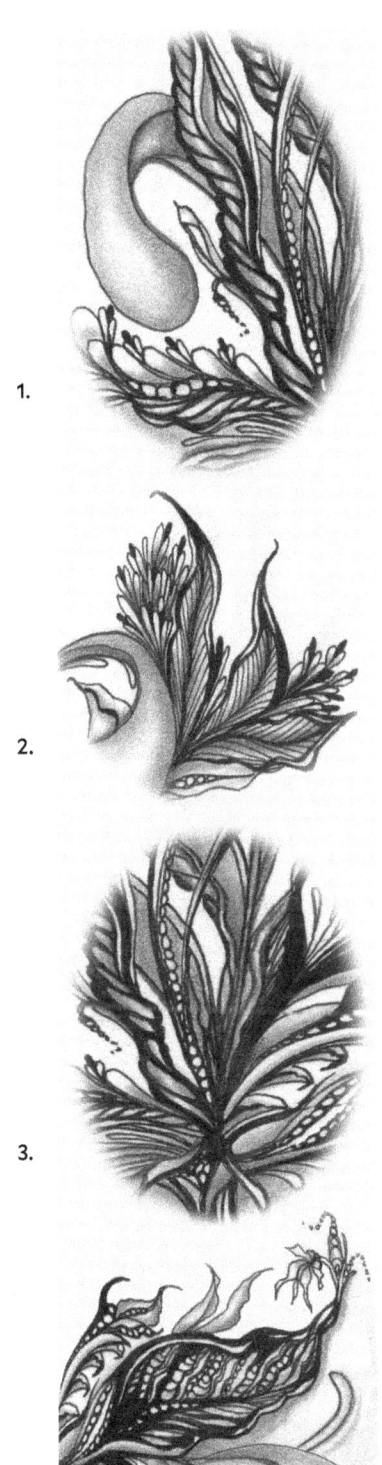

1.
2.
3.
4.

GUIDELINES FOR SHADE, SHADOW, AND CAST SHADOW

Shading choices are fluid and will evolve and morph, so study these guidelines and rely on intentional intuition to guide your choices. Placement is important because the eye visually picks up on poorly placed shadows.

Highlights
Examples 1, 2, 3, and 4
Highlights are the lightest lights, and almost every form has one to add dimension and depth. As forms move into the background, the highlights will not be as bright.

Dimension
Example 2
The leaf takes on more depth by combining a darker center shadow and highlights in the middle or on the edge.

Deep Shadows
Example 3
The darkest darks recede visually. Look for crevices, V shapes, and line clusters in the dense bottom layers to make the darkest shadows. Use multiple techniques for variation, and consider adding expressive line, hatching, wedges, and blackout. (See Lesson 11, page 46.)

Cast Shadows
Examples 1, 2, 3, and 4
Cast shadows are created by overhead light and will be on the *underside* of a form (example 1) or behind large shapes and clusters (examples 2 and 3). To create the cast shadow, follow the shape of the top image. Cast shadows can be a dark to light gradation or have a strong line.

Cast shadow can also ground a composition (example 4), so look for shapes that would cast a shadow below the denser foliage at the bottom. If more grounding is needed, add a light layer of shading under the foliage.

Mooka Hook Pillow Shading, Reflected Light, and Cast Shadow
Examples 1, 2, 3, and 4
The large Mooka hooks are similar to the circle and are good candidates for pillow shading and reflected light. They create cast shadows as they stand tall over other smaller shapes and forms. For extra depth, with a pen or pencil, add a thick line under the hook, tapering as the line travels down the stem (consider this line a long wedge).

Chapter 4: Adding Expression Through Shade, Shadow, and Highlights

LESSON 32

Black Backgrounds
Partner with Shading and Highlights

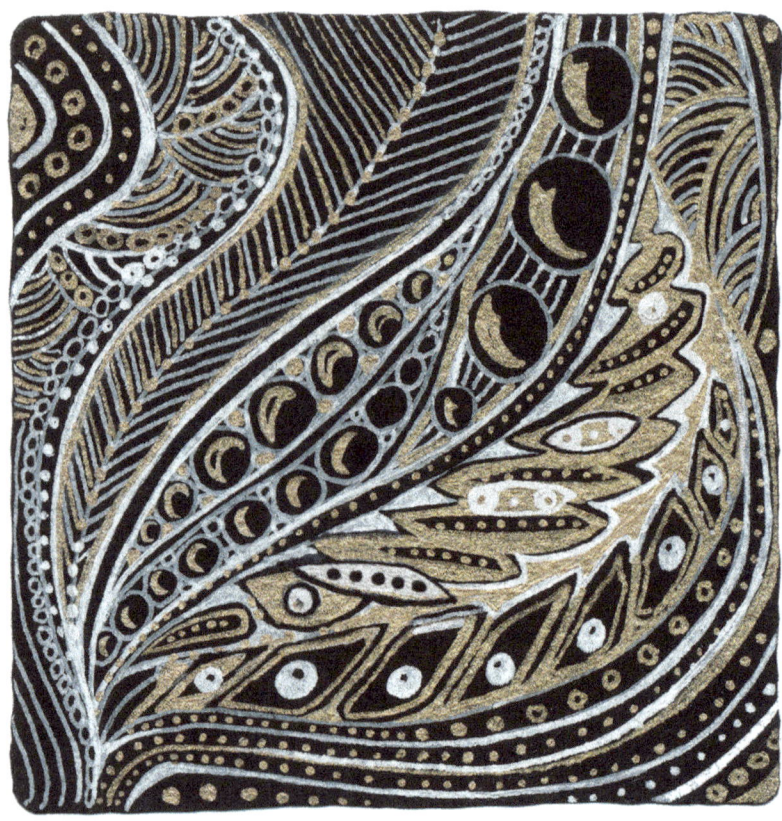

▲ *Between Two Lines*, 2011

Black paper offers a magical alchemy when combined with white and metallic pen line, shading, expressive line, and enhancers.

 EXERCISE: Explore the Magical Alchemy of Black Backgrounds

1. White shading is done with the same techniques as pencil. It sounds contradictory, but trust that it is the same and that the end result will look like the examples.

2. Create three to five tiles that use:
- White pen line only
- White and metallic pens combined
- White line and shading combined
- White and metallic pen combined with white shading

◂ SharlaRella, 2012

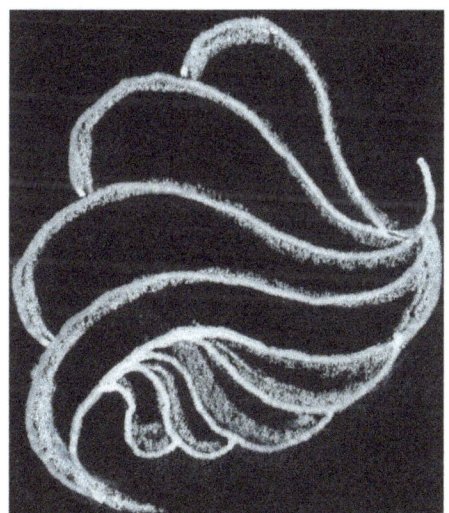
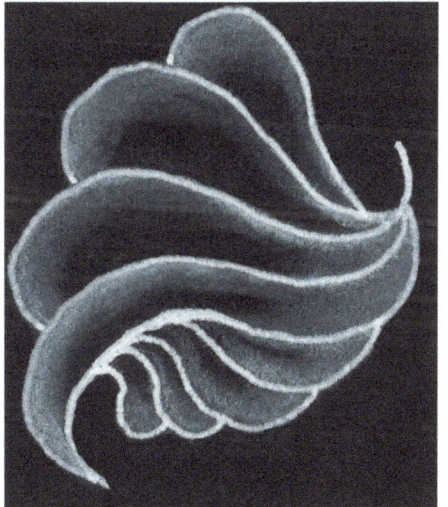

▲ **Layer 1:** With a light hand and circular motions, add white charcoal or pastel. *TIP:* In tight spaces, use white pencil and trace on the line. (See Lesson 21, page 78.)

▲ **Layer 2:** Blend with a shading tool, experimenting with different sizes of blending tips. If needed, add more white for strong rounding highlights.

▲ **Clean-up is important.** To keep integrity of the shading, remove unwanted white with a malleable kneaded eraser. Carefully press over and lift off unwanted marks. Watch for accidental dark gaps between line and shading.

Chapter 4: Adding Expression Through Shade, Shadow, and Highlights 113

LESSON 33

Neutral Backgrounds
Partner with Pen Line, Shading, and Highlights

SUPPLIES
- Neutral-toned backgrounds
- White pastel or charcoal
- White and metallic pens
- Dark fine-line pen
- Graphite or matching colored pencil

Combining the magical alchemy of white and pencil shading with neutral backgrounds is the extra something that brings life to the work. In the examples below, it is clear the expressive line Verdigogh variation has good design potential, but more is needed, a flop-portunity. On a neutral mid-tone background, dark expressive line and enhancers are not enough to add character to the artwork. The composition becomes enchanting with the simple addition of graphite and white shading.

Blackout and overlapping line create weight, separation, and depth. (See Lessons 11 and 12, pages 46 to 51.) White highlight shading and graphite create recessed shadows. Keep the paper clear as the middle to deep shadow.

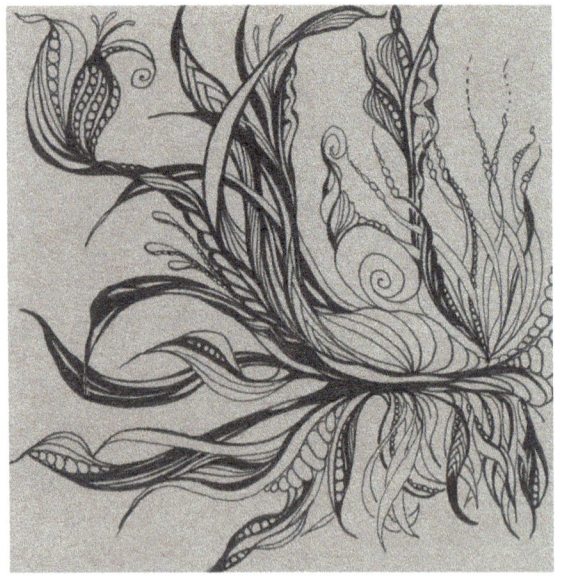
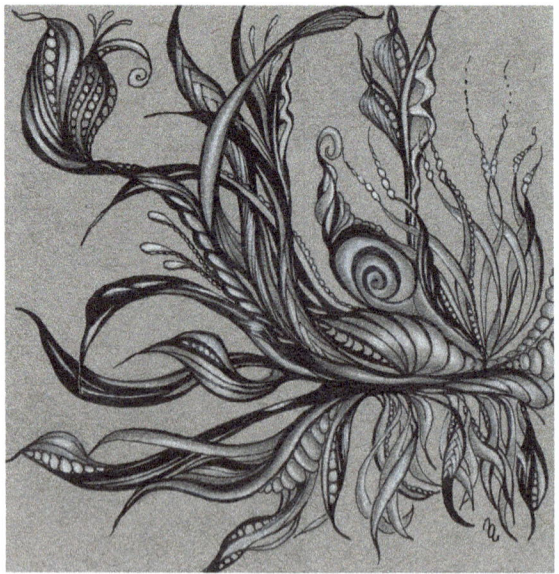

▲ Verdigogh Series, 2015, 4" x 4" (10.2 x 10.2 cm)

▲ Shading choices affect the mood of a piece, experiment with adding white only and white plus pencil combinations.

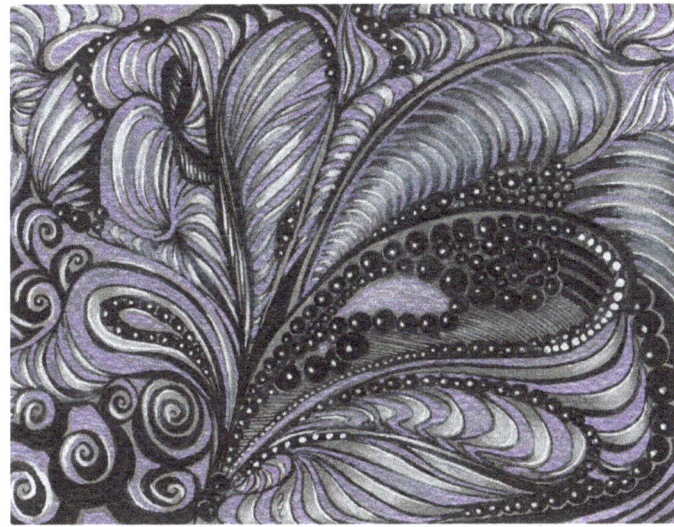

◀ Mid-tone gray background with purple metallic, white, and black pens. The glow is created with white shading and pen highlights. Recessed shadows are made with graphite and gray marker. Striping is excellent practice for adding pen line highlights.

 EXERCISE: Explore Shading Using White Highlights, Pencil Lowlights, and Recessed Shadows

1. On neutral backgrounds, white shading is done with the similar techniques as pencil with three differences:
- You add the white highlights.
- The paper is one of the mid- to dark-gradation tones.
- Similar to black, white on mid-tone can act as shadow that glows, as shown in the examples above.

2. Create tiles similar to those from the previous lesson to compare the differences between shading on dark- to mid-tone neutral backgrounds.

3. To add white and pencil shading, use the steps outlined in that lesson.

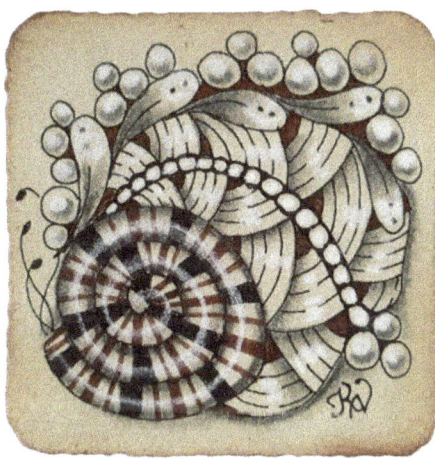

▲ Kim VanZyll, © 2016, 2" x 2" (5 x 5 cm). Kim is a master at shading orbs and adding highlights.

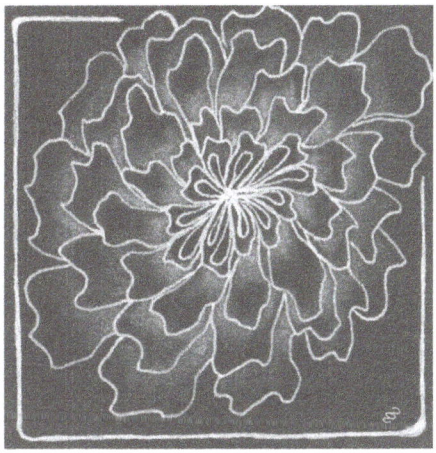

▲ SharlaRella Series, 2012, 4" x 6" (10.2 x 15.2 cm)

For continuity, keep the highlight and lowlight placement consistent to suggest a directional lighting that adds to the rounding of the shape.

LESSON 34

Bring Color, Shading, and Highlights
to the Botanical Dance

Working in a series is about experimentation and trying out new ideas, background choices, and pen colors.

Color is a complex variable in tangling, so it is important to limit color choices. In example A, note how the pink and red additions in the first example feel out of sync. Limiting a palette to one pen color and white pen highlights on a mid-tone background offers many combinations. This limited palette teaches how the variable of color can add or distract from the work.

Example B is a tile in progress. White and green shading add rounding and dimension. The green deepens the recessed crevices, between the Vs, and the cast shadows. The finished tile, example C, has white pen accents. Shading and highlights are personal, and each decision adds your unique vision as an artist.

Note how the two tones of green pen add definition to the shapes. The brightest highlight position is usually at the roundest point above a deeper shadow. This is a good opportunity to add the optional reflected light shown in Lesson 29, page 104.

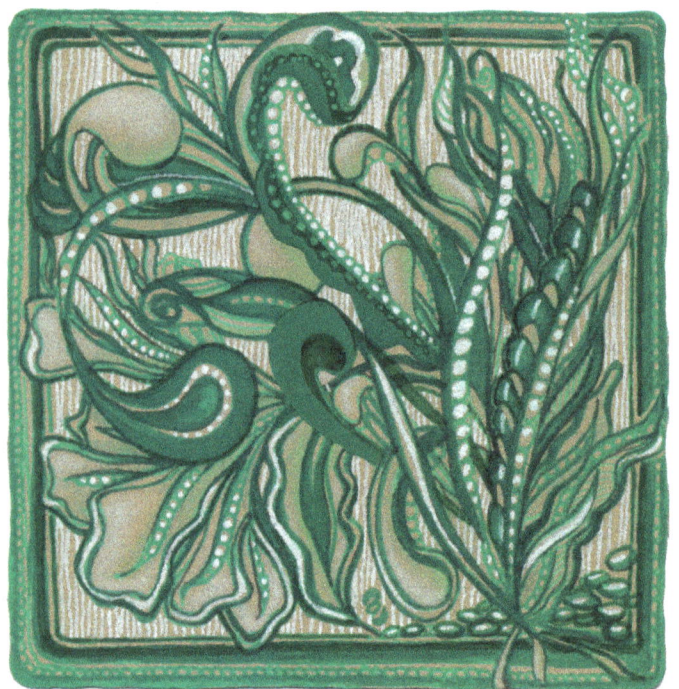

▲ Example C

Tips for Testing Pen and Paper Combinations

It is important to know how ink color dries on a paper surface. Many fine-line colored pens have transparent ink. When drawing, it may look like you are adding layers of deeper colored expressive line but, unfortunately, sometimes the ink dries a flat single color and the visible depth disappears. See "Pens and Paper" on page 14 and Lesson 16 on page 62.

The solution is to select two or three similarly colored pens with mid- to dark tones. Create the line design with a mid-tone pen. When separation between shapes is needed, use the darker pen as an outline. If multiple values of similarly colored pens are not available, use a fine line gray or black. (See Lesson 21, page 78.)

✏️ EXERCISE: Colored Pen, White Highlights, and Shading

1. Create three similar designs on the *same* background. Limit yourself to one pen color and white highlights. See example A.

2. If the pen color dries the same value, use the darker fine line outline technique for definition between shapes. (See example B and Lesson 21, page 78.)

Layer 1: For shading, use a color similar to the pen choice; it does not have to be exact. With a light hand, add shadows to the deep crevices and between the Vs.

Layer 2: White adds a bright roundness to the hooks, petals, and leaves. Green adds the mid-tone shading for rounding the shapes. Both help the paper's background and deep shadow layer recede. (See B close-up.)

Layer 3: White pen highlights push shape edges and dots to the forefront. Optional: Compare example C and the close-up, and consider adding white pen striping or another enhancer to brighten the background. The background still recedes behind the stronger forefront shapes.

Layer 4 (optional): If the deep shadows are not dark enough, add another layer.

Layer 5 (optional): If further definition is needed, determine whether more enhancers and weighted line will help. Also look at adding the darker fine line outline between shapes.

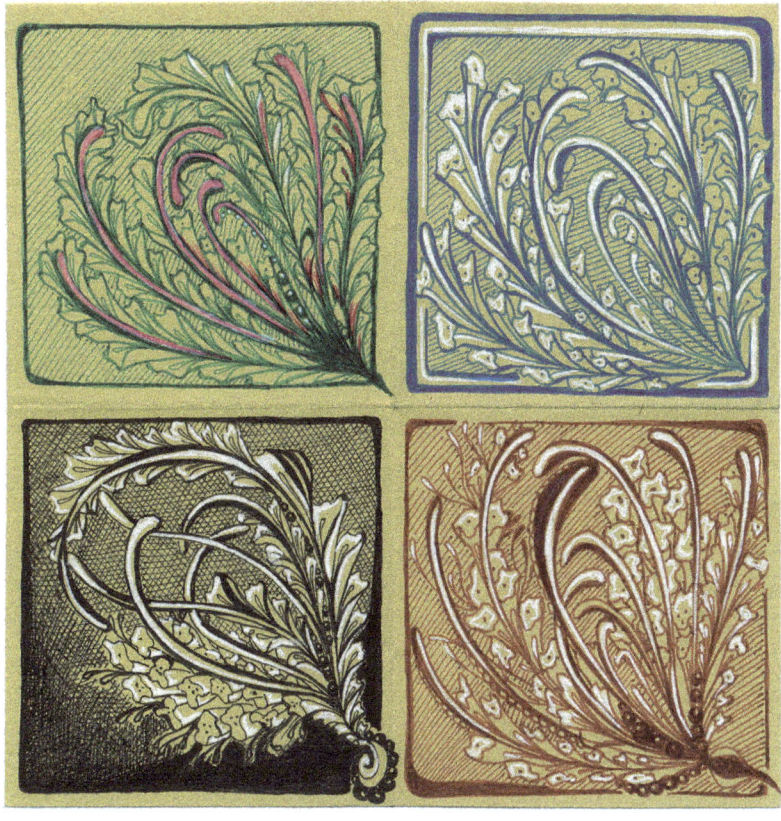

▲ Example A

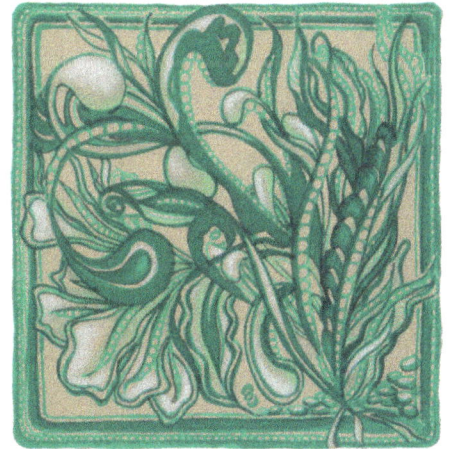

▲ Example B

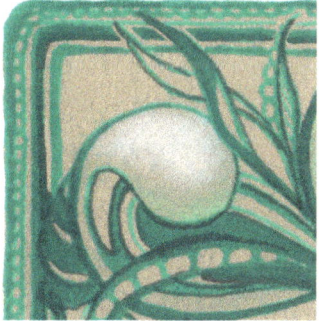

▲ Close-up of example B

> LESSON 35

Reeds & Weeds Meets Color
and the Grounded Landscape

Reeds & Weeds is an expressive pattern that lays the groundwork for successfully using multiple pens to create a specific look and feel with color. It is the ultimate grounded landscape, as it creates foliage layers that incorporate foreground overlay, grounded layer, middle ground, and receding background.

Building Reeds & Weeds

To achieve different pen widths, change hand pressure or use different pen sizes, such as .08, .06, .05, .03, .02, .01, and .005.

Remember, warm colors come forward; cool colors recede.

Warm colors: Red, yellow, orange, and yellow-green in a dark value help push forward the foreground and bottom layers.

Cool colors: Red-violet, purple, blue, and blue-green help the middle ground and background layers visually recede.

Foreground Overlay and Bottom Ground

The foreground overlay and the bottom layer are the dominant players in a landscape. To create the illusion of being front and center, use large, well-formed shapes that are pushed forward by pen width and color choices.

Pen width and expressive line: The darkest and heaviest line comes forward. Use blackout, weighted lines, and highlights to separate shapes from their neighbors. Include dramatic enhancements using dark expressive line, marks, and strong highlights.

Foreground and bottom layer color interaction: Remember, the darkest dark comes forward. Create depth by pairing the darkest warm-valued color with the foreground overlay and bottom layer.

When using a warm or cool color selection, make sure the darkest value is used in the foreground and at the bottom of the tile.

Middle Ground

As the name implies, the middle ground is in a neutral position, not showy or dominant. It is always a step behind the foreground.

Pen width: Lines are thinner than the foreground. The enhancements are less showy. Shapes are smaller and less dominant.

Color interaction: When using similar colored pens—for example, all browns—use a distinctly different mid-tone value. To create strong foreground separation, use a cool mid-tone pen. If you want the middle ground to blend slightly with the foreground, use a color similar to the foreground and keep the middle ground somewhat lighter with thinner lines.

Receding Background

Backgrounds are in the cheap seats, and the shapes and forms are minor players in the value and color game.

Pen width: Use thinner light lines and subdued enhancements, and no strong darks or lights. Light shading can be used to separate the background shapes from the paper's tone.

Color interaction: The background uses the very lightest value and the thinnest lines. When it is a light-value cool, it really recedes.

▲ A single color, monochromatic uses blackout and repetitive lines to create a foreground and middle ground only.

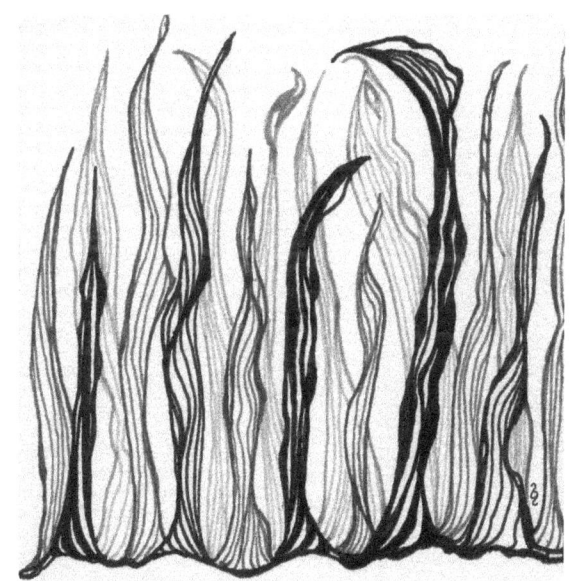

▲ The foreground is created with black lines, the middle ground is medium gray, and the receding background is light gray.

Chapter 4: Adding Expression Through Shade, Shadow, and Highlights

LESSON 35

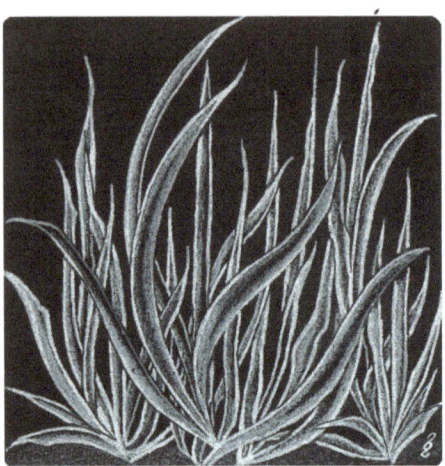 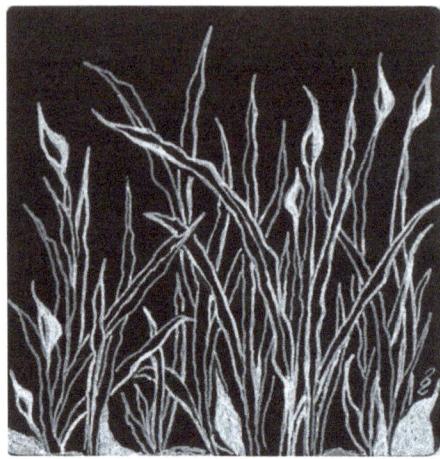 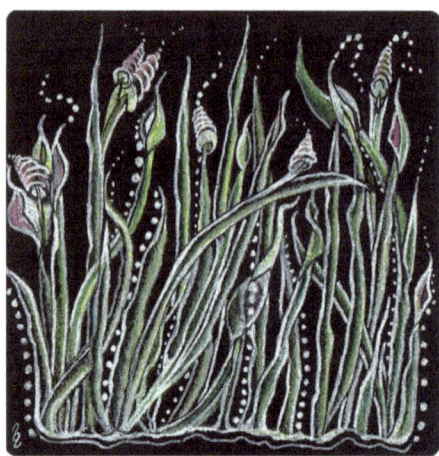

▲ The roots of the series began with the first two black tiles. With further play, the simple strokes evolved—morphed—emerged into the Reeds & Weeds Series. Another unique departure in the series is the last piece with its whimsical Zingers, dots, and color shading.

SUPPLIES

- Tiles with three or more different backgrounds
- Light, medium, and dark colored pens

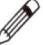 **EXERCISE:** Reeds & Weeds

Use intentional intuition. Add shading and white highlights when needed. Try these variations:
- Same pen
- Three different pens in the same color family
- Black, gray, and light gray pens
- Warm-colored pens
- Cool-colored pens
- Warm- and cool-colored pens

1. Create a strong grounded landscape with distinct layers.

2. Create a rhythmic landscape without grounded layers using balance and contrast.

3. Create a themed tile using Reeds & Weeds, color, background selections, and enhancers. If needed, consider one of the following: a time of day, whimsy, an emotion, an event, a holiday, or a season.

4. Document in your journal how thinking requirements differed when using intentional intuition for three different concepts. When you are able to use vocabulary to describe a process, you will be able to draw on the inspiration again in the future.

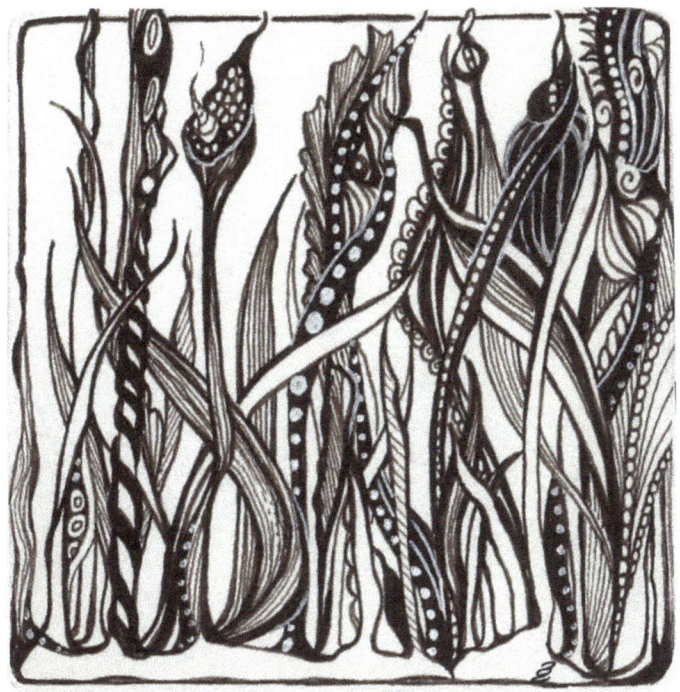

▲ This tile has an excellent sense of depth created by balance and contrast *without* grounding layers. It is easy to lose layers by not keeping the strong, dark-enhanced elements in the foreground.

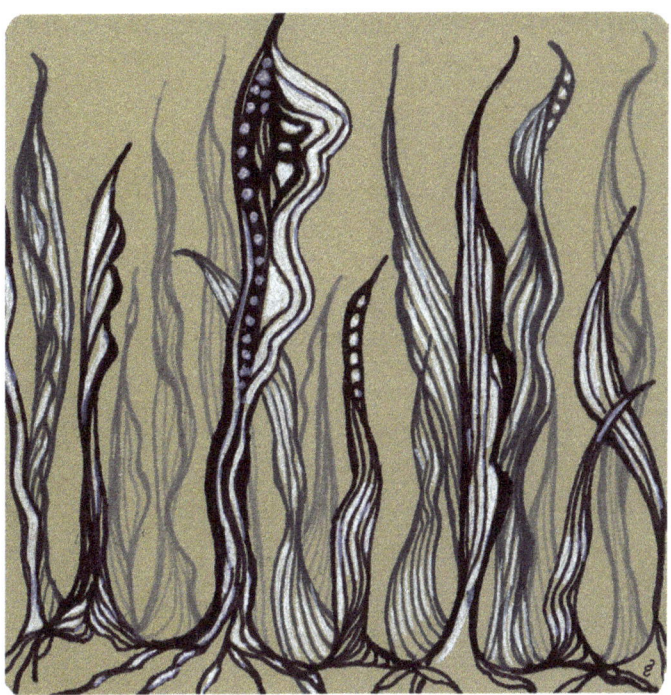

▲ Reeds & Weeds is a pattern of similar cohesive shapes. The similarity requires pushing the limits of expressive line and white highlights for a strong foreground. It is easy to create an accidental focal point that draws too much attention to itself. If needed, rework and include two or three strong images to act as counterbalance to each other.

Tips for Reeds & Weeds Design

When adding enhancers and expressive marks, repeat a similar variation two to five times, paying close attention to intuitive balance and contrast in the overall design. When doing grounded landscapes, create balance in each layer.

LESSON 35

COLOR'S EFFECT ON GROUNDED LANDSCAPES AND BACKGROUND VARIATION

These Reeds & Weeds series are done on three different backgrounds. In the first, note how each background makes the same pen look like a different color. The second combines warm rust and cool purple pen line for a complexity that only color can bring. When using darker backgrounds, highlights help move forms into the foreground. These tiles rely on weighted lines, enhancements, and blackout to delineate shapes and create the illusion of foreground, middle ground, and background.

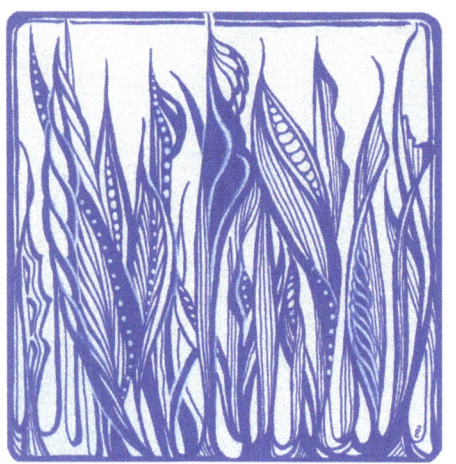
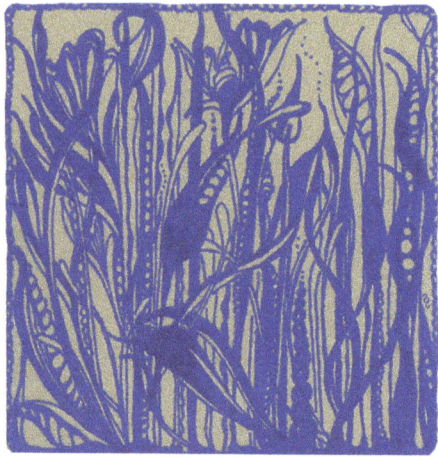
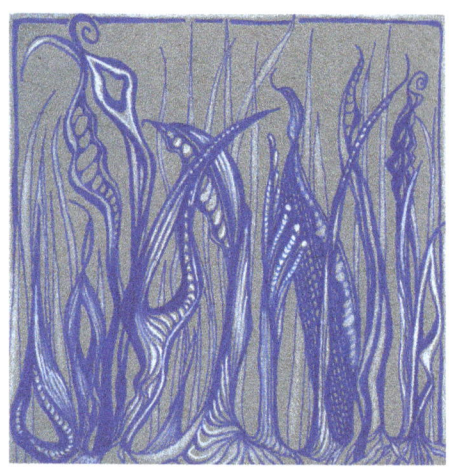
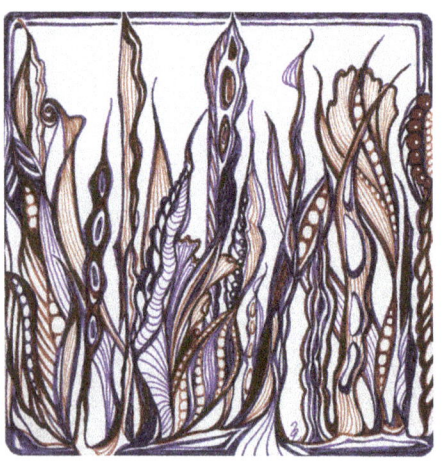
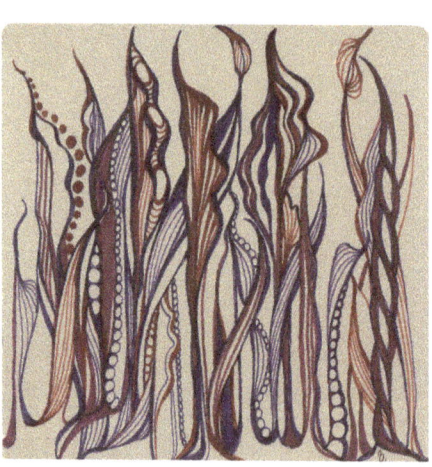
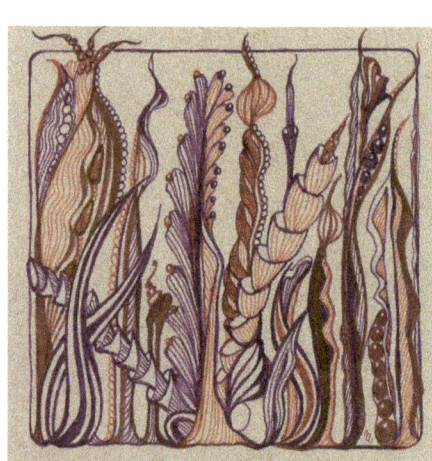

▲ These tiles have a rhythmic balance between the warm and cool and the light and dark that creates an illusion of depth. There is *no* clear distinction between foreground and middle layers. The background is nonexistent.

▲ Using one color to create individual shapes makes them stand apart from neighbors. The warm rust shapes come forward and the cooler purple shapes recede, creating a strong illusion of depth.

122 Tangle-Inspired Botanicals

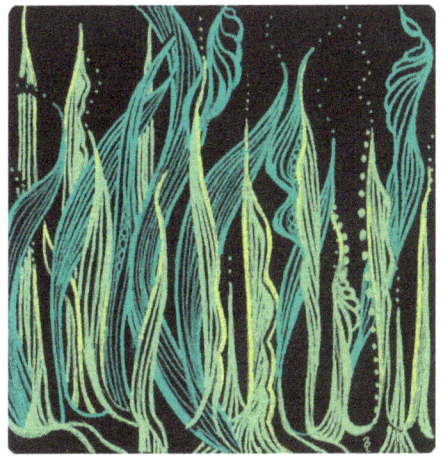 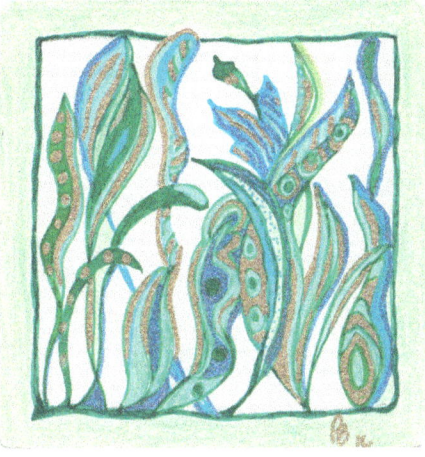

FIND YOUR VOICE

Take command of the content, inform the viewer of your message, and project your artist voice by learning how to use color, value, background, and pattern to make a statement. Reeds & Weeds is a pattern that quickly taps into intentional intuition, logic, and mindful focus.

▲ The opaque florescent gel pens are glowing! Why? The dark background pushes the light pen forward while the cooler, darker pen recedes for a very strong illusion of depth and glow. (See Lesson 34, page 116, for more on colored pens.)

▲ Peggy Buggy's unique artistic voice combines gold metallic pen, a creative border, and watercolor technique using balance and contrast to create depth.

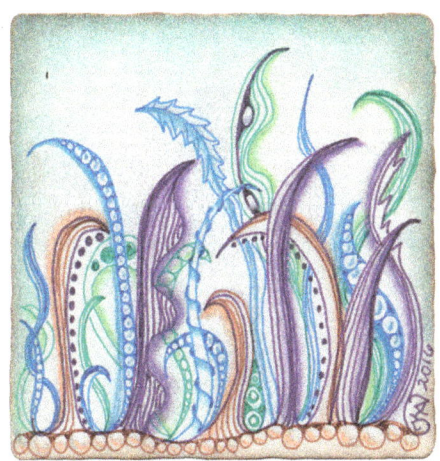

▲ Kim VanZyll's creative implied frame and shading choices reflect her signature artistic voice.

▲ Deborah Goldman's artistic voice uses very little shading and relies heavily on expressive line and enhancements. Her work often has a whimsical look and feel.

Chapter 4: Adding Expression Through Shade, Shadow, and Highlights

LESSON 36

Pulling It All Together

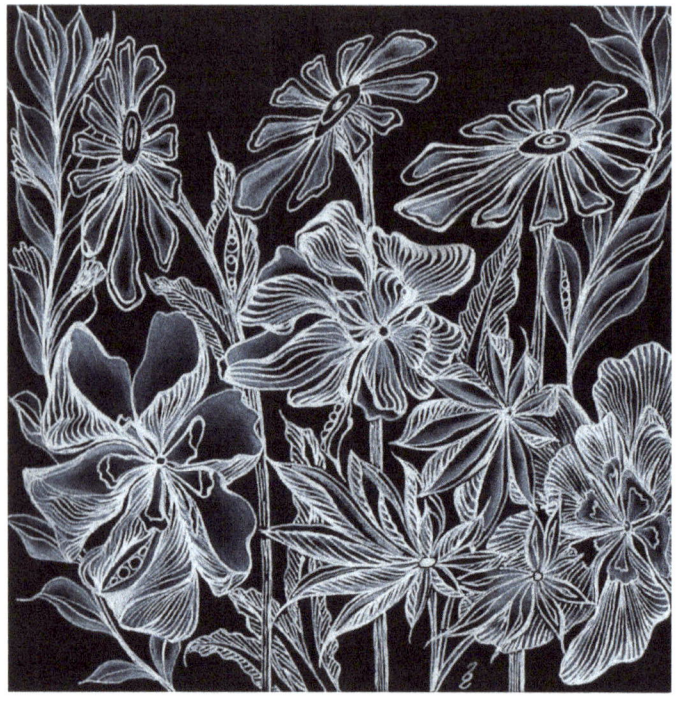

▲ *The Black Bouquet*, 2015, 6" x 6" (15.2 x 15.2 cm)

▲ *The Black Bouquet* has three ovals, three hearts, and three geometric forms. Clusters of three can hold a design together.

Starting a large artwork can feel intimidating. Remember, every art piece is practice. Most will be successful, some will be iffy, others will be bad, and yet each helps you grow as an artist.

Don't Stop at Ugly: It Is a Flop-portunity

Every piece goes through an ugly phase—especially in the early stages. Please hear my roar: *Don't stop at ugly.* Do not give in to the impulse to tear up your piece and throw it away. Keep working to transform a so-so project into something wonderful. The ugly phase is just the beginning of "the flop-portunity."

 EXERCISE: Add Your Unique Expressive Vision to a Large Piece

1. Select the type of paper and pen(s) you want to use. See "Pens and Paper" on page 14 and Lesson 16, page 62.

Size: If you are new to patterning, start with a smaller size. If you are a more confident tangler, go large.

2. Explore compositional ideas. Feel confident that you can make your own choices. Reference this book, your journal, and tiles for inspiration.

3. In light pencil, set up the floral's basic outline, using a variety of shapes and sizes to add interest. Overlapping is okay.

4. Include possible leaf and stem placement. Look for where the shapes will overlap, and whether you want the shape to be in front or behind. You do not need to erase the lines: They will disappear as the work progresses. If not, erase when them you are done.

5. In pen, draw the *outline* for the petals, stems, and leaves. Pay careful attention to overlapping shapes.

6. Determine your look and feel for the overall piece. Make intentional intuitive choices for line and pattern development. Each choice will offer context: realism, tangle-esque, whimsical, thematic, and so on. As the work progresses, contemplate and listen to logical intuition for the answers about what is, or is not, working. Use "what If," "what's next," and "how can I" questions.

7. Test ideas using a clear overlay or a copy. If using an overlay, use a pen that easily wipes off.

8. Is your artwork complete? (See Lesson 7, page 32.) Remember, when the questions slow, you are nearly done. Take care not to go too far.

> **Guideline Questions for Intuitive Composition**
>
> Ask the following question as the work progresses:
>
> - Does it feel balanced? Do the light, airy sections hold their own against the heavy, darker design areas? How does the empty (negative) space feel?
> - Does the overall design feel restful, pleasing, and complete? If something more is needed, what else can you do to change up the composition?
> - What enhancements can add the extra edge?

▶ The arrows are pointing at awkward petals. The green shows the original form. Extra petals created a fuller shape. Weighted line, wedges, hatching, and enhancers can be added to make the petals more pleasing.

Chapter 4: Adding Expression Through Shade, Shadow, and Highlights

Final Words of Advice

Remember, "Perfection is not required" offers artistic freedom to explore without unrealistic expectations. Visual memories are accumulating, waiting to reveal new inspiration and insight. Regular practice builds muscle memory. The visual vocabulary of art partnered with logical intuition stands ready to guide this joyful journey of discovering your artistic voice and expressive lines!

▲ Expressive Line Series, 2016

Make Your Mark!

"Engage Fear.
Engage Logic.
Engage Intuition.
Find Rhythm.
Find Expression.
Make Your Mark!"

—Sharla R. Hicks, 2016

Artist Contributors

These talented artists are students, members of my Tangle Friendship groups, or have attended my Petals and Leaves: Tangle-Inspired Botanical Retreats in Big Bear, California. Their personal styles have broadened the perceptions and concepts I teach and many are included in this book. The following have contributed works:

Holly Atwater, CZT, whose personal serenity presents itself in her art and her ability to help others find mindful focus through tangle meditation. http://hadesigns.blogspot.com. Page 84.

Peggy Buggy, whose desire to learn and try new ideas in her early tangle journey in a very short three-day period inspired each of us with her creative drive to grow as an artist, resulting in inspired works that reflect her unique vision. Page 123.

Anne Cathcart and Ed Gutierrez, two of my students whose determination to pursue their love of tangling no matter the obstacles, are heroes in my eyes. Page 11.

Deborah Goldman, CZT, whose deep understanding of her art is offered freely to anyone willing to join her in a collaborative journey of art making. http://silverwomanstudio.blogspot.com. Pages 74 and 123.

Donna Hicks, whose unique vision presented itself on the very first tile she made and continues on in practice journals, each bringing the quiet of mindful focus to her life. Pages 77 and 87.

Susan Valentino, an art historian whose personal art making started with portrait quilts, led to tangling, and has moved into realistic portraiture, a place she would never have gone without tangling. Pages 25 and 57.

Kim VanZyll, CZT, whose understanding of her skills produced exponential growth that incorporated both her already strong bank of skills with her desire to learn new information was an inspiration to all. Pages 115 and 123.

Susan Zimmerman, an artist whose work was on hold for over twenty years until she found tangling, unleashing a flood of mixed-media expressive botanicals with an ever increasingly powerful portfolio of impressive works. Pages 21 and 39.

About the Author

Sharla R. Hicks is an artist with a keen interest in mixed media and how patterning creates joyful art. She has released the unrealistic expectation that drawing requires exact rendering of a subject. She has been teaching creativity, design, and composition principles to artists since the mid-1980s. The path has had many twists and turns, all leading to Certified Zentangle Training in 2011. There she fused a lifetime of art making into the daily practice of creating expressive botanicals, a coalescence of mixed media and her love of floral and organic forms. She continues today to inspire those new to art to find their path. Follow her journey at www.sharlahicks.com. She is the co-owner of www.softexpressions.com, where you can find tangle supplies.

Acknowledgments

Thanks to:

Ernest, my husband, who did everything and beyond to create the time and space needed to write this book. His loving support created an environment that allowed words to flow and the book to see fruition.

Beckah Krahula, my powerful mentor, whose gentle guidance and belief in my abilities as an artist and teacher opened doors, providing the opportunity to move intuitive ideas to the page. Her constant presence through the process was the needed lightning rod to forge through the highs and lows.

Quarry Books, Mary Ann Hall, Meredith Quinn, and Heather Godin, for their support and wise recommendations that helped me become a better writer.

Most importantly, I must acknowledge my students. My favorite part of teaching is the collaboration between student and teacher that helps each one overcome obstacles on the personal and creative journey. The foundation principles in this book are what I have learned from each. I thank them for the immeasurable joy they have brought into my life.

www.ingramcontent.com/pod-product-compliance
Lightning Source LLC
Chambersburg PA
CBHW041923180526
45172CB00014B/1372